Type Graphics

GLOUCESTER MASSACHUSETTS

ROCKPORT PUBLISHERS

Margaret E. Richardson

Type Graphics the power of type in graphic design Foreword by Matthew Carter

ROCKPORT

First published in the United States of America by

Rockport Publishers, Inc.
33 Commercial Street
Gloucester, Massachusetts 01930-5089
Telephone: (978) 282-9590
Facsimile: (978) 283-2742 www.rockpub.com

ISBN I-56496-714-X
IO 9 8 7 6 5 4 3 2 I Printed in China

Design: MvB Design www.mvbdesign.com

Art direction: Mark van Bronkhorst
Typography: Alan Greene
Production: Akemi Aoki

Editorial/design intern: Kristi Kraxberger

Eidetic typefaces courtesy of PsyOps. PsyOps is
a registered trademark of PsyOps Type Foundry.

Following spread:
Detail from a poster
by Leonardo Sonnoli

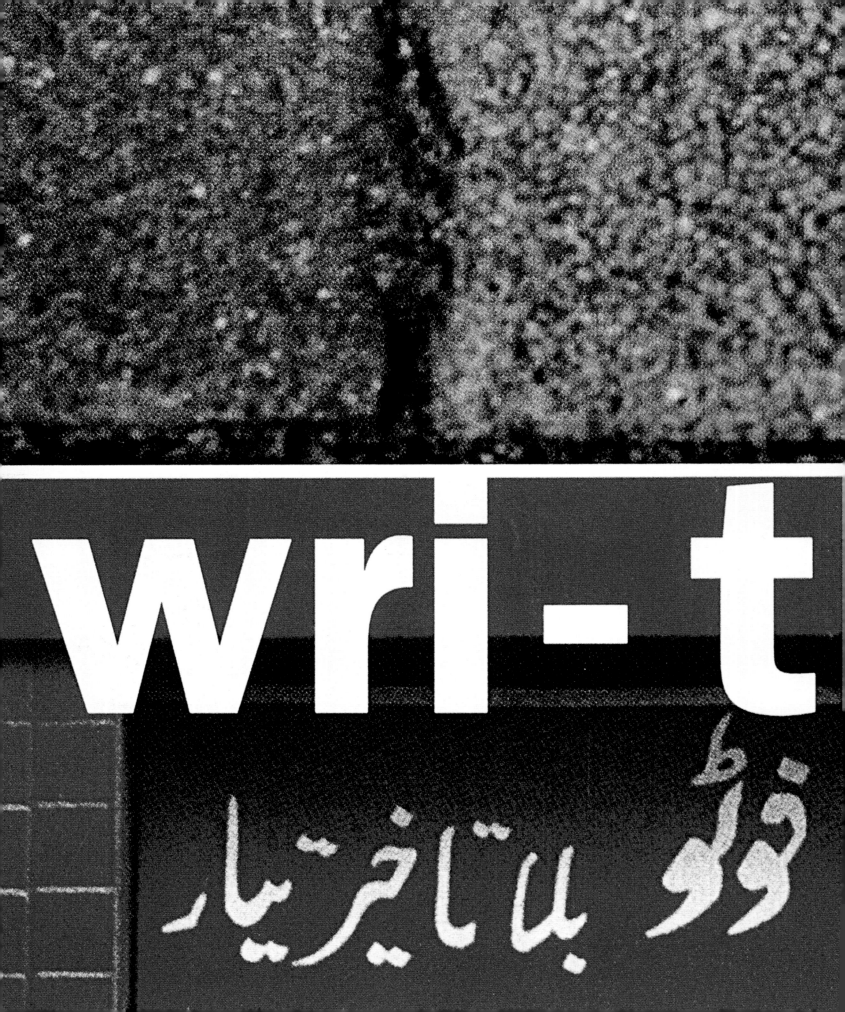

leona
@ ist
unive
di ar
di ve
10/1

hing s

پاسپورت ساز

Foreword Matthew Carter

"If one can't play cricket for England, one should be a typographer." This pronouncement, made many years ago in a London pub by the great typographer and cricket spectator, Derek Birdsall, can be translated from the original British into English as "You can fantasize about doing anything you like, but in real life being a typographer is the best job there is." The truth of Derek's remark, never in doubt, is even more obvious today with the rise of typography's status—nowadays international sporting stars probably fantasize about being typographers.

The flourishing state of typography owes much to the personal computer technology that has changed the practice of all forms of design since the mid-1980s. At first the new tools seemed more of a threat than a blessing. Might not the computers themselves with their artificial intelligence quickly learn everything typographers knew and automate the design of documents with no help from humans? Or if not too few humans then too many: might not the sheer accessibility of "desktop publishing" tools turn every secretary in every office into a designer and "de-skill" the business? But there turns out to be something irreducible about good typography that neither the robot-laboratory nor the typing pool ever quite co-opted. It's significant that the word "typographist" coined on the analogy of "typist" to describe the

desktop non-designer never caught on, and not for the lack of ever more affordable computers and give-away supplies. A cab driver in New York told me recently he had just bought his first PC. As part of the package came several free software applications and games, and 900 fonts. This is generous; the total number of fonts used by two dozen of the world's best typographers in illustrations to this book is just on 400. By the way, to my obvious question "What do I have to do to get 900 free cab rides in New York City?" I got the obvious answer: "Buy a ****ing cab."

The term "typography" has the portmanteau meaning of both design *of* type and design *with* type. It was elegantly defined by Ellen Lupton as "the art of creating letters for reproduction and organizing them in space" in her introduction to *Mixing Messages: Graphic Design in Contemporary Culture*. That exhibition (in 1996) and the book that accompanied it, looked at graphic design with the broadest possible scope and gave typography its due as a constituent part of a complex whole. The present book, *Type Graphics*, (as the order of words suggests) takes a different view by focusing on typography against a background of graphic design. It is possible to emphasize type but not to isolate it; the "space" of Ellen Lupton's definition is seldom empty; letterforms share it with other graphic elements—photographs, illus-

Following spread: Detail
of the back side of
Typerware's letterhead

trations, diagrams, collages — and how well they share it is a measure of the typographer's art.

Type design, the raw material stage of typography, was also transformed by the personal computer, perhaps not so much by the arrival of the Macintosh itself as by the coming five years later of open font formats. New typefaces for the Mac had been designed on the Mac from the get-go, most innovatively by Emigre, but the fonts were technically inferior to commercially manufactured PostScript fonts. From the moment late in 1989 when font-making software tools were first able to generate Type I fonts, so called, every kitchen-table typefoundry was on a technical par with the industrial giants.

Just as graphic designers could use page composition software to control the production of their work, type designers now had tools that combined the functions of designing letterforms and making fonts. Designing and making, inseparable for the first three centuries of type's existence in the term "punch-cutter," had been uncoupled when craft changed to industry in the late 1880s with the mechanization of typesetting, and were only joined together again in the late 1980s with its digitization, the reunion blessed by Fontographer. The term "digital punchcutter" was heard — the type designer as *auteur*.

Typographers, designers *with* type, who once thought of the design *of* type as something arcane and daunting, now found its digital form accessible and "interesting" (in Lorraine Wild's word). A spate of new typefaces, by-products of more general graphic design as much as the work of specialists, began in about 1990 and is still in flood in the distribution channels of the retail font market. Independently produced types color this book, and give many of its pages more individuality, perhaps, than at any time since the handwriting of scribes was systematized into printing type. Used at its best the personal computer is ... well, personal.

Introduction

Type Graphics: the power of type in graphic design was conceived by Winnie Prentiss, publisher of Rockport Publishers, Inc. The form of this book — an overview of work from individuals/studios — emerged from our conversations. Winnie perceived that each of the subjects to be featured had a range of work that demonstrated contemporary typography in a variety of media. The text was to provide in-depth information on the studios, the work, and the thinking of each of the subjects.

The 24 designers in the book were selected based on what each contributes to effective use of type in design.

Any enthusiastic follower of contemporary typography will be interested in seeing the latest work of those whose names have become synonymous with innovative use of type. These include Neville Brody, Fred Woodward, David Carson, Louise Fili, Why Not Associates, and Rudy VanderLans — all have contributed to a redefinition and refinement of type in design. Each has been documented in design publications, books featuring their work, and in surveys of design history.

These well-known designers were asked to provide recent work for this book. Images that have been seen elsewhere were selected for inclusion because they contribute to the total oeuvre of the designer and add a context for the designer's style.

A secondary goal for this book was not to emphasize "radical" design, which has been sufficiently documented elsewhere and comes with the caveat that what is radical this year may be conventional by next year. The work featured here reflects contemporary typography in effective designs, and also includes traditional use of type, which is challenging in digital design and demands subtlety and craft in execution.

The original list of candidates whose work is typographically outstanding exceeded 100, and we intended to show a wide range of individual typographic styles within the pages of this book, so the task of choosing a limited number was daunting.

Each of the designers and studios featured here complements the others. For example, Plazm Media Collective has a range of work that moves from graphic minimalism to heightened expressionism. Designers like Rod Cavazos, of PsyOps, and Jeremy Tankard have come from graphic design to concentrate on type design. Phil Baines has made an art form of reinventing classical design. Henrik Birkvig and Torben Wilhemsen provide insights into how to subtly influence design styles for conventional projects. Susan Mitchell and Michael Ian Kaye have each brought typographic ingenuity to book jacket design through strong concepts.

Following spread:
Detail of a screen shot from
2 Multimedia Tracts CD by
Stephen Farrell

DJ Stout transformed *Texas Monthly* magazine with an aggressive typographic style that informed the character of that magazine. Don Zinzell combines graphic design, type design, photography, and attitude into a singular style. Smay Vision provides an edgy, quirky, typographic, illustrative body of work. Petr van Blokland shares a strategy for both conceptualizing and actualizing identities for businesses that might be local or global. Leonardo Sonnoli reinvents poster art digitally. Laurie Haycock Makela pursues an emphatic, energized use of type treatments in ads.

Scott Clum focuses on fluid type on the page and on screen. Stephen Farrell incorporates his passion for form into ingenious contemporary designs. Andreu Balius and Joan Carles Casasin of Typerware combine Spanish sensibility with a contemporary vernacular. Jonathan Barnbrook continues his meteoric displays of type in ways never seen or used before. To all these participants in the book, I offer thanks for their work, their cooperation, and their support.

I need to also acknowledge the numerous collaborators on this book. Kristi Kraxberger, the Portland State University intern, researched, annotated, cataloged, and advised not only effectively, but inspiringly. Project manager Jack Savage needs thanks for his hand-holding and prodding. Sue Ducharme proved to be a sensitive, sympathetic copyeditor.

Rockport managing editor Jay Donahue diligently pushed us forward, and art director Silke Braun offered guidance.

But the main thanks go to three people. I am grateful to the impeccable Matthew Carter for writing the foreword, since Matthew is known for his outstanding type designs as well as his stalwart support of typographic talent. Winnie Prentiss for her vision deserves thanks not only for giving me rein but for supporting my intention that this book have typographic integrity. I am especially grateful to her for selecting the designer who made this book what it is. Mark van Bronkhorst's talent and skill are seen on every page of this book. Mark has himself been featured in books on type and design. To *Type Graphics*, he brings sensitivity to the work of each subject while effectively creating the book's typographic style. Without Mark, this book would not be this book. I am honored and grateful to have worked with him again.

Personal thanks goes to the Land family who cosseted me during this amazing adventure.

Margaret Richardson

Of course, past typographic bodies had been showcased to
flaunt the prestige or virtuosity *of those in whose service they w*
employed. But these calligraphic specimens demonstrated their
own corporeality only insofar as they exhibited the event and

Plazm

Above: *Plazm 21* "LawnScapes" cover explores issues of livability and growth
ART DIRECTION: JOSHUA BERGER, NIKO COURTELIS, PETE McCRACKEN. DESIGN: PETE McCRACKEN. PHOTOGRAPHY: MARK EBSEN. LETTERPRESS OVERLEAF: CRACK PRESS

Opposite: The design of the "Against Livability" spread for *Plazm 21* was a result of a two-day student workshop given by Plazm at Oregon State University.
ART DIRECTION: JOSHUA BERGER, NIKO COURTELIS, PETE McCRACKEN. DESIGN: GARRETT ANDRES, MATT BALDWIN, LAUREN McKENNA

PLAZM MEDIA COLLECTIVE is based in a spacious office surrounded by artists' studios near the Willamette River in Portland, Oregon. Here, the collective runs a design studio, Plazmfonts, and *Plazm* magazine, published quarterly.

The most visible Plazm entity is the magazine. This publication is eclectic, intelligent, and edgy with typocentric, quirky design. It is also the calling-card and portfolio for the interrelated talents of the art directors Joshua Berger, Pete McCracken, and Niko Courtelis (now based along with Riq Mosqueda in New York at Lintas Lowe & Partners, embodying Plazm East).

"Although the magazine has evolved since we started it in 1991," according to Berger, it remains "our printed laboratory, our ongoing experiment. It still is a forum for our varying interests. The fonts grew out of the magazine and the Plazm design group as well."

Berger says that from its inception, Plazm was dedicated to merging multiple visions and voices. "We started as a cooperative and non-profit enterprise. Eventually we needed to run the business of the magazine properly, so Pete and I started working here full time. And with Niko (who then worked at Wieden & Kennedy), we've remained dedicated to experimentation through discourse. We value everyone's contribution here from managing editor Jon Raymond to the intern. The magazine is the product of whoever is involved at the time. We begin with this internal critique, by listening first." McCracken adds that "the results are much better when you let this process work. It's like having everyone's input in my band—the music then becomes much more interesting both to listen to and to play." According to Courtelis, this interplay of personalities "speeds up the process. Each person brings his or her particular interest, be it film, music, photography, to the table. The group thinking and talking gives each project parameters. From the ideas generated comes a vision, a direction, and we agree on a brief. This approach has evolved, but it allows us to explore what something is or isn't, to deconstruct on paper."

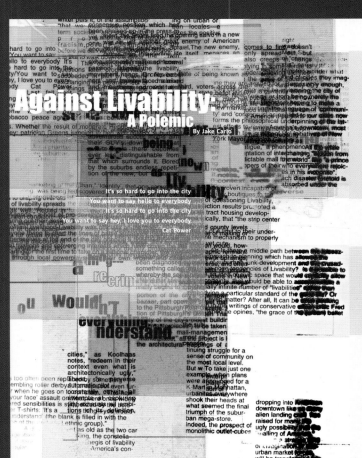

Against Livability:
A Polemic

By Jake Carlo

It's so hard to go into the city
You want to say hello to everybody
It's so hard to go into the city
You want to say hey, I love you to everybody

Cat Power

Last fall, not long after their attorneys general returned home with the Big Tobacco peace agreement, the States fired the opening salvo in a new war on yet another great enemy of American health and prosperity: Sprawl. The new enemy, rather than threatening life itself, menaces an even more ephemeral state of being known as Livability.

On November third, voters across the country faced a mixed bag of state ballot initiatives and constitutional amendments, over two hundred of them at final count, aimed at somehow curbing the relentless expansion of the suburbs. A surprisingly large majority of these measures passed, often by comfortable margins, and within a week big-city dailies were declaring the birth of a national livability movement. Suddenly Al Gore, known for his inhuman enthusiasm for land-use, planning and other tedious "soft-green" issues, went from laborious wonk to political bellwether and was being quoted from coast to coast, possibly for the first time in his career. And while Gore busied himself formulating the administration's new "Livability Agenda," a host of pro-development politicians defeated at the city and county levels began clearing out their desks. Growth-control had been definitively proven capable of making or breaking political livelihoods. Livability was officially on the map.

Anyone trying to chart the lines of battle tentatively drawn in the fall election would, however, find themselves at the end of the day gripping a hopelessly confused cartographic remnant. The political filiations and converging interests which have driven the latest anti-growth uprisings, while appearing for the first time to take on a national character, are frequently perverse, and often channeled through local powerplays with their own arcane and case-sensitive sets of ground rules. Whether the result of patrician Greens jumping in bed with NIMBY suburbanites in Ventura County or mega corporations hijacking Sierra Club legislation in Arizona, the defense of livability continually defies the balding liberal/conservative dichotomy that once purported to organize the nation's political life.

Moreover, in addition to draping over old political paradigms, the cloak of livability spreads across geographic borders as well. Rooted in both disenchantment with the suburban condition—its failure of public transportation, dearth of affordable housing, and engulfment of open space—as well as a strange nostalgia for urban life—its density, variety, and texture—the fight against sprawl, perhaps by definition, renders the boundaries between city and suburb somewhat blurry. For sprawl, one comes to find, doesn't only spread out, but also creeps in, hangs on, and bubbles up, applying in some sense to almost any example of underachieving architecture. But whether taking the guise of suburban "livability," urban "quality of life," or even rural "way of life," the anti-sprawl movement is currently offering a national referendum on public space and how it works, and moreso, on life and how to live it.

Waxing discontent with America's architecture and infrastructure has most recently been diagnosed by marketing consultants as "mall fatigue," the phenomenon whereby the serial presentation of interchangeable outlet stores in predictable mall formats finally begins to rob shoppers of their enthusiasm, of their sense of shopping as event. In focus groups, the petri-dishes of marketing's gay science, the epidemiologists of mall fatigue have learned that consumers crave a more unique shopping environment, one which offers both commercial variety and the patina of city living excitement. As marketing consultant Robert Gibbs puts it in his article, "Urbanizing: A Primer on How Downtowns Can Compete with Retail Malls," "(Americans) long for the community consensus and sense of place which once ruled our commercial and civic lives." In other words, the bustle and clang of the old city, cleaned up and encoded in the very blueprints of the new.

Consider an extreme case, that of Pittsburgh, where Mayor Tom Murphy and the city government have set in motion an unprecedented redevelopment plan to transform a portion of the city's downtown into a new cyborg mall-district, "part bazaar, part open-air street mall and part big-city promenade" according to the Pittsburgh Post-Gazette. Murphy's plan calls for a seven-block portion of Pittsburgh's Golden Triangle, encompassing a total of more than eighty of the city's oldest buildings (including more than a few "architectural masterpieces"), to be taken over by eminent domain and turned over to a single mall-management company, Urban Retail Properties. "Marketplace," as the project is known, will exist within and retain most of the architectural trappings

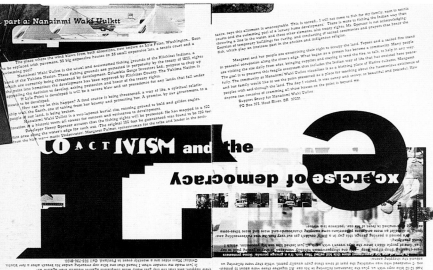

part a: Nanainmi Wakí Uulktt

The place where the wind blows from both directions, now known as Lyle Point, Washington... Soon to be replaced with pavement, 33 big expensive houses on 33 small expensive lots, a tennis court and a swimming pool?

Nanainmi Wakí Uulktt is the usual and accustomed fishing grounds of the Klickitat Indians, a band of the Yakima Nation. These fishing grounds are protected in perpetuity by the treaty of 1855, which are currently being threatened by development. Columbia Gorge Investors Ltd. propose to chop up the point into homesites for development has been approved by Klickitat County. The Yakima Nation is appealing the decision to develop, asking protection and honor of the treaty for any lands that fall under threat to be developed.

If Lyle Point is developed it will be a serene blow and set precedence for any lands that fall under...

How can we let this happen? A food source is being threatened, a way of life, a spiritual relationship with the Earth, one of taking from her bounty and protecting her. A promise, by our government, to a people of our land, is being broken.

Nanainmi Wakí Uulktt is a two-layered burial site, a reuniting ground to bald and golden eagles. Developer Henry Spencer assures that all causes for concern and resistance to development...

tance, says this allotment is unacceptable. This is sacred... I will not come to fish for my family, next to tennis courts and the swimming pool of a luxury home development. There is more to fishing the Indian way than throwing a line in the water, and these three elements, also treaty rights. Mr. Spencer is not acknowledging...

Margaret and her people are exercising their rights to occupy the land. Teepees and a sacred fire stand in peaceful occupation along the river's edge. What began as a protest has become a community. Many people are visiting the site daily from afar, bringing supplies and staying to tend the fire, to talk, to help in any way.

Support Group for Nanainmi Wakí Uulktt
PO Box 371, Hood River, OR 97031

CO ACTIVISM and the
exercise of democracy

NIGHT BUSINESS
by Rachel Fenimore

The skirt didn't need direction the wind took care of that playing /silly computer games only humans could win the electronic circuit/over loaded the truck of course it was an accident just like the/one in ecuador I never saw the yin yang pin on a tourist's coat was/stolen by a poor man who used it to hold his broken shirt around/his shoulder as the circuit melted the mayhem grew then dissipated/very slowly taking its time unlike the world on the street where/the tie and the high heels flew in the wind like the skirt with/direction away from the broken shirt to the tall building in the/safe city where the heels clicked like the clock that only/pretended to know how long it had been since the heels had left the/tall building to eat and sleep maybe even have some fun in the/bright lights of the home where the candle burned the house to ashes which blow in the wind/like the skirt.

PLAZM MAGAZINE
The magazine has allowed Berger, McCracken, and Courtelis to art direct designer/collaborators for the covers and within its pages, including Ed Fella, The Attik, David Carson, and Why Not Associates. Although *Plazm* is deliberately intended to never look the same twice, to evolve with each issue, the magazine can be characterized as being filled with innovative design treatments of its editorial subjects, with an emphasis on typographic virtuosity. *Plazm*'s commitment to type diversity is reflected in their varying treatments of the *Plazm* logo for each issue. Berger characterizes the magazine as a "well-produced 'zine."

The content of *Plazm*, with themes like "Identity" or "Architecture," is often esoteric, and the design matches the intensity of the content. Admitting that there was a period when the typography in *Plazm* was based on "experimenting with type as type," so that "*Plazm* became known for deteriorated type and messing things up," that phase has ended, says Berger. "We're not dedicated to sameness," he reiterates.

PLAZMFONTS AND TYPOGRAPHY
A spin-off generated by the magazine includes a range of Plazmfonts. "We got

WHEN THE BODY DISAPPEARS
by Haley Marie Isleib

It's mostly a story about pain, she said. It's about how it was before it got worse, because that's the way it goes. That's the whole story, from conception to crucifixion.

She also said, maybe a rose is a rose is a rose, but any other flower isn't, she kept stressing that any other flower isn't,

which I didn't get because of course it isn't, if it isn't, it isn't, so what? It meant something to her though, it made her laugh. So what? It made her mad.

Then she said,

That's the way it is, and you've got to fight the way it is, even though it always is that way, from the first to the last. A woman's crucifixion begins at conception, it only ends when the body disappears. You're getting adult now almost, she said, getting breasts even, everything will follow and you'll be seeing what I mean.

I blushed and I said, like what? What will follow and what will it follow? Me getting breasts? So what?

And she laughed.

About the pain, she said,

you'll be flat on your back and there will be pain and you'll be so embarassed you won't do anything about it, it hurts, it hurts, but you won't get any response. You'll think you're dying.

You will be.

Whether it takes eight eternities or eight milliseconds, you'll die and die like a cat till you only have one life left of the nine and you'll be asked to believe that the last is the least and all the rest of your life is this last least life.

But, she said, a long time ago the last was made first and the first was made last. The alpha and the omega changed places. That's when life arose from death and resurrection became the price and prize of surviving. See what I mean, arose is arose?

And she laughed.

She said, the last life you've got, the one you've got after you've been killed eight times, that's the most important one. That's when you've got to regret you have but one life left to give to give and give and give.

And I said, so what? I made her mad.

SUBMIT TO PLAZM. Plazm Magazine is published quarterly by Plazm Media Cooperative. We are a group of artists serving other artists and the global community with a unique open forum of expression, bringing ideas to the forefront in a discernable way. We are dedicated to the unrestricted expression of ideas, beyond the constraints of any single medium. Submit for Magazine: Photography, literature, illustration, unnatural art, poetry, humor, manifestos and experimental ideas, interviews, and reviews.

VISUAL: Black and white prints or slides. Cover submissions should be color prints or slides. Mail nothing larger than 8" X 10". All work must have name, address and phone number attached (to each piece). Digital submissions must include a hard copy and be in Macintosh format.

WRITTEN: Limit submission to 3 selections. All material (except poetry) must be typewritten & double spaced. Name, address, phone on each page. May send accompanying Macintosh format disk.

INTERVIEWS: Gladly accepted as a submission with editorial consultation. Please call to arrange.

REVIEWS: discussing music, books, zines, movies, art, subversive gatherings whatever's going on in your creative neighborhood. Limit reviews to 200–400 words (see above guidelines for written submissions).

FONTS: Send a laser print containing each character in the typeface along with a working version of the font. Include your name, address, phone number, and a short description of your original idea. Font submissions will be considered for use in our quarterly catalog. Creators of accepted fonts will be compensated for each sale of their font.

PLAZM MEDIA, Attn: Submissions, PO Box 2863, Portland, OR 97208-2863 T 503-222-6389 E Plazmmedia @ aol.com
Deadlines (must be in our hands): May 7, 1997; August 7, 1997.

Plazm Ecoactivism spread
ART DIRECTION: JOSHUA BERGER, NIKO COURTELIS. DESIGN: KAT SATO

Plazm XY spread
ART DIRECTION: JOSHUA BERGER, NIKO COURTELIS, PETE McCRACKEN. DESIGN: JOSHUA BERGER. STYLE EDITOR: STORM THARP. TEXT: JON RAYMOND

Plazm 16 announcement poster
DESIGN: DAVID CARSON

Plazm poetry spread
ART DIRECTION: JOSHUA BERGER, NIKO COURTELIS. DESIGN: NIKO COURTELIS

Plazm Submit poster
ART DIRECTION/DESIGN: NIKO COURTELIS
PHOTOGRAPHY: BOB WALDMAN

Plazm 22 Identity cover
ART DIRECTION: JOSHUA BERGER, NIKO COURTELIS, PETE McCRACKEN. DESIGN: JOSHUA BERGER, ANDRÉ THIJSEEN
PHOTOGRAPHY: ANDRÉ THIJSEEN

Plazm

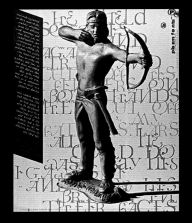

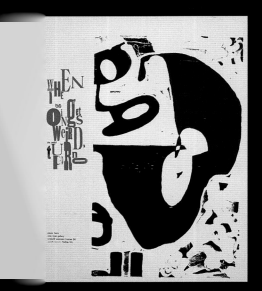

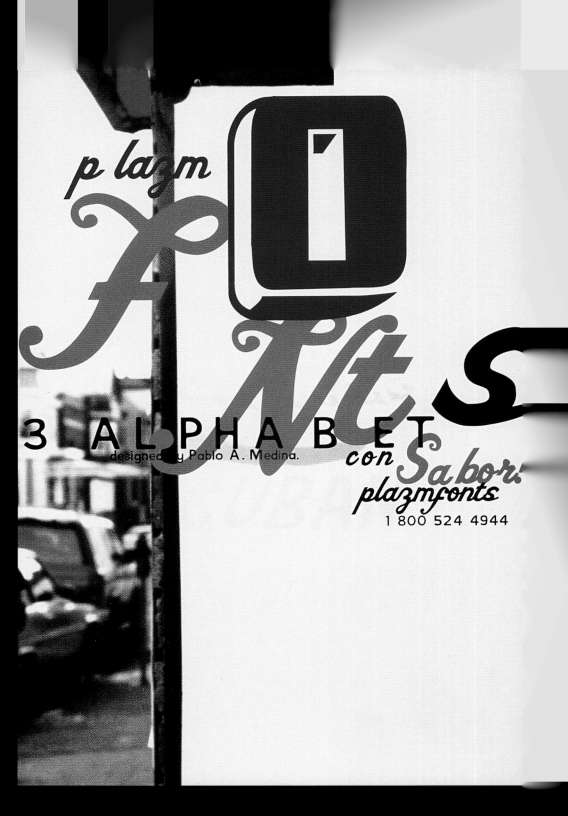

plazm

ANTS

3 ALPHABET
designed by Pablo A. Medina.

con Sabor.
plazmfonts
1 800 524 4944

bored with the options we had available in type choices, so I started creating my own things to be something new to

magazine. McCracken expounds on the many talents of type designers discovered by and now distributed by Plazm

promote the individual who creates the font for Plazmfonts, rather than promoting ourselves as the found..." he says.

using them," Berger says. Courtelis reiterates, "Our typographic approach stays on the conceptual level. We chose the

Opposite, clockwise from upper-left:

Plazmfonts Subluxation poster

ART DIRECTION: JOSHUA BERGER, NIKO COURTELIS,
PETE McCRACKEN. DESIGN: NIKO COURTELIS
PHOTOGRAPHY: PETE McCRACKEN

Plazmfonts: Con Sabor!

ART DIRECTION: JOSHUA BERGER, NIKO COURTELIS,
PETE McCRACKEN. DESIGN: PABLO MEDINA

Seybold Type Gallery poster

DESIGN/PRINTING: PETE McCRACKEN

Right: Mtvpe. Plazm was commissioned to create a new typeface for MTV for use as the channel's primary on-air presence. MTV asked Plazm to "challenge the notions of what a typeface can and should be." Plazm responded by creating a typeface that was not only readable on screen but that suggested an entire aesthetic. Rather than creating a typeface within a restricted framework, Plazm built the framework around the typeface.

Mtvpe is a post-Helvetica typeface based on a simple geometric architecture in which smooth edges contrast right angles. Its varying stroke width and unconventional x-height suggest a modern style tempered by tradition.

ART DIRECTION: JOSHUA BERGER, NIKO COURTELIS,
PETE McCRACKEN. DESIGN: JOSHUA BERGER, NIKO
COURTELIS, PETE McCRACKEN, RIQ MOSQUEDA
PRINCIPAL TYPE DESIGN: PETE McCRACKEN. TYPE-
FACES SHOWN: MTVPE, MTVPE SLANT, MTVPE BOLD,
MTVPE BOLD SLANT. CLIENT: MTV NETWORKS

Mtvpe WAS DESIGNED EXCLUSIVELY FOR MTV NETWORKS
ABCDEFGHIJKLMNOPQ
RSTUVWXYZabcdefghi
jklmnopqrstuvwxyz
1234567890

out, producing a hand-crafted feeling for *Plazm* work is important to the art directors, although they will opt to use Univers or Helvetica when the editorial direction of an issue demands it.

PLAZM DESIGN

Plazm Design works for outside clients including Nike, PICA (the Portland Institute for Contemporary Arts), and MTV (for which Plazm designed the Mtvpe typeface). The Plazm process of internally brainstorming is again the start-ing point. "We view ourselves as problem solving the concepts aesthetically," Berger says. "Our approach ends up being a creative solution rather than a style," McCracken adds. Again the Plazm work responds to client needs with careful and considered type treatments.

THE FUTURE

With Niko Courtelis and Riq Mosqueda (formerly a Plazm intern and one of the collective) now both in New York, Plazm East is launched. Berger says that this allows more access to the contributing designers based there, which adds even

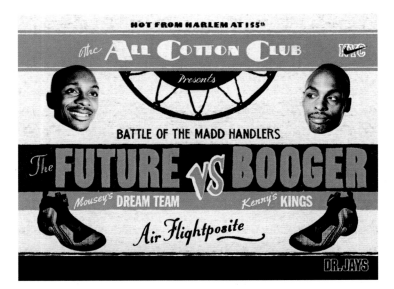

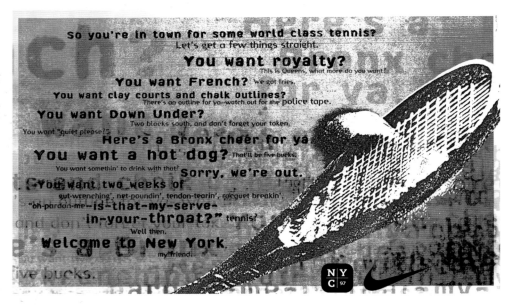

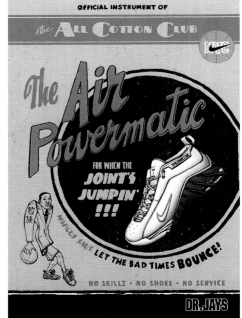

From bottom left:

Nike US Open Limited Edition poster. This poster is a component of Nike's overall graphic presence at the US Open tennis tournament. The assignment was to evoke "tennis with a unique New York attitude," and included design of 38' walls, product displays, banners, etcetera.

ART DIRECTION: JOSHUA BERGER, NIKO COURTELIS, PETE McCRACKEN
DESIGN: JOSHUA BERGER, PETE McCRACKEN. CLIENT: NIKE

All Cotton Club/NYC City Attack. Outdoor advertising promoting basketball shoes employs both street and professional New York players. Hand lettering was utilized to reflect Cotton Club posters from the 1920s.

DESIGN FIRM: PLAZM DESIGN. AD AGENCY: WIEDEN & KENNEDY. ART DIRECTION: DANIELLE FLAGG. DESIGN: JOSHUA BERGER, PETE McCRACKEN, LOTUS CHILD, JON STEINHORST. WRITER: JIMMY SMITH. CLIENT: NIKE

more voices to the publication. Courtelis adds that he and Mosqueda are art directing upcoming issues and recruiting Graham Wood of Tomato as one of their contributors. Also from Plazm East, Courtelis will pursue Plazm book projects, including one on "the design of

'zines." Also scheduled for distribution is Plazm Video, a new venture for the magazine.

Although more clients are lining up for Plazm design, the linchpin of this complex, contemporary collective is the publication. Berger sums up, "*Plazm*

magazine is passionately presented, and it is personal. We don't really do it for anyone but ourselves."

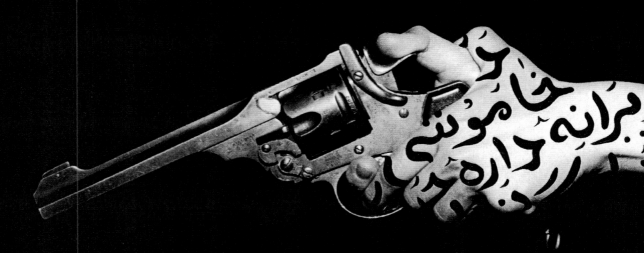

muslimgauze
hussein mahmood jeeb tehar gass

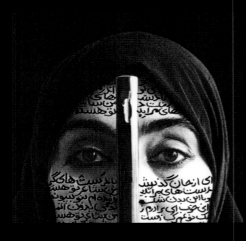

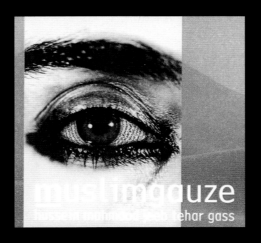

CD packaging and promotional poster
for Muslimgauze: self-described as
"fake Arab ethnic industrial music
with political overtones"

ART DIRECTION: JOSHUA BERGER, NIKO COURTELIS,
PETE McCRACKEN, RIQ MOSQUEDA. DESIGN: RIQ
MOSQUEDA. PHOTOGRAPHY: SHIRIN NESHAT
CLIENT: SOLEILMOON RECORDINGS

Rudy VanderLans

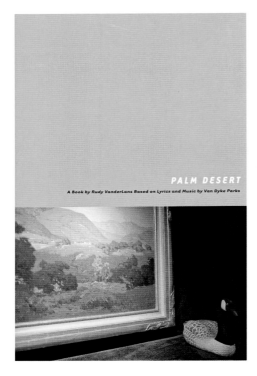

Above: Book cover for *Palm Desert,* a book by
Rudy VanderLans based on lyrics and music by
Van Dyke Parks (a CD accompanies the book).
Published by Emigre
DESIGN/PHOTOGRAPHY: RUDY VANDERLANS
TYPE DESIGN: ZUZANA LICKO

Opposite: Spread from *Palm Desert*
DESIGN/PHOTOGRAPHY: RUDY VANDERLANS
TYPE DESIGN: ZUZANA LICKO

RUDY VANDERLANS AND ZUZANA LICKO have earned a unique place in type and typographic history. When they started their magazine *Emigre* in 1984, together they provoked an aesthetic revolution affecting type design and typographic treatments that has resonance today. Their work in *Emigre* had at the outset the most formidable influence on digital design, and their continuous experimentation consistently generates interest and inspiration for designers.

VanderLans is editor/designer of the quarterly magazine that redefines design potential in every issue. Licko is a type designer whose fonts have transformed expectations and inspired both users and other designers. Both are icons to designers. Their studio in Sacramento is the hub of their retail font and publishing domain. Through Emigre, a new repertory company of type designers has added individualistic and sensitive fonts to the Emigre catalog. VanderLans has frequently offered the pages of *Emigre* to other designers to allow an opportunity to follow a thesis and experiment with form. As a result, *Emigre* has evolved into a laboratory for experimental design, as well as a forum for some of the most important issues in design theory and practice.

Emigre is undoubtedly the most consistent and important influence on contemporary design. Since its inception, the magazine has been touted in the design press and has received every coveted award. Since the work reflects the passionate and personal interests of VanderLans and Licko, it has inspired generations of designers to forge ahead with their own designs, many of which then appear in the pages of *Emigre.*

Since Emigre's design and fonts come from this personal aesthetic, it is not surprising that VanderLans has expanded his experiments to other areas of expertise, including music production and distribution, as well as photography. One of VanderLans' recent projects combines these enthusiasms. Using the lyrics and music of Van Dyke Parks as his inspiration, VanderLans designed the book *Palm Desert,* in which he combined his photographs with Licko's typefaces to interpret the Parks' text into a visual, typographic exploration of sound (published by Emigre, the book also includes a CD). The design is both subtle and profound. VanderLans offers his photographs with text (set in Licko typefaces) as performance. He captures nuance and rhythm, meaning and emotion. (*Palm Desert* was recently featured in the inaugural National Design Triennial, "Design Culture Now," at the Cooper-Hewitt, National Design Museum in New York.)

buy your leave or stay beyond the game

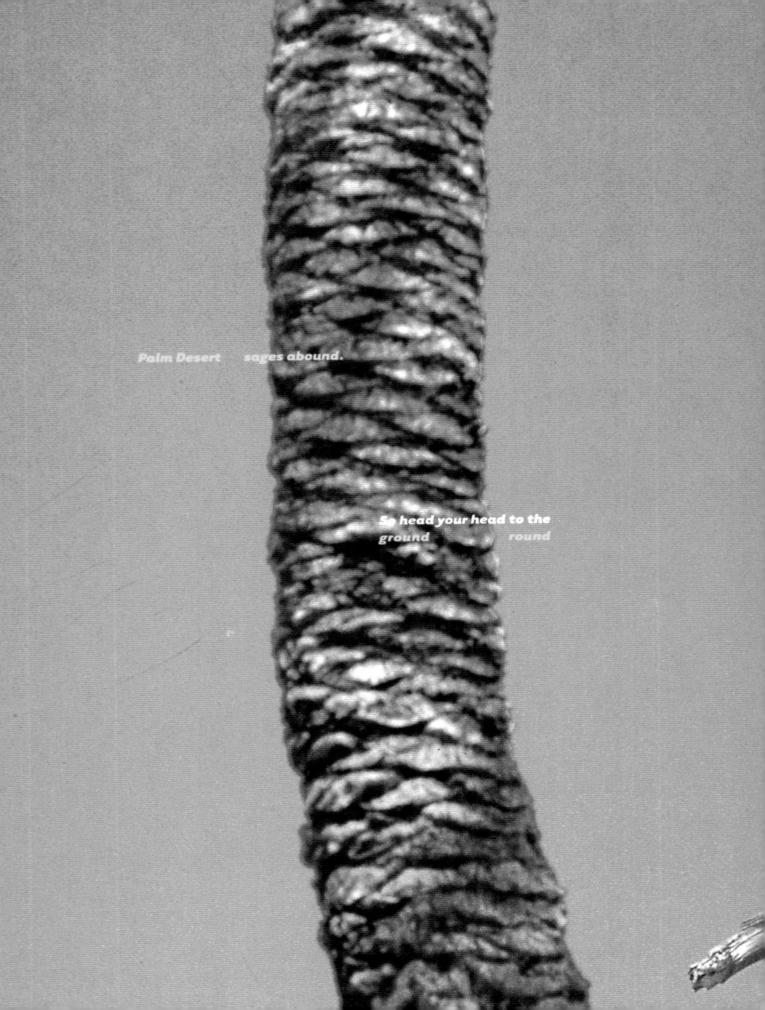

Palm Desert sages abound.

So head your head to the
ground round

Detail of spread from *Palm Desert*
DESIGN/PHOTOGRAPHY: RUDY VANDERLANS
TYPE DESIGN: ZUZANA LICKO

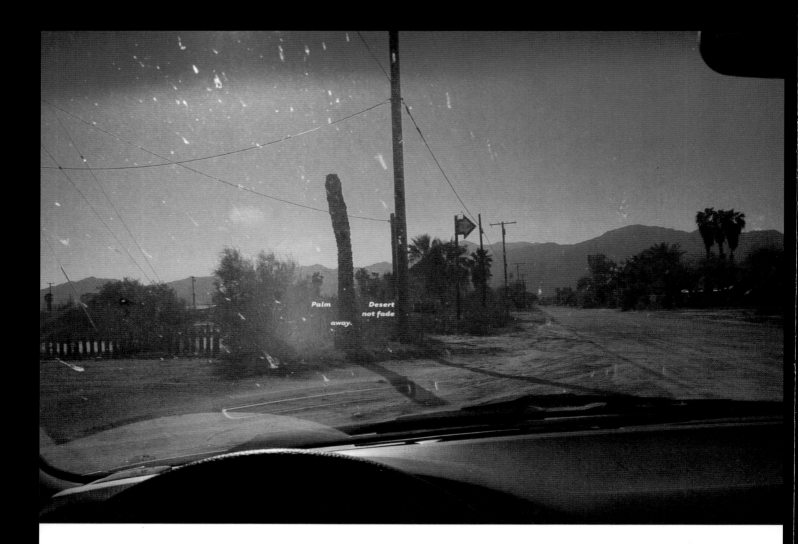

Palm

Desert
not fade

away.

DESIGN PHILOSOPHY

VanderLans would posit that a formal design philosophy can restrict rather than enhance the process of designing, and since much of his design is intuitive and responsive, he is reluctant to commit himself to one philosophical approach. In a recent interview (*50 Questions/50 Answers*, published on the occasion of an Emigre exhibition in Istanbul and available from Emigre), VanderLans defines what may be at the heart of his work— a style that is essentially personal and empathetic to each design project. He says, "A personal style comes from honest investigation and experimentation. It comes from the ability to recognize what comes naturally to you, and the ability to express those feelings honestly, without much concern for what is currently in style."

TYPE AND TYPOGRAPHY

VanderLans and Licko are the architects of an integrated relationship of type creation and type interpretation. They have inspired generations of designers through their consistency in introducing new fonts and presenting them

DESIGN/PHOTOGRAPHY: RUDY VANDERLANS
TYPE DESIGN: ZUZANA LICKO

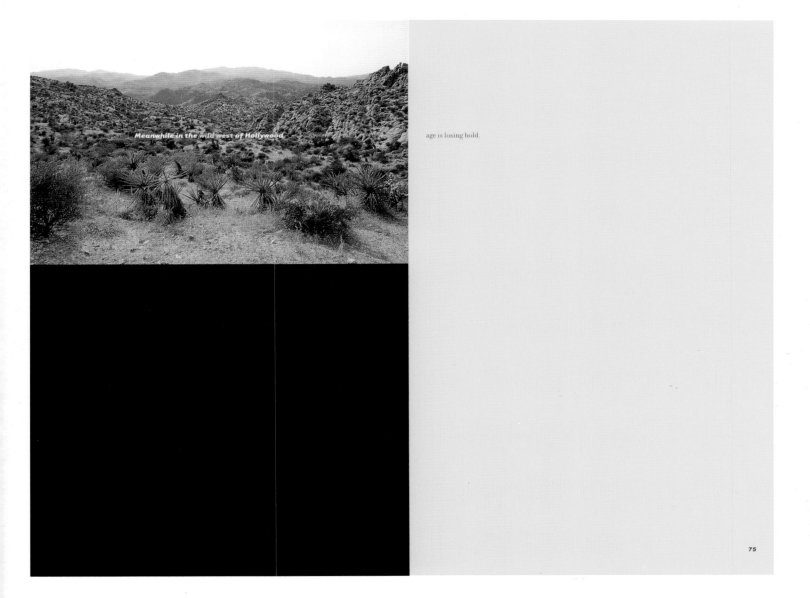

Meanwhile in the wild west of Hollywood

age is losing hold.

75

effectively on the pages of *Emigre*. The Emigre fonts created by Licko and such notables as Barry Deck, P. Scott Makela, Jonathan Barnbrook, Jeffrey Keedy, and VanderLans himself, as well as a host of others, have forever changed the way designers choose and work with fonts.

Through the magazine, the catalog, and the Web site, Emigre continues to provide new offerings that inspire an avid interest in type and emphasize the challenge to experiment typographically.

Scott Clum/Ride Studio

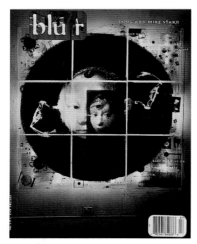

Above: *Blur* magazine spread, and cover design
ART DIRECTION: SCOTT CLUM
COVER ILLUSTRATION: STARN TWINS

Opposite: Cover for Marshall Arisman book
Tales from the Edge: Sacred Monkey Man
ART DIRECTION: SCOTT CLUM
ILLUSTRATION: MARSHALL ARISMAN

BASED IN HIS LARGE, AIRY STUDIO in Salem, Oregon, Scott Clum and his small staff create designs for every medium. These are provocative and sensitive, edgy and calm, artful and graphic, technically adventurous and hand-wrought. These apparent contradictions are inevitable because the Clum rationale for the work is based on his innate belief that the work is organic and ebbs and flows as dramatically as nature itself. As the self-published book on Ride Studio's work indicates, there is a very definite Clum style, but while that style is fluid, amorphous, and impressionistic, it is tightly controlled to get it that way.

Clum has been a professional snowboarder, finessing the extreme sport that has not only influenced his life but inspired the name of his studio. "Ride" implies movement and destination and all of the swerves and moves it takes to get there.

For Clum, designing is an extreme profession that balances his artist's sensibilities with the tight strictures of craft. The range of work emerging from Ride encompasses print, illustration, broadcast, photography, exhibition design, typography, and Web development.

Clum is as comfortable designing magazines as snowboards. He was with *RayGun* for seven years and was the original creator and designer of *Bikini* and *Stick* magazines. Clum also created the original prototype for publisher Marvin Jarrett's *Nylon* (although he doesn't design this monthly, Clum's original *Nylon* logotype influences the direction of the magazine).

Clum has a facility for affecting every arena of design, from print to exhibition design to on-screen graphics. The characteristic Clum signature is movement. And integral to this sense of flux is his use of type. Scott Clum makes type move, causing the eye to race across the page in his designs for *Blur* magazine and his *Untitled: Selected Work from Ride Studio.* He literally has the type streaming across the screen in his film and video work and on Web pages. Combined with his painterly imagery, Clum flows type as naturally as water.

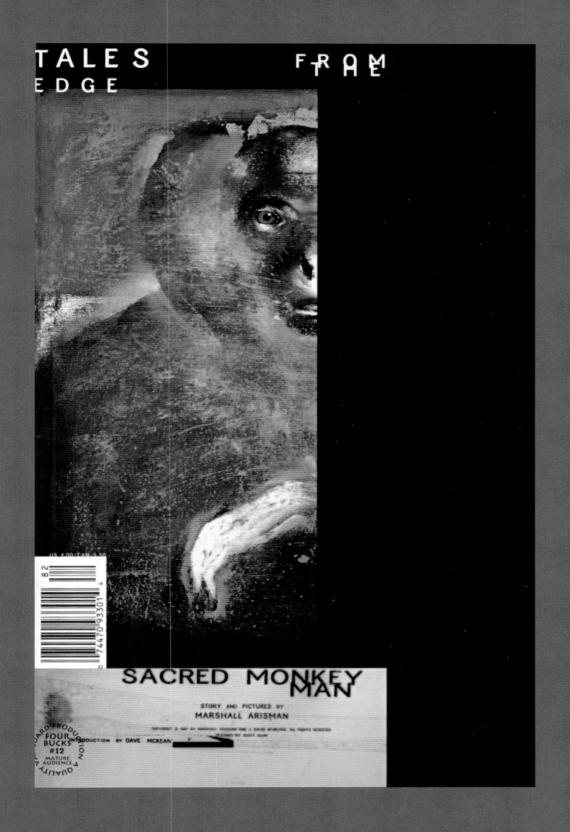

This page: Cover and spreads from *Untitled: Selected Work from Ride Studio*

ART DIRECTION: SCOTT CLUM

Opposite, left: MTV Online visual short (Best cinematography in a video)

DIRECTORS: SAMUEL BAYER, SCOTT CLUM

Opposite, right: MTV Online visual short (Best breakthrough video)

DIRECTORS: SCOTT CLUM, TODD McFARLANE

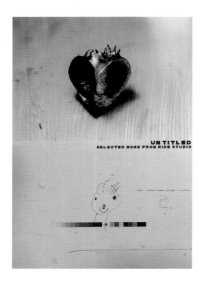

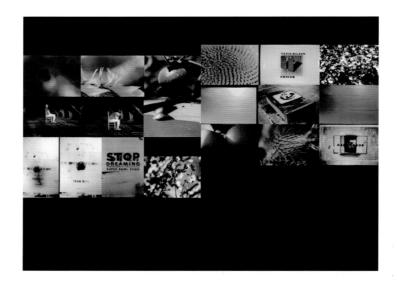

DESIGN PHILOSOPHY

Explaining the Ride Studio approach in his book, Clum says, "Our problem-solving is a full study in a balanced solution. The client-studio relationship is an important part of our creative process. Our aesthetic is a combination of working and experimenting with ideas. Keeping an organic presence in our work is one of our strong points allowing it to have a life of its own."

In conversation, Clum is apt to elaborate on his affinity with nature, his relationship with the great outdoors, and his continuing passion for racing down a steep slope on a snowboard. He is equally inspired by his family and watching his two sons grow and develop. The influences, however strong and personal, all find their way into the work.

For Clum, designing is as important as breathing. He finds the process essential to his own evolution and growth. He is obsessed by the challenges in design, where problem-solving is not just technical or literal, but exploratory and inevitable.

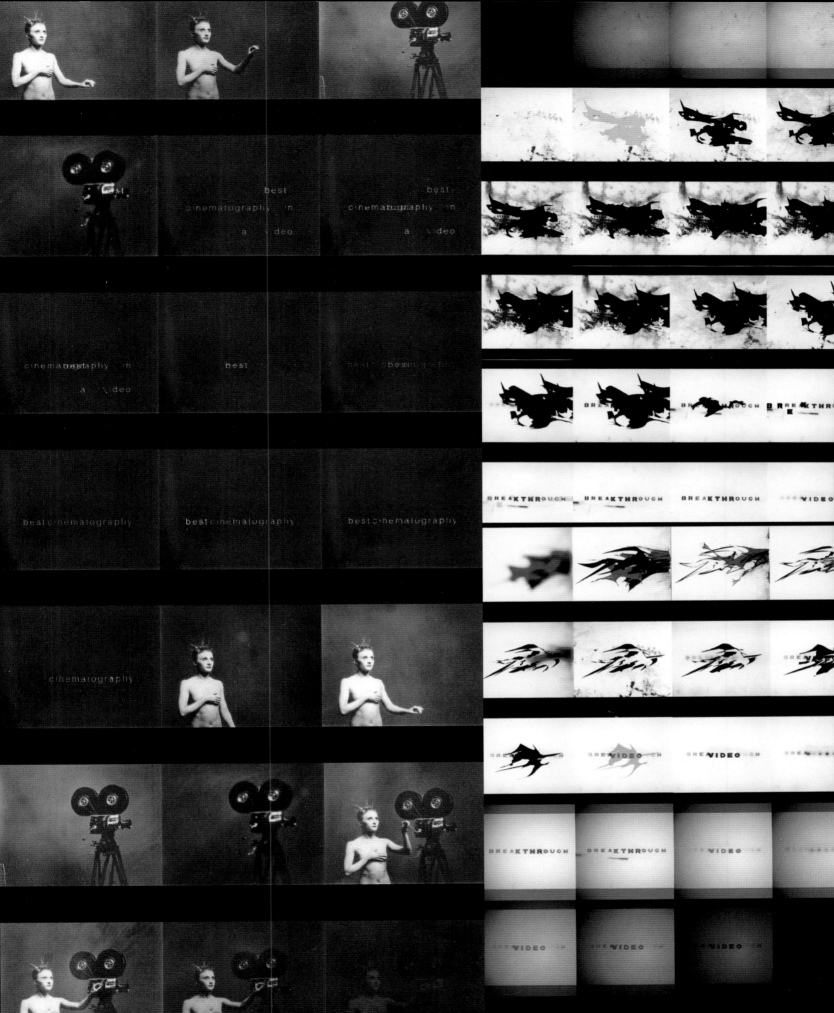

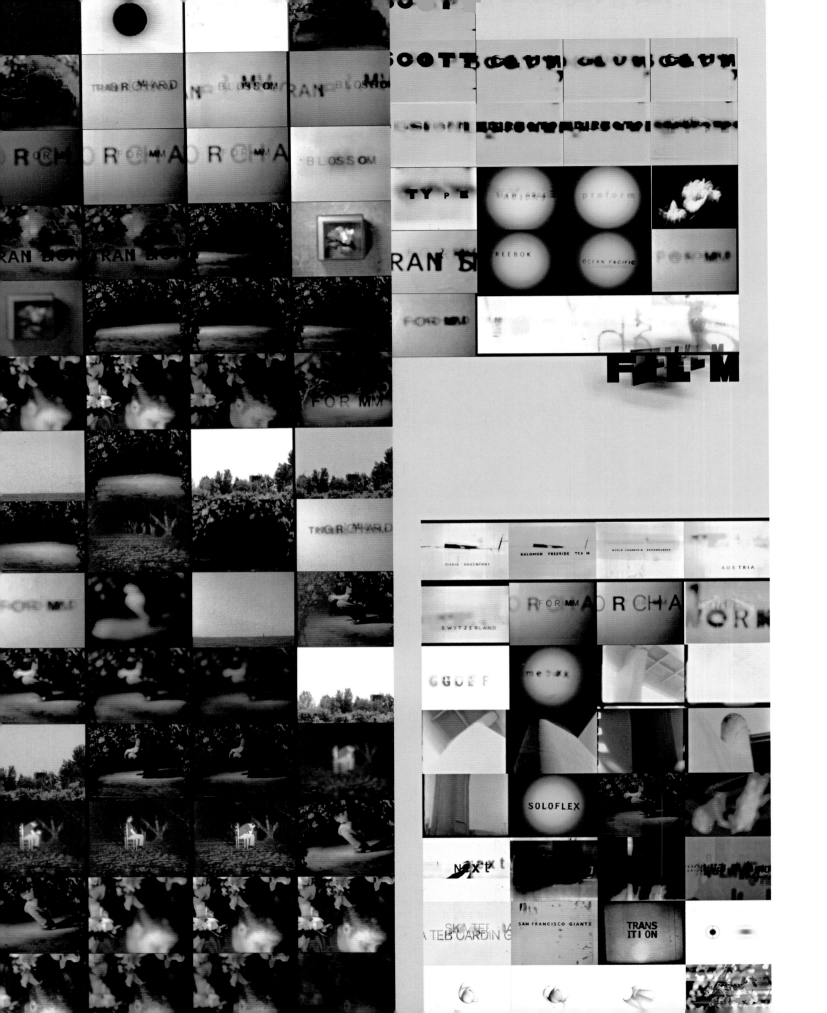

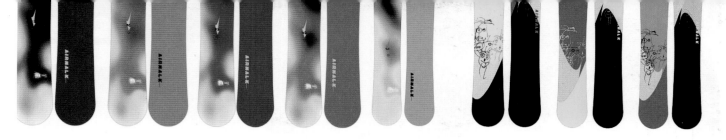

Opposite: Type and graphic reels
from Ride Studio
ART DIRECTION: SCOTT CLUM

**Above and left: Airwalk Snowboards
B-1 Series and sport line**
DESIGN: SCOTT CLUM

TYPE AND TYPOGRAPHY
Type, often designed by Clum, is more
than a design element or a typographic
exercise. Type treatments rendered by
Clum are as inherent as paint on a can-
vas, or snow on a mountain. Although
many of Clum's stylistic experiments

with type have become familiar (unusual
word spacing; criss-crossing type hori-
zontally and vertically; superimposed
type of various sizes; the exclusive use
of sans-serif), there is always an element
of surprise and anticipation of what will
come next.

Scott Clum's current experiment is
Ride Studio's Web site, which he sees
as an extension of all that he has done
before. His many interests – including
art, photography, music, film, and, of
course, extreme type treatments – all
converge in this medium. Dealing with

the technical challenges of designing
this site has made him consider form
and content as exponentially exciting.

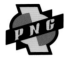

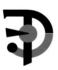

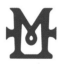

Rodrigo Xavier Cavazos / PsyOps

PSYOPS IN SAN FRANCISCO is the type foundry and brainchild of Rodrigo Xavier Cavazos. The name implies the theme Psychological Operations, which indicates the mind-set and the intention of Cavazos. On his PsyOps Web site, Cavazos explains, "Why Psycholgical Operations? Because type is a powerful behavior modifi-cation tool. Transparent to the consumer; transcendent to the designer who knows how to use it."

Cavazos both designs typefaces (his Eidetic is used as the text for this book) and edits fonts for other designers. In addition, he has originated proprietary alphabets for various organizations, including the creation of the official Dr. Seuss font set for Dr. Seuss Enterprises and Esprit de Corp. He has also created logo-types/typographic symbols for clients like the Tokyo Directive Collection of skate sportswear graphics.

His logos and type symbols have a dimensional quality, a transformation of type form into object. His working of letterforms is tactile and bold, resulting in symbols with density, physicality, and presence. His letterforms have body, as in the monogram for the Tokyo Directive or the PNG (Persona Non Grata) skate logo.

Explaining his penchant for the crafting of type, Cavazos cites the influence of his father, saying, "Before he retired, my father had been a machinist and painter. I like to think that the work I do pays mild tribute to this technical-creative duality — and this makes me happy."

Selection of logos include PNG (Persona Non Grata, a skate company), Wedgeboy, and the stylized monogram for Tokyo Directive (TD). Others are PsyOps logos relating to typefaces.
DESIGN: RODRIGO XAVIER CAVAZOS

Opposite: EXO Skate logo for Tokyo Directive Collection
DESIGN: RODRIGO XAVIER CAVAZOS. CLIENT: STRATOS, TOKYO

EXO™

SKATE

Opposite: Detail of poster design for
Steve Lucky and the Rhumba Bums

Below: CD insert for Steve Lucky and
the Rhumba Bums

DESIGN/TYPE DESIGN:
RODRIGO XAVIER CAVAZOS/PSYOPS

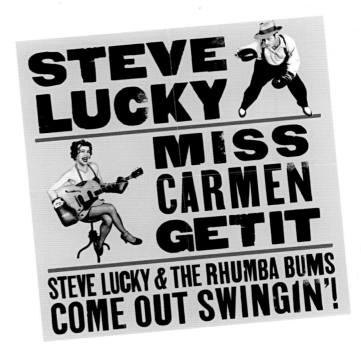

DESIGN PHILOSOPHY
"I place a lot of value in simplicity and
structure, as well as in irony and rever-
sal," Cavazos says. He defines his true
nature, and therefore his way of working,
as "an odd sort of constructive icono-
clasm." His approach to design, starts

from "the general and moves to the spe-
cific, with the aim of creating something
clean and functional."

TYPE AND TYPOGRAPHY
According to Cavazos, the trajectory of
his work has shifted from design (first

textiles, then graphics and symbols) to
an intense concentration on type devel-
opment, including not only creating his
own fonts but "editing and providing cri-
tiques" for other font designers. PsyOps,
which Cavazos established in 1995, has
become his base for honing typefaces

E e Ɛ e E E

9/11 ON THE ORIGIN OF "NEW" TYPE – This narrative chronicles the efforts of Fra Boniface Doboni, a Jesuit monk at the Abbey San Formaggio in northern Italy who successfully experimented with typographic crossbreeding in the sixteenth §1

century. ¶ *The mountainous area surrounding the abbey was renowned for a unique breed of typeface called the Sidehill Gouger. Each letterform possessed one short leg, which enabled it to stand and walk about on hilly terrain. Thus the* §2

SIDEHILL GOUGER TYPE WAS UNIQUELY ADAPTED TO ITS PARTICULAR DESIGN NICHE, BUT TO LITTLE ELSE. ¶ WITHIN ANY ONE POPULATION OF SIDEHILL GOUGER TYPE, TWO DISTINCT MORPHOLOGICAL FORMS APPEARED. ONE OF THESE HAD §5

the short leg on the right side of the letter and was able to walk around mountains in the clockwise direction only. The other type, having a short left leg, could walk only in a counterclockwise fashion. ¶ While not distinct species, §3

mating between the two was rare in the wild. Brother Doboni, inspired by his overindulgence in communion wine, felt the native faces would benefit from interbreeding. One day after mass, while juryrigging an fl ligature, he inadvertently §4

selected a counterclockwise f and a clo[ckwise] l. The results both stunned and deligh[ted] the inebriated monk, and he was compel[led] to continue his experiment over the fol[low]ing years. ¶ He came to regret his resear[ch] however, as the resulting progeny produc[ed] M1

faces with unexpected results: fifty perce[nt] of the zygotes were of a genotype of po[ten]tially lethal faces, yielding fonts that tip[ped] over and whose serifs fell off or were abs[ent] entirely upon birth. Resulting progeny [in]cluded squat and ungainly faces; elonga[ted] M2

AND CONDENSED FACES; AND FACES LAT[ER] USED IN DECONSTRUCTIVE TYPOGRAPHY[.] [A LITTLE KNOWN FACT IS THAT SANS SE[RIF] FACES CAN TRACE THEIR ANCESTRY TO TH[E] TYPOGRAPHIC EXPERIMENT GONE AWRY[.] UNDOCUMENTED ACCOUNTS HAVE EVEN

gone as far as to suggest that certain postmodern experimentalists have bo[r]rowed heavily from Doboni's work.] ¶ [In] 1574 Doboni was banished by Abott Ad[...] Carnase when he was found in flagran[t] delicto with a Jenson minuscule. His t[rea]M3

tises were relegated to the Index Librore[um] Prohibitorum but not before he had passed on his unorthodox secrets to [his] assistant, Fra Pacificus Tufuri. Dobo[ni] lived the remainder of his life in obscur[ity] and died of tarantism in Genoa in 159[?] M4

19

EIDETIC SUPERSET™ · 10 FONTS · RXC · $115

{[($0123456789)]}?!&@ABCDE
FGHIJKLMNOPQRSTUVWXYZ
abcdefghijklmnopqrstuvwxyz
S1. Regular

{[($0123456789)]}?!&@ABCDE
FGHIJKLMNOPQRSTUVWXYZ
abcdefghijklmnopqrstuvwxyz
M1. Regular

{[($0123456789)]}?!&@ABCDE
FGHIJKLMNOPQRSTUVWXYZ
abcdefghijklmnopqrstuvwxyz
S2. Italic

{[($0123456789)]}?!&@ABCDE
FGHIJKLMNOPQRSTUVWXYZ
abcdefghijklmnopqrstuvwxyz
M2. Italic

ABCDEFGHJKLMNOP
QRSTUVABCDEFGHIJK
LMNOPQRSTUV13579
S5. SmallCaps

EIDETIC

ABCDEFGHJKLMNOPQ
RSTUVWABCDEFGHIJK
LMNOPQRSTUVW02468
M5. SmallCaps

{[($0123456789)]}?!&@ABCDE
FGHIJKLMNOPQRSTUVWXYZ
abcdefghijklmnopqrstuvwxyz
S3. Bold

{[($0123456789)]}?!&@ABCDE
FGHIJKLMNOPQRSTUVWXYZ
abcdefghijklmnopqrstuvwxyz
M3. Bold

{[($0123456789)]}?!&@ABCDE
FGHIJKLMNOPQRSTUVWXYZ
abcdefghijklmnopqrstuvwxyz
S4. Bold Italic

{[($0123456789)]}?!&@ABCDE
FGHIJKLMNOPQRSTUVWXYZ
abcdefghijklmnopqrstuvwxyz
M4. Bold Italic

GERVSQ

QSVREG

E e *E e* E E

ON THE ORIGINS OF "NEW" TYPE –
This narrative chronicles the efforts
of Fra Boniface Doboni, a Jesuit monk
at the Abbey San Formaggio in north-
ern Italy who successfully experiment-
S1

ed with typographic crossbreeding in
the Sixteenth Century. ¶ *The moun-*
tainous area surrounding the abbey
was renowned for a unique breed of
typefaces that were dubbed Sidehill
S2

GOUGERS. EACH LETTER POSSESSED
ONE SHORT LEG, WHICH ENABLED IT
TO STAND AND WALK ABOUT ON HILLY
TERRAIN. THUS THE SIDEHILL GOUGER
TYPE WAS UNIQUELY ADAPTED TO ITS
S5

particular design niche, but to little
else. ¶ Within any one population of
sidehill gouger type, two distinct
morphological forms appeared. One
of these had the short leg on the
S3

right side of the letter and was able
to walk around mountains in the
clockwise direction only. The other
type, having a short left leg, could
walk only in a counterclockwise fash-
S4

ion. ¶ While not distinct species, mating 10/11
between the two was rare in the wild.
Brother Doboni, inspired by his over-
indulgence in communion wine, felt the
native faces would benefit from inter-
M1

breeding. One day after mass, while jury-
rigging an fl ligature, he inadvertently
selected a counterclockwise f and a
clockwise l. The results both stunned
and delighted the inebriated monk
M2

AND HE WAS COMPELLED TO CONTINUE
HIS REASEARCH OVER THE FOLLOWING
YEARS. ¶ HE CAME TO REGRET HIS EXPER-
IMENTS, HOWEVER, AS THE RESULTING
PROGENY PRODUCED FACES WITH UNEX-
M5

pected results: fifty percent of the
zygotes were of a genotype of poten-
tially lethal faces, yielding fonts that
tipped over and whose serifs fell off
or were absent entirely upon birth. Re-
M3

sulting progeny included squat and
ungainly faces; elongated and con-
densed faces; and faces later used in
deconstructive typography. [A little
known fact is that sans serif faces
M4

20 21 22

Leonardo Sonnoli

FOR THE LAST TEN YEARS Leonardo Sonnoli has been art director of Dolcini Associati in Pesaro, Italy. The firm's founder, Massimo Dolcini, manages the firm, and Sonnoli is the designated "creative leader." Dolcini Associati has a diverse list of clients and produces work ranging from corporate identity and signage systems to books and magazines, but Sonnoli is best known for "cultural communication," work done on behalf of municipalities (like Pesaro), museums, and non-profit foundations.

On behalf of these clients, Leonardo Sonnoli has managed to create a range of posters that are stark, complex, typographically acute, and brain teasing. He provokes and challenges his audience to delve into a poster's meaning, rather than explicitly conveying it.

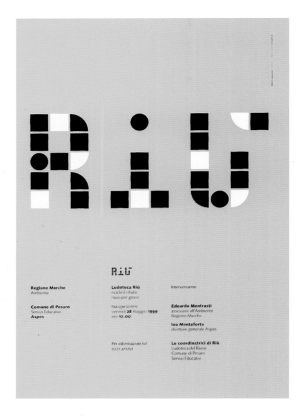

Above: RIU poster with the collaboration of Monica Zaffini. Opposite: Poster for City of Pesaro announcing an exhibition of women's textile work

DESIGN: LEONARDO SONNOLI

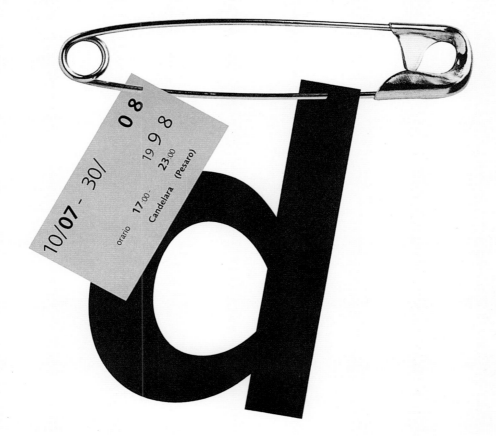

10/07 - 30/ 08 orario 17.00- 19 9 8 23.00 Candelara (Pesaro)

Comune di Pesaro
Servizi Culturali

Circoscrizione
delle Colline e dei Castelli

Il lavoro delle donne
nei borghi rurali del pesarese

 PESARO CULTURA

proza

Comune di Pesaro/Amat
Teatro Rossini Stagione Teatrale 1999 - 2000

Abbonamento a 7 spettacoli (Turni A/B/C/D)

Posto di platea e posto di palco di I e II ordine sett. cent.	L.308.000
ridotto per anziani oltre 65 anni e giovani fino a 24 anni	L.266.000
Posto di palco di I e II ordine sett. lat. e posto di palco di III ordine sett. cent.	L.259.000
Posto di palco di III ordine sett. lat. e posto di 1a fila di galleria	L.203.000
Posto di palco di IV ordine e posto di 2a e 3a fila di galleria	L.161.000

Attenzione: il programma può subire variazioni per cause di forza maggiore

Biglietti

Posto di platea e posto di palco di I e II ordine sett. cent.	L.45.000
ridotto per anziani oltre 65 anni e giovani fino a 24 anni	L.40.000
Posto di palco di I e II ordine sett. lat. e posto di palco di III ordine sett. cent.	L.38.000
Posto di palco di III ordine sett. lat. e posto di 1a fila di galleria	L.30.000
Posto di palco di IV ordine e posto di 2a e 3a fila di galleria	L.25.000
Loggione	L.12.000

Biglietteria:
nel corso della stagione la biglietteria del Teatro Rossini (Piazzale Lazzarini, 29 - Tel. 0721 33184) sarà aperta dal giorno precedente la prima rappresentazione con orario 10-12, 16-19. Dalle ore 16 alle ore 19 è possibile effettuare prenotazioni telefoniche.

Orario degli spettacoli:
salvo diversa indicazione gli spettacoli avranno inizio alle ore 21,00 nei giorni feriali e alle ore 17,00 la domenica e i giorni festivi. A spettacolo iniziato è vietato l'ingresso in platea e ai posti numerati di galleria.

de filippo
molière
shakespeare
pirandello
ionesco
ibsen
baricco

21/22/23/24 ottobre 1999 Diana Or.I.s presenta NATALE IN CASA CUPIELLO di Eduardo De Filippo con Carlo Giuffrè e Angela Pagano regia Carlo Giuffrè

4/5/6/7 novembre 1999 Teatro de gli Incamminati presenta IL MALATO IMMAGINARIO di Molière con Franco Branciaroli regia Lamberto Puggelli

25/26/27/28/29 novembre 1999 Teatro Stabile del Friuli-Venezia Giulia presenta AMLETO di William Shakespeare con Kim Rossi Stuart regia Antonio Calenda

10/11/12 dicembre 1999 (fuori abbonamento) Fondazione "Le Città del Teatro" Teatro Stabile delle Marche presenta

SCENE D'AMOR PERDUTO da William Shakespeare regia Massimo Navone - Giampiero Solari

13/14/15/16 gennaio 2000 Plexus T. - Teatro Stabile di Catania presentano PENSACI, GIACOMINO! di Luigi Pirandello con Turi Ferro regia Guglielmo Ferro

10/11/12/13 febbraio 2000 Compagnia Glauco Mauri presenta IL RINOCERONTE di Eugène Ionesco con Glauco Mauri, Roberto Sturno regia Glauco Mauri

24/25/26/27 febbraio 2000 Teatro Stabile di Firenze presenta HEDDA GABLER di Henrik Ibsen con Anna Bonaiuto regia Carlo Cecchi

6/7/8/9 aprile 2000 Teatro Laboratorio Settimo presenta NOVECENTO di Alessandro Baricco con Eugenio Allegri regia Gabriele Vacis

PESARO TEATRI

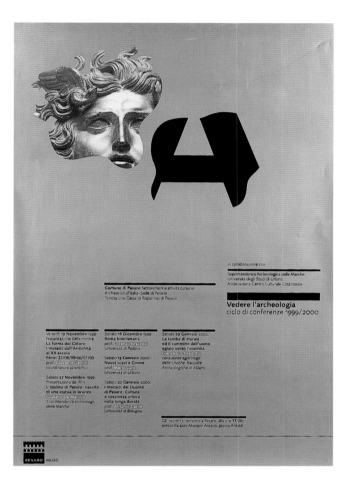

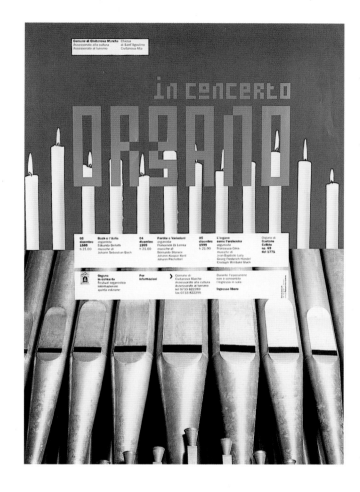

Opposite: Poster for City of Pesaro Theater
Above left: Poster for City of Pesaro archeo-
logical exhibition and lectures. Above right:
Poster for organ concert designed with the
collaboration of Massimiliano Patrignani

DESIGN: LEONARDO SONNOLI

DESIGN PHILOSOPHY

Although dismissing a philosophy of
design as "pretentious," Sonnoli does
relate to his work in very definite terms.
He elaborates, saying "I consider my job
as a profession, and I regard myself as
a professional. This means I try to solve
each problem of communication as
effectively as possible. Definitely I
have my own ideas on how to design.
Mainly I base my creative skills on
a knowledge of the past, especially
gleaning techniques and methods
from the masters, and interpreting
these, like using collage, digitally."

For Sonnoli, the masters are the
European Avant Garde. He says, "I
grew up loving the 20th century de-
signers like Piet Zwart, El Lissitzky,
Jan Tschichold, Laszlo Moholy-Nagy,
and also the Italian Futurists. I have
based my creative skills on this knowl-
edge of the past."

To explain how he works, Sonnoli
uses this analogy: "You can compare
designing to driving a car. To go safely
ahead, you have to check the rear-view
mirror, in this case to glance to the

Right, clockwise from upper left:
Poster for Conference on Sister Town
(three circles form a "g" standing for
"gemellaggio," Italian for "sister town."
The alphabet designed for the poster
is composed by "sister shapes": circles
and its modules and squares); Poster
for Conference for Hope (Speranza), a
lecture by the philosopher Massimo
Cacciari; Easy Cooker poster for a de-
sign competition for new pots and
frying-pans; and Alphabet poster for
the opening of the academic year of
the architectural university of Venice

Opposite: Poster for the City of Pesaro
announcing a kitchenware design
competition to benefit the disabled

DESIGN: LEONARDO SONNOLI

past. Then I use these aesthetics and
remix the past with our own 'zeitgeist'
and our new technology."

He further compares what he does as
a designer to what a disc jockey does
with music, saying, "The way a DJ works
as a mixer of music, I am working with
my keyboard and my mouse and mixing

bits of text with bits of pictures." Sonnoli
calls this approach "neue remix" with ref-
erence to the title of the Jan Tschichold
classic, *Die Neue Typographie*.

Although this may describe the
Sonnoli process of design, it doesn't
fully reflect the effectiveness of the
results. His work not only displays

these formidable influences, but it also
brings them into a contemporary con-
text. His posters are large not only in
terms of size, but in terms of ideas.
Sonnoli produces eye-catching, mind-
provoking posters with intriguing type
treatments and suggestive imagery.
Sonnoli has moved from avant garde

to a heightened minimalism while cre-
ating a sense of shock with sheer scale.
His use of balance, negative space, and
illustrative text put the viewer in awe.
(Imagine Pesaro festooned with posters
by Sonnoli.)

Cucinare senza handicap

Concorso per la progettazione
 di pentole per ipovedenti
 e cucine per disabili
Pesaro, sala Laurana

fondazione **don gaudiano**

6 > 21 giugno 1998
orario 18.00 - 22.00

Posters for film festival 1997, 1998
designed with the collaboration of
Monica Zaffini

DESIGN: LEONARDO SONNOLI

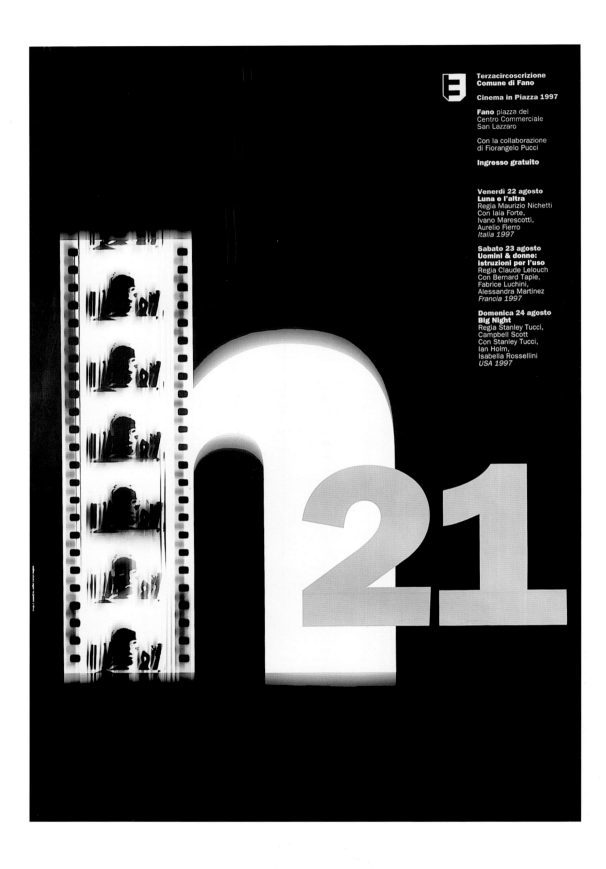

Terzacircoscrizione
Comune di Fano

Cinema in Piazza 1997

Fano piazza del
Centro Commerciale
San Lazzaro

Con la collaborazione
di Fiorangelo Pucci

Ingresso gratuito

Venerdì 22 agosto
Luna e l'altra
Regia Maurizio Nichetti
Con Iaia Forte,
Ivano Marescotti,
Aurelio Fierro
Italia 1997

Sabato 23 agosto
Uomini & donne:
istruzioni per l'uso
Regia Claude Lelouch
Con Bernard Tapie,
Fabrice Luchini,
Alessandra Martinez
Francia 1997

Domenica 24 agosto
Big Night
Regia Stanley Tucci,
Campbell Scott
Con Stanley Tucci,
Ian Holm,
Isabella Rossellini
USA 1997

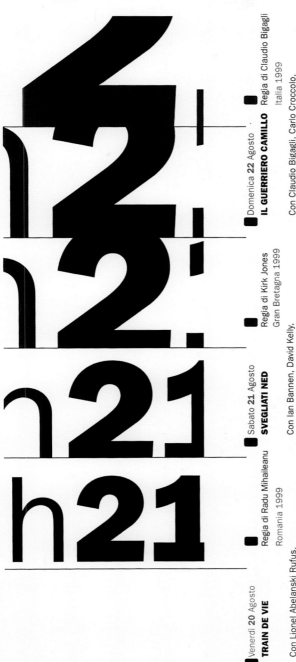

Venerdì **20** Agosto

TRAIN DE VIE

Regia di Radu Mihaileanu
Romania 1999

Con Lionel Abelanski Rufus,
Clement Arari, Michael Muller

Sabato **21** Agosto

SVEGLIATI NED

Regia di Kirk Jones
Gran Bretagna 1999

Con Ian Bannen, David Kelly,
Fionulla Flanagan

Domenica **22** Agosto

IL GUERRIERO CAMILLO

Regia di Claudio Bigagli
Italia 1999

Con Claudio Bigagli, Carlo Croccolo,
Marco Messeri

**Terza
circoscrizione
Comune
di Fano**

**Cinema
in Piazza '99**

Fano
piazza
del Centro
Commerciale
San Lazzaro

Proiezioni alle
ore 21:00

Con la
collaborazione
di Fiorangelo
Pucci

**Ingresso
gratuito**

From left to right: "Wri-things" poster for
Leonardo Sonnoli talk, poster announcing
lecture by Leonardo Sonnoli, and poster
for a photographic exhibition on the
Bosnian war

Opposite left: Poster announcing a lecture
on poverty (poverto) with Vinicio Albanesi,
and poster for lecture by Massimo Cacciari:
Jerusalem and Athens for the Don Guadiano
Foundation

DESIGN: LEONARDO SONNOLI

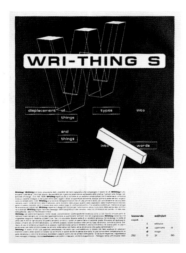

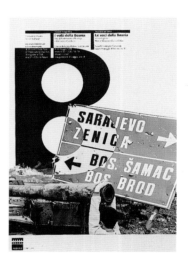

TYPE AND TYPOGRAPHY

Sonnoli says the unique use of type in
his designs originates in "taking away
rather than adding. It's really a challenge
to communicate with as little informa-
tion as possible without being boring
or not expressing ideas," he says. In part,
this minimalist vision is enhanced by
his choice of sans serif, no-frills type.

He hearkens to the Bauhaus experi-
ment and typographic aesthetic, saying,
"Moholy-Nagy wrote that type contains a
visual element so strong that it commu-
nicates more than just intellectual
meaning, and photography when used as
a typographical element is efficient, so
you substitute text on its own as photo-
text." In other words, text works effec-
tively as illustration.

Sonnoli invented the term "wri-thing"
to elaborate on the theme of type as an
object in its own right. This was the sub-
ject of a lecture he gave at the univer-
sity of Venice. And Sonnoli designed
the "Wri-Thing" poster, which defines
the term as "the displacement of type
into things and things into words." In
further explaining this concept, he adds,

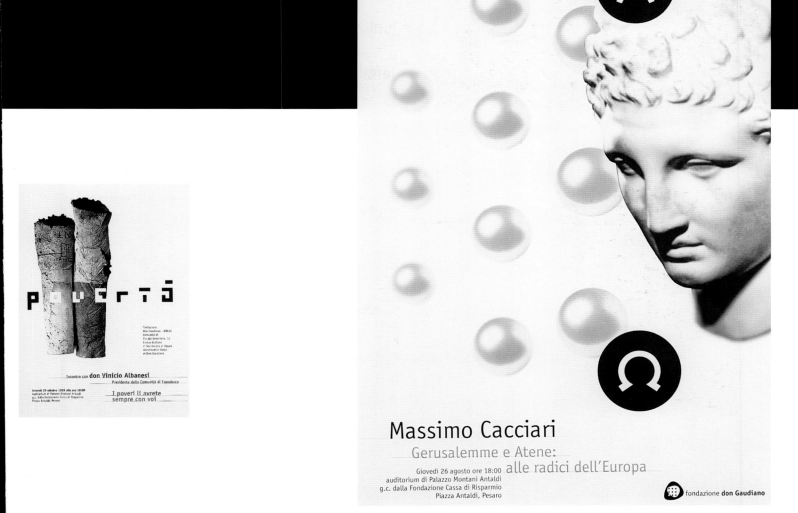

Massimo Cacciari

Gerusalemme e Atene:
alle radici dell'Europa

Giovedì 26 agosto ore 18:00
auditorium di Palazzo Montani Antaldi
g.c. dalla Fondazione Cassa di Risparmio
Piazza Antaldi, Pesaro

fondazione **don Gaudiano**

"Essentially I am saying that text is type-based and that you show the shape of an idea through the use of type."

Although Sonnoli has designed type that he says is primarily display type, he doesn't claim to be a type designer. What he feels he does best is design with type. Although Sonnoli is known for his typographical experiments, he says that when choosing a typeface, he often falls back on a "comforting" sans serif like ITC Franklin Gothic.

Although there is a definite style evident in Sonnoli's work, he claims that "it is not my goal to have a style but to visibly express an idea. With my work, I'd like to stimulate people to think and not just 'receive' a message. Furthermore I think good graphic design has to help people to enlarge their visual aesthetic and (maybe artistic) knowledge. In this sense I believe in good visual communication as an important cultural tool."

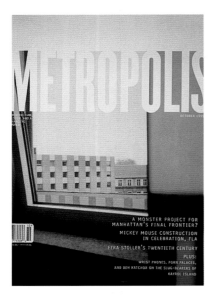

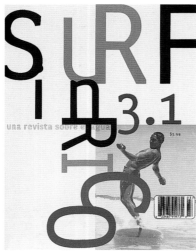

Above: Cover for *Metropolis* magazine
DESIGN/PHOTOGRAPHY: DAVID CARSON

Cover for *Surf in Rico* magazine
DESIGN: DAVID CARSON

Opposite: Posters for David Carson talks
Left: Venice. Right: Paris
DESIGN: DAVID CARSON

David Carson

WHEN THE MAGAZINE *Beach Culture* was launched a decade ago, the name of art director David Carson became synonymous with expressionistic, subjective design. Since Carson is a professional surfer, this lifestyle magazine for those who think life is a beach created an empathetic response. But Carson's next designing gig, the music magazine *RayGun,* forced the design world to sit up and take notice, too. Dubbed everything from "enfant terrible" to "anarchic genius," Carson prevailed. Both *Beach Culture* and *RayGun* continue to be associated with explosive magazine design.

Primarily, Carson became known for his irreverent use of type. His typographical layouts were an improvisational response to the content, and since the content was tied to the hot new bands and styles of music, Carson filled *RayGun* pages with excitement and freneticism corresponding to the releases. For his efforts, Carson was defined as both a "master of typography" and "the king of non-communication."

Now, Carson continues his subjective interpretations of design without the hoopla. He is based in his Manhattan studio, which remains small so that he can work on projects that he "hand picks, and specifically chooses."

Recently, he designed an issue of *Metropolis* magazine, which was on the verge of downsizing after 14 years as a tabloid. Carson's response was to frame the smaller size pages within the large format—setting a template for the new size while celebrating the old.

He has also designed a cover for a magazine focused on surfing (one of his favorite pursuits), called *Surf in Rico.* Carson's typographic cover treatment captures the glamor of the sport.

Carson is currently working on designing the print campaign for Volvo and the new glide.tv Web site. He is also working with the Marshall McLuhan estate on an exhibition and book on McLuhan. Carson's new book, *Trek,* deals with travel images and will be released this fall. He is also preparing for exhibitions of his work later this year in Equador, Finland, France, and the Czech Republic.

His work for the band Nine Inch Nails is impressionistic, fluid, and sensuous, with sedate type and strong color. His affinity for the music is captured through the design.

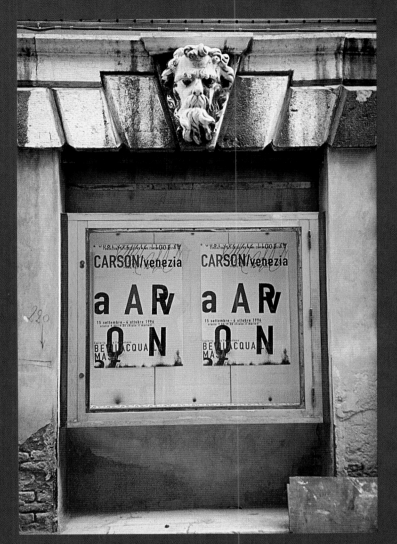

**Above: Photographic type treatments
for a series of TV commercials for
LEAP batteries**

DIRECTOR/DESIGN: DAVID CARSON

**Opposite left to right:
Still from David Garza music video**

DIRECTOR: DAVID CARSON

**Spread (pages 130,131) from
*Fotografiks***

yoshinori
o n d a
tokyo
april
H

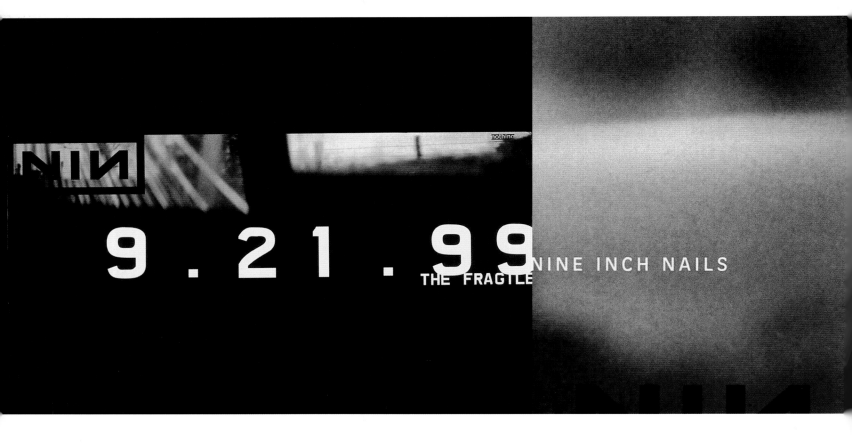

Still from TV commercial for
Nine Inch Nails' "The Fragile"
DIRECTOR/DESIGN: DAVID CARSON

THE FRAGIL

NINE INCH NAILS THE FRAG

DESIGN PHILOSOPHY

Carson runs workshops and gives lectures all over the world. David Carson promotes his philosophy of keeping a subjective edge and capturing emotion in design. He acts as a catalyst by reminding designers that each can bring to design a personal statement, a commitment to finding more than a solution to a design problem. His talks are filled with images he has photographed, experiences that he shares, and an armory of influences, all of which go into his design. His essential message is that design is intended to be emotional, to convey feelings and attitudes through the content. It is a form of expression, and a subjective approach only enhances what the design can be. Carson advocates that design should always be more than mere design.

TYPE AND TYPOGRAPHY

Carson does not use type conventionally. Nor does he use, or believe in, grids. In fact, Carson says he has to remove all guidelines before working on a page. Type is not ephemeral or decorative in his designs. Instead, Carson forges and manipulates text to evoke emotions. One signature of Carson design is his use of truncated letterforms and unusual spacing. The audience is expected to get

TYPE GRAPHICS

57

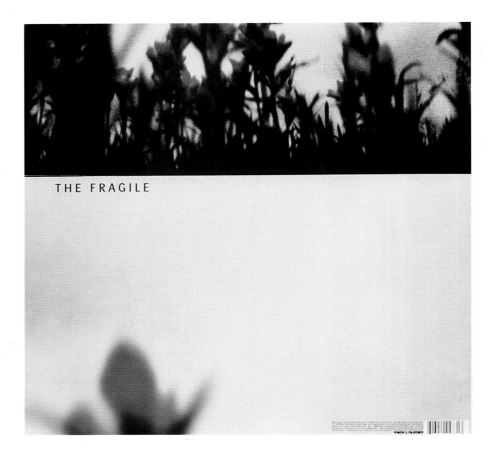

THE FRAGILE

into the text and interpret the elisions. The posters designed for his talks, for example, show a free-form use of his name, but never allow a doubt that the speaker is David Carson.

In the reflective treatise on his work, *The End of Print: The Graphic Design of David Carson*, authored by Lewis Blackwell, the individual personal design that is essentially Carson affects every page. Carson approaches type and typography expressionistically. He expects his reader to empathize with the message. His text is often fractured, his typefaces can be jarring (and he has created his own), but the reader is captured and forced to respond to every word.

While working on the second edition of the book, Carson noted that *The End of Print*, published by Chronicle Books, sold more than 150,000 copies to date.

David Carson remains an icon to designers for his bravado in designing. Carson looks for "the next wave"—the unexpected—and there is much more of that to come.

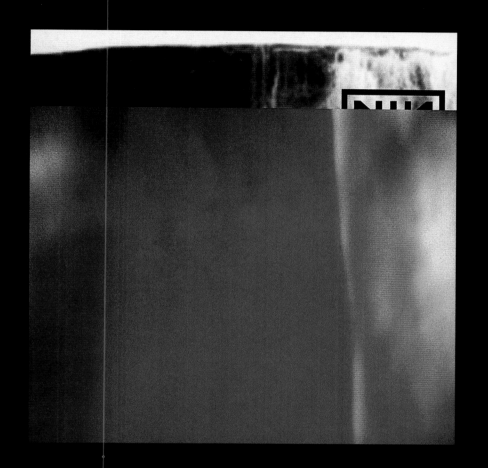

Phil Baines

PHIL BAINES' STUDIO is "a funny little building in my back garden, which is about the size of a country railway station waiting room," he says. It is steps away from his London home, his wife, Jackie, and daughters Beth and Felicity. Here Baines designs meticulously, as he has done since 1987, the year he received his Master's Degree in Graphic Arts & Design from the Royal College of Art. In many ways, Baines is a designer's designer. The formality and precision he builds into his typographic designs awe many designers (including fellow RCA graduates David Ellis and Andy Altmann of Why Not Associates).

Baines once studied to be a Roman Catholic priest, and this experience not only influenced his work, but in many ways has permeated his designs. For example, there is a conscious sense of order, harmony, and reflection in Phil Baines' posters. Biblical text-transfers for use on liturgical candles, which he renders with a modern sensibility, a contemporary typographic interpretation, and an aura of devotion are often the subject of his work.

Baines has a consistent client list, including Phaidon Press, a variety of small presses, and arts organizations such as Matt's Gallery, London, but designing is only one facet of his involvement with type. With colleague Catherine Dixon, Baines teaches typography at Central Saint Martin's College of Art & Design; he also oversees the Central Lettering Record (an ongoing project initiated by Nick Biddulph in 1964). He has also acted as typographic director on a CD-ROM project, *Typeform Dialogues* (Editors Erick Kindel and Catherine Dixon, to be published by Hyphen Press). Since he writes frequently on type and typographic subjects for publications like *Eye, Druk* and *Point,* he was recently off researching sculptural letterforms in Barcelona. He also designs typefaces.

Baines became enamored with type when he started working with letterpress as a student at St. Martin's in London. He liked the immediacy of handling types, plus the control he had. "I could set it, proof it, and it was done," he says. And although letterpress still appeals to Baines, when he was asked to contribute to the first issue of *Fuse,* the CD-ROM experimental type magazine, he created a digital font Can You (read me)?, which was eventually released by Font Shop International as FF You Can (read me). He then edited *Fuse 4,* the "Exuberance" issue, and contributed Ushaw to *Fuse 8,* "Religion."

Above: Text transfer for liturgical candle
Opposite: Detail of liturgical poster
DESIGN: PHIL BAINES

Poster for Central St. Martin's
College of Art & Design Archives
DESIGN: PHIL BAINES

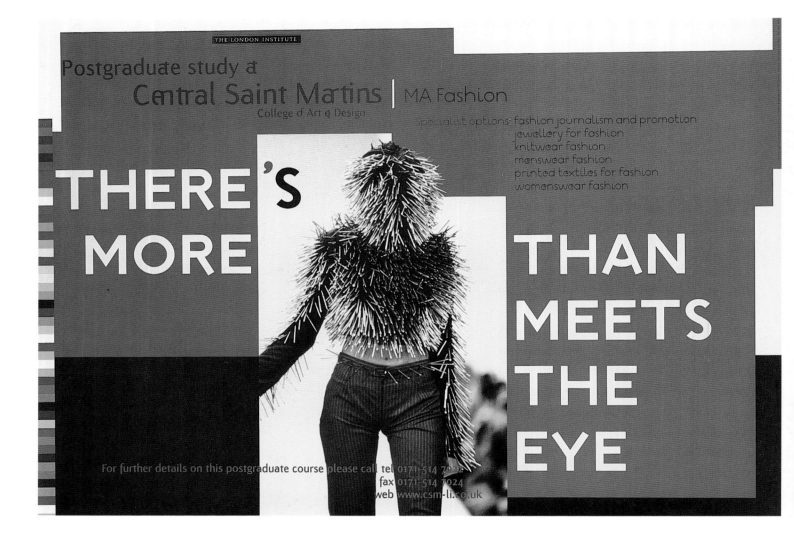

THE LONDON INSTITUTE

Postgraduate study at
Central Saint Martins | MA Fashion
College of Art & Design

specialist options: fashion journalism and promotion
jewellery for fashion
knitwear fashion
menswear fashion
printed textiles for fashion
womenswear fashion

THERE'S
MORE

THAN
MEETS
THE
EYE

For further details on this postgraduate course please call tel 0171-514 7022
fax 0171-514 7024
web www.csm-li.co.uk

DESIGN PHILOSOPHY
The various facets of Baines' work entwine to form his philosophy. His research, teaching, and writing all influence his designs. Much of what he does is instinctive, but has a conceptual rationale. Nothing is flashy for its own sake; all is seamlessly relevant to the design. When designing, he tries to create something "interesting visually." His posters are intended to "grab people's attention," yet he manages to inform them with a sense of history, an inherent classicism, and a strong use of color. His design aim is to produce a "strong, visually attractive thing," he says. Baines also accepts that design is a collaborative process, so he works with people he has known for years. Then, he feels, communication is clear and the work straightforward.

TYPE AND TYPOGRAPHY
For Baines, type is both an obsession and a tool. Although it's been many years since he moved from using metal type to designing on a Mac, the tangible, visible, emotional qualities from working in metal remain. There is fine

Posters for Central St. Martin's

DESIGN: PHIL BAINES

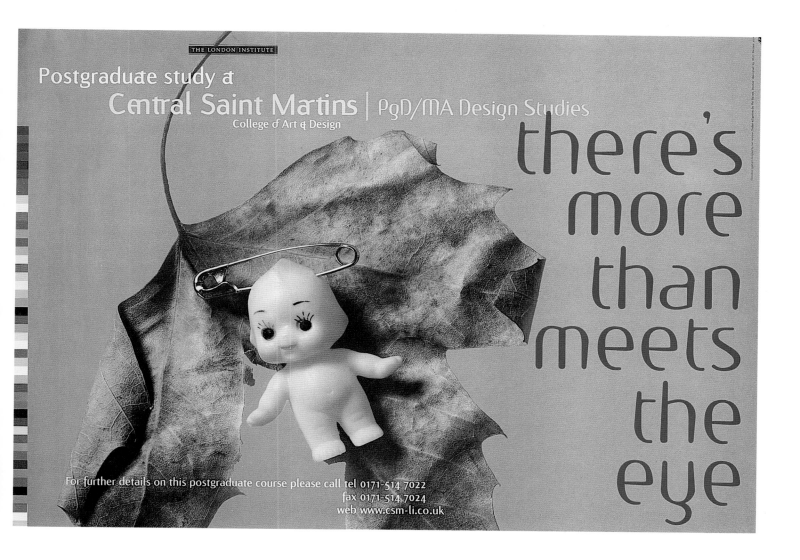

THE LONDON INSTITUTE

Postgraduate study at
Central Saint Martins | PgD/MA Design Studies
College of Art & Design

there's
more
than
meets
the
eye

For further details on this postgraduate course please call tel 0171-514 7022
fax 0171-514 7024
web www.csm-li.co.uk

craftsmanship in his typographic de-
signs, which appear timeless rather
than trendy. Even when he experiments
boldly, it is always within set param-
eters, including creating a typeface
when he cannot find what he likes.
Touted in typographic surveys as

innovative, Phil Baines produces typo-
graphic work from the inside out, work
that is reflective, calm, and deep. He is
currently completing two new typefaces,
Hauser and Toulon.

DJ Stout

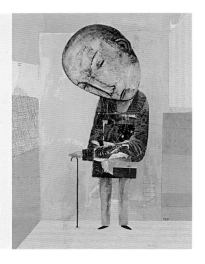

Home Away From Home?
Texas' largest nursing home operator says it provides a "better place to live" for the elderly. State investigators tell a much different story, alleging that one woman was underfed to the point of starvation, another was bitten by fire ants from head to toe, and a third, an Alzheimer's patient, wandered into oncoming traffic and was killed. by Skip Hollandsworth

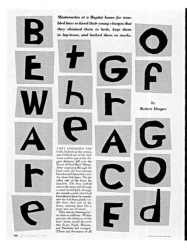

IN JANUARY, DJ Stout left his position as art director of the news and cultural monthly, *Texas Monthly*, to join Lowell Williams in Austin as a partner of Pentagram. Stout will be specializing in magazine and book design for the prestigious design firm, extending the legacy he has created in the pages of *Texas Monthly*. In many ways, joining the hallowed group of Pentagram partners was a hard decision for Stout, since he had been so involved with the magazine. He is proud to remain on the *Texas Monthly* masthead as a contributing editor.

For this art director, the magazine became a forum for working with content that he describes as "outstanding." His relationship with the magazine's long-time editor Greg Curtis allowed him the leeway to create effective and memorable designs responsive to the magazine's subject matter, which Stout interpreted in a myriad of ways. Stout says, "This was a really great job for an editorial art director. I respect the entire staff and was considered part of the editorial team. I had wonderful copy to work with—well-researched, investigative reporting from great writers. *Texas Monthly* is a bastion for well-done, independent journalism. And Texas is a great state to write about. It is steeped in myth and legend. And currently there is so much going on here."

Stout's contributions to this magazine's success are his astute editorial sense and a keen sensitivity to the text. Each cover and editorial spread he designed is a case study in interpreting content.

Above: Spread for *Texas Monthly* article on a nursing home
ART DIRECTION: DJ STOUT
ILLUSTRATION: JORDIN ISIP

Spread for *Texas Monthly* article "Beware the Grace of God," a story on an abusive Baptist boys' home
ART DIRECTION: DJ STOUT
ILLUSTRATION: GARY TANHAUSER

Opposite: Spread for *Texas Monthly* feature on bank robber
ART DIRECTION: DJ STOUT
ILLUSTRATION/LETTERING: MELINDA BECK

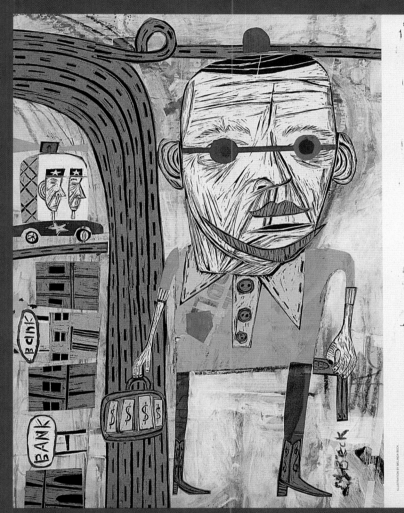

THE LAST RIDE OF THE POLO SHIRT BANDIT

WILLIAM GUESS WAS HIS NAME-AND IT WAS PROPHETIC. WHEN HE SHOT HIMSELF WHILE SURROUNDED BY THE POLICE, HE LEFT UNANSWERED THE QUESTION THAT HAD STUMPED HIS PURSUERS: WHY DID AN ORDINARY MIDDLE-CLASS TEXAN TURN INTO THE MOST PROLIFIC BANK ROBBER IN THE STATE'S HISTORY? BY HELEN THORPE

TEXAS MONTHLY 123 March 1997

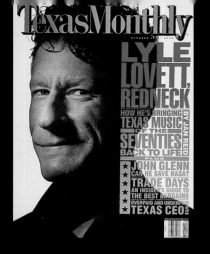

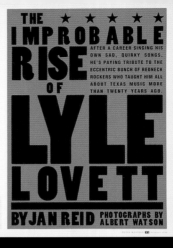

Above: *Texas Monthly* cover
and spreads on Lyle Lovett

ART DIRECTION: DJ STOUT
PHOTOGRAPHY: ALBERT WATSON

Right: Opening spread for
Texas Monthly article on a
contemporary posse

ART DIRECTION: DJ STOUT
PHOTOGRAPHY: LAURA WILSON

Opposite page: Opening spread from
Texas Monthly feature on Willie
Nelson at 65

ART DIRECTION: DJ STOUT
PHOTOGRAPHY: DAN WINTERS

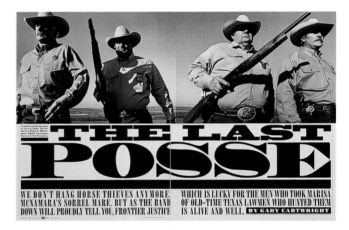

DESIGN PHILOSOPHY

DJ Stout designed editorially for *Texas Monthly.* He used the magazine articles as the media for the canvases he created. He did not gloss over words, but made them come alive on the page. He knows the writers, the editorial direction, and the audience of *Texas Monthly,* and all these factors contributed to his art direction. As Stout would have it, he designed as part of the editorial team. "I was more into the journalistic function of the magazine, more interested in what the magazine was doing rather than creating pure design. The art direction of this magazine is part of the team mission, the editorial driving force of this publication," he says.

It is hard to imagine any of these stories without these designs. Using the words as his inspiration, Stout managed to combine text, image, and type treatments into exquisitely crafted editorial design that is universally understood, but steeped in the visual lore of Texas.

For example, the spread that Stout did for trial of the murderer of the

AS A SMALL-TOWN TEENAGER, LYLE LOVETT WAS CAPTIVATED BY THE SONGS OF MODERN RURAL TEXAS WRITTEN BY CRUSTY **STEVE FROMHOLZ**

LOVETT NAMED HIS NEW ALBUM "STEP INSIDE THIS HOUSE" AFTER THE FIRST SONG EVER WRITTEN BY THE LEGENDARY **GUY CLARK**

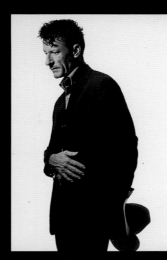

LOVETT LEARNED A THING OR TWO ABOUT SINGING SONGS AND TELLING STORIES FROM ONE OF THE ORIGINAL COSMIC COWBOYS **MICHAEL MARTIN MURPHEY**

ONE OF LOVETT'S BIGGEST INFLUENCES AS A SINGER WAS THE MAN WHO WROTE "MUSKRAT LOVE," NOTED ICONOCLAST **WILLIS ALAN RAMSEY**

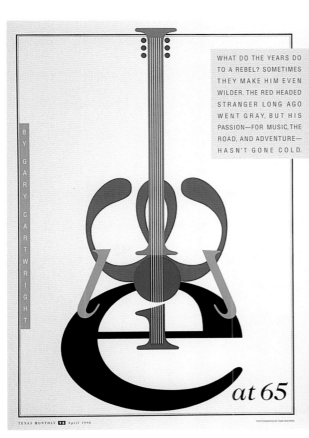

WHAT DO THE YEARS DO TO A REBEL? SOMETIMES THEY MAKE HIM EVEN WILDER. THE RED HEADED STRANGER LONG AGO WENT GRAY, BUT HIS PASSION—FOR MUSIC, THE ROAD, AND ADVENTURE—HASN'T GONE COLD.

BY GARY CARTWRIGHT

e at 65

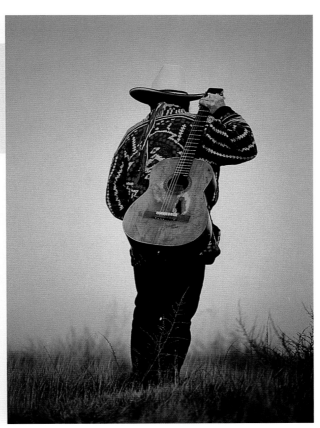

TEXAS MONTHLY April 1998 PHOTOGRAPHS BY DAN WINTERS

The SWEET SONG of JUSTICE

It took the jury less than three hours to find Yolanda Saldivar guilty of murdering Selena. But for two weeks in October, all of Texas followed the most sensational trial in years. A behind-the-scenes look at what happened inside the courtroom. by Joe Nick Patoski

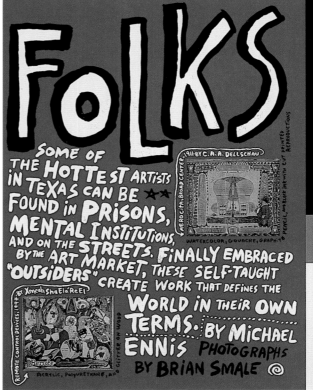

FOLKS

SOME OF THE HOTTEST ARTISTS IN TEXAS CAN BE FOUND IN PRISONS, MENTAL INSTITUTIONS, AND ON THE STREETS. FINALLY EMBRACED BY THE ART MARKET, THESE SELF-TAUGHT "OUTSIDERS" CREATE WORK THAT DEFINES THE WORLD IN THEIR OWN TERMS. BY MICHAEL ENNIS PHOTOGRAPHS BY BRIAN SMALE

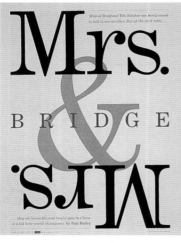

Mrs. & .sıM

BRIDGE

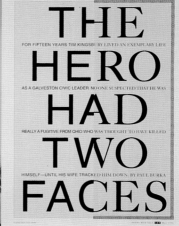

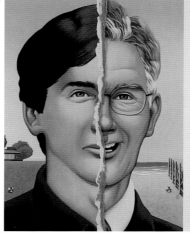

THE HERO HAD TWO FACES

FOR FIFTEEN YEARS TIM KINGSBURY LIVED AN EXEMPLARY LIFE AS A GALVESTON CIVIC LEADER. NO ONE SUSPECTED THAT HE WAS REALLY A FUGITIVE FROM OHIO WHO WAS THOUGHT TO HAVE KILLED HIMSELF—UNTIL HIS WIFE TRACKED HIM DOWN. BY PAUL BURKA

This page and opposite from above left:

Opening spread on the trial of Selena's murderer
ART DIRECTION: DJ STOUT
ILLUSTRATION: OWEN SMITH

Texas Monthly spreads on Texas folk art
ART DIRECTION: DJ STOUT
PHOTOGRAPHY: BRIAN SMALE

Texas Monthly spread on Ross Perot
ART DIRECTION: DJ STOUT
ILLUSTRATION: HANOCH PIVEN

Texas Monthly spread on George Foreman
ART DIRECTION: DJ STOUT
ILLUSTRATION: DAVID COWLES

Texas Monthly spread "The Hero Had Two Faces"

This is the opening spread for a feature about a man who had a double life. He abandoned his family in Ohio where he faked a suicide note before fleeing town and then was discovered years later in Galveston, Texas where he had become a prominent and respected civic leader.
ART DIRECTION: DJ STOUT
ILLUSTRATION: STEVE CARVER

Texas Monthly opening spread for feature on two champion bridge players
ART DIRECTION: DJ STOUT
ILLUSTRATION: KEITH GRAVES

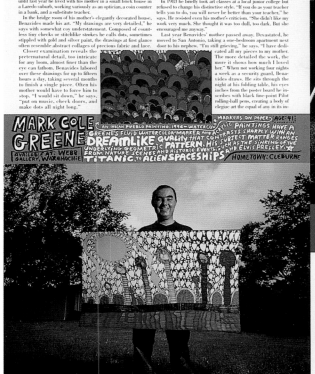

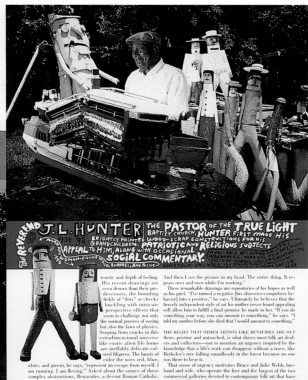

until last year he lived with his mother in a small brick house in a Laredo suburb, working variously as an optician, a coin counter in a bank, and a substitute teacher.

In the bridge room of his mother's elegantly decorated house, Benavides made his art. "My drawings are very detailed," he says with somewhat coy understatement. Composed of countless tiny checks or stitchlike strokes he calls dots, sometimes stippled with gold and silver paint, the drawings at first glance often resemble abstract collages of precious fabric and lace.

Closer examination reveals the preternatural detail, too intricate for any loom, almost finer than the eye can fathom. Benavides labored over these drawings for up to fifteen hours a day, taking several months to finish a single piece. Often his mother would have to force him to stop. "I would sit down," he says, "put on music, check doors, and make dots all night long."

In 1983 he briefly took art classes at a local junior college but refused to change his distinctive style. "If you do as your teacher tells you to do, you will never be better than your teacher," he says. He resisted even his mother's criticism. "She didn't like my work very much. She thought it was too dull, too dark. But she encouraged me anyway."

Last year Benavides' mother passed away. Devastated, he moved to San Antonio, taking a one-bedroom apartment next door to his nephew. "I'm still grieving," he says. "I have dedicated all my pieces to my mother. The more detailed the work, the more it shows how much I loved her." When not working four nights a week as a security guard, Benavides draws. He sits through the night at his folding table, his eyes inches from the poster board he inscribes with black fine-point Pilot rolling-ball pens, creating a body of elegiac art the equal of any in its in-

MARK COLE GREENE AN INDIAN PUEBLO PAINTING, 1996 ~ WATERCOLOR/MARKER AND ACRYLIC PAINTINGS HAVE A **DREAMLIKE** QUALITY THAT CONTRASTS SHARPLY WITH AN UNDERLYING GEOMETRIC **PATTERN**. HIS SUBJECT MATTER RANGES FROM NATURE SCENES AND HISTORIC EVENTS, SUCH AS THE SINKING OF THE **TITANIC** TO **ALIEN SPACESHIPS** · MARKERS ON PAPER · AGE: 41 · AVAILABLE AT: WEBB GALLERY, WAXAHACHIE · HOMETOWN: CLEBURNE

THE REVEREND J.L. HUNTER THE **PASTOR** OF THE **TRUE LIGHT** BAPTIST CHURCH, **HUNTER** FIRST MADE HIS BRIGHTLY PAINTED WOOD-SCRAP CONSTRUCTIONS FOR HIS GRANDCHILDREN. **PATRIOTIC** AND **RELIGIOUS** SUBJECTS **APPEAL** TO HIM, ALONG WITH OCCASIONAL **SOCIAL COMMENTARY** · AGE: 92 · WOOD, ENAMEL, AND GLUE

tensity and depth of feeling. His recent drawings are even denser than their predecessors, the brooding fields of "dots" or checks buckling with intricate perspective effects that seem to challenge not only the normal process of seeing but also the laws of physics. Seeping from cracks in this extradimensional universe like exotic alien life forms are ineffably delicate colored filigrees. The bursts of color (he uses red, blue, white, and green), he says, "represent an escape from myself. I am running. I am fleeing." Asked about the source of these complex abstractions, Benavides, a devout Roman Catholic, says, "I just sit down and ask God what he wants me to see.

And then I see the picture in my head. The entire thing. It repeats over and over while I'm working."

These remarkable drawings are repositories of his hopes as well as his grief. "I've turned a negative [his obsessive-compulsive behavior] into a positive," he says. Ultimately he believes that the fiercely independent style of art his mother never found appealing will allow him to fulfill a final promise he made to her. "If you do something your way, you can amount to something," he says. "I told my mother before she died that I would amount to something."

THE BELIEF THAT OTHER ARTISTS LIKE BENAVIDES ARE OUT there, pristine and untouched, is what drives most folk art dealers and collectors—not to mention an urgency inspired by the knowledge that a life's work can disappear without a trace, like Berkeley's tree falling soundlessly in the forest because no one was there to hear it.

That sense of urgency motivates Bruce and Julie Webb, husband and wife, who operate the first and the largest of the two commercial galleries devoted to contemporary folk art that have opened in Texas in the past several years (the other is Austin's

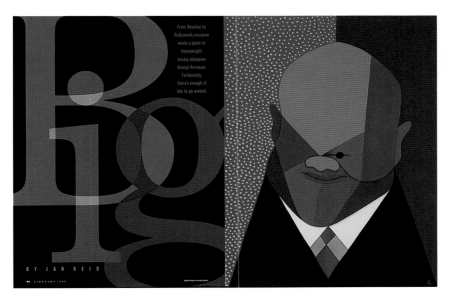

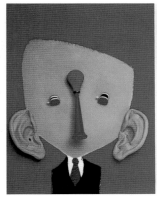

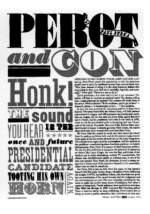

singer, Selena, illustrated the singer as a religious icon, while the type treatment was in the style of an old-fashioned Mexican bible. Stout had acquired one of these bibles and for three days, he photocopied, cut, and pasted type to simulate that biblical feeling. This spread won a

gold award from the Society of Publication Designers for Stout.

TYPE AND TYPOGRAPHY

It is not unusual for Stout to hand-render a type treatment, as in "The Horse Killers," where he used a child-

like scrawl that added a sense of menace. This worked in conjunction with a searing illustration done by Matt Mahurin.

For a feature on Willie Nelson (whom Stout describes as "the best-known person in Texas"), at age 65, the photographer Dan Winters shot this musical leg-

end from behind (with Nelson's guitar slung over his shoulder), while Stout created a letterform montage to simulate the guitar to render the singer's name in this title.

And for interpreting another Texas favorite son, singer Lyle Lovett (for the

TYPE GRAPHICS

71

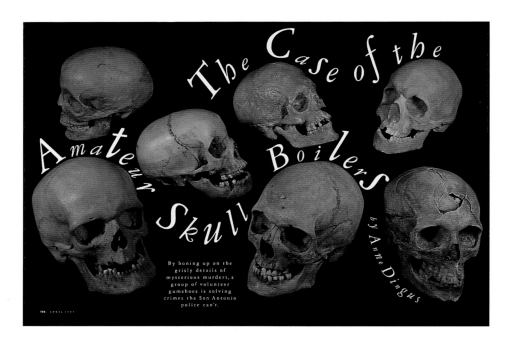

The Case of the Amateur Skull Boilers

By boning up on the grisly details of mysterious murders, a group of volunteer gumshoes is solving crimes the San Antonio police can't.

by Anne Dingus

Left: *Texas Monthly* spread on "Amateur Skull Boilers," a group of amateur detectives in San Antonio
ART DIRECTION: DJ STOUT

Opposite: *Texas Monthly* spread on children who killed a horse
ART DIRECTION: DJ STOUT
ILLUSTRATION: MATT MAHURIN

release of a CD featuring Texas music of the 1970s), Stout set the cover lines in the style of music posters of the 1970s. He repeated this look throughout the editorial spreads with photographs of Lovett by photographer Albert Watson.

Stout collects old type books so that he can find references that capture the

mood of the editorial pieces, as he did with "The Last Posse." Here, the type is reminiscent of that used on "wanted" posters and conveys the Wild West ethic of these contemporary Texas law men.

There is a distinctive, handcrafted quality to Stout's headline treatments, along with his coherent blending of

title, image, and text. This is the designing forte that he takes with him into his new role at Pentagram.

As the 17th Pentagram partner, Stout relishes the support of other partners, like Paula Scher and Woody Pirtle in the New York office, as well as all of the resources and opportunities Pentagram

can offer. He travels frequently to work with clients, but is happiest in the Austin Pentagram office. Texas is home, and although Stout may now design for every corner of the world, this is where he is content to stay.

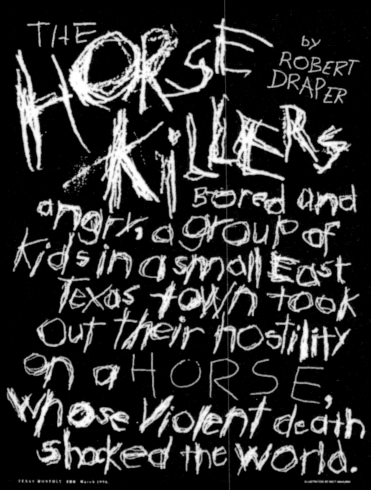

THE HORSE KILLERS

by ROBERT DRAPER

Bored and angry, a group of kids in a small East Texas town took out their hostility on a HORSE, whose violent death shocked the world.

TEXAS MONTHLY 186 March 1996. ILLUSTRATION BY MATT MAHURIN

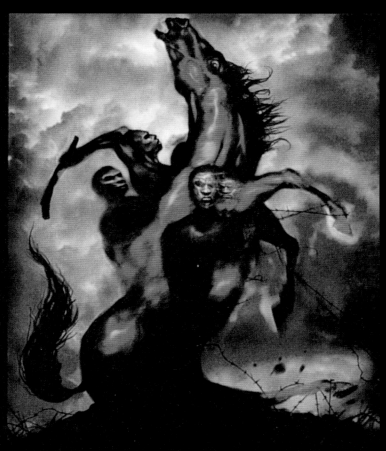

Jeremy Tankard

Above: Jeremy Tankard used the Aesthedes system attached to a pen plotter to create this poster. The skeleton design was keyed to the system and sent to the plotter (with up to eight colored pens). During the "print" routine he swapped the pens around, changed the "fill" commands and used the joystick to scribble over the artwork. Each resulting poster was different but from the same master design.

Opposite: Interactive presentation. Done as a huge PDF file incorporating hotspots and links, Tankard can adapt it for a variety of audiences.

DESIGN: JEREMY TANKARD

JEREMY TANKARD is an amiable typophile. He works exclusively with type from his studio Jeremy Tankard Typography, on the Grand Union Canal, Paddington Branch, in London. In 1998, Tankard left corporate design after a six-year stint, first at Addison and then at Wolff Olins, where, with other designers, he worked on accounts including British Telecommunications, British Airways, and GM Motors. His plan was, he says, "to pursue my interests in typography and make my knowledge available to a broader range of companies and people, and to develop typefaces for general retail and corporate use."

Tankard's impetus for going on his own came from sales of his typeface, Bliss. "Bliss gave me the ability to establish my own company. It was released in 1996, and has recently become popular. Any text type will take around three to five years to become established and known. There is a lot of time and investment in developing a type and you have to be ready to wait for the returns," he states.

Tankard has a personal goal "to develop a typeface/family each year." The first typeface produced in this time frame was Enigma. Shaker, a sans serif complement to Enigma, was recently completed.

For clients, Tankard does "everything, anything type-related — these could be typefaces, logotypes, on-screen work, type critiques," he says. For Telstra, a major Australian telecommunications company, Tankard developed the typeface Harmony, for example, which he describes as a large family consisting of display, text, and text bold weights in roman and italic. (It covers most Western European, Greek, Vietnamese and Turkish languages.) He also developed a display type for Frogdesign Gmbh in Düsseldorf called Epsilon and the type Gameplay (used for Gameplay.com) for the U.K. design group Salterbaxter. He also designs logotypes.

ALCHEMY

A menagerie of letters and ligatures to create detailed and varied word shapes in a modern gothic style

Ecclesiastical decoration

[·LETTERS·]

The populist interpretation of the Middle Ages is one of magic and mystery. Many bizarre symbol alphabets were developed during this period; from the simplicity of Runes to the very strange Celestial, Alchemical and Slavic alphabets. Elements from these forms have been re-created with those from the Manuscripts resulting in the graphic forms of Alchemy.

some key strokes contain
pre-designed ligatures

diamond finials can be attached
to either side of a character

the monastic scribes twisted and
stretched their illuminated letters into
graphic forms of almost infinite variety

"CON CEIVED WI

The Manuscripts of the Middle Ages contain a rich diversity and ingenious use of capital lettering. During this period the monastic scribes twisted and stretched their illuminated letters into graphic forms of almost infinite variety. Many of the letterforms of the Alchemy™ typeface have been derived from the decorated pages of the Lindisfarne Gospels (around 689AD), which contain Anglo-Saxon capitals that have several alternative forms and appear freely mixed together to enhance a word's shape.

Tt PASIO-n BY UNKNOWN AR

a linking bar joins characters
and continues the line of the
diamond finials

Tists, & ·CONSUMED· IN

IMAGE IF NOT IN USAGE

superior letters
are contained in
Alchemy Silver High

BY A WHOLE POPULATION WH

inferior letters
are contained in
Alchemy Silver Low

ICH APPROPRIATES THEM AS A

many bizarre symbol alphabets were
developed during the Middle Ages

Plug-in characters allow for the
creation of a multitude of ligatures

PURELY MAGICA OBJE-CT."

after Roland Barthes *Mythologies* [1957] 'La Nouvelle Citro

Information
Alchemy consists of four typefaces that include all the standard ISO/Adobe characters. The range of characters available depends on the software and hardware platform being used. The types are available for the Macintosh computer and include the new Euro Currency Symbol €.

ALCHEMY GOLD 24
ALCHEMY GOLD 18
SILVER HIGH
SILVER LOW

For more information about the Alchemy type please contact Jeremy Tankard.

Jeremy Tankard | Typography
122 Canalot Studios
222 Kensal Road
London W10 5BN
ENGLAND

Telephone +44 (0)20 8964 0985
Fascimile +44 (0)20 8969 2420
Email jtankard@typography.demon.co.uk
Internet www.typography.net

Alchemy is defined as *'seeking to turn base metals into gold or silver'*. This idea has been retained in the naming of the Alchemy types with Gold 24 and Gold 18 containing the main letterforms and Silver High and Silver Low containing superior and inferior letter positions. All key strokes contain a character, some of which are pre-designed ligatures, others have the ability to plug-in to other characters to create new ligatures. There is also a linking bar and diamond finials that can be attached to either side of a letterform.

Alchemy © Jeremy Tankard 1998

DESIGN PHILOSOPHY

Jeremy Tankard was brought up surrounded by design (and, to some extent, type), since his father was publicity manager for several engineering companies in England. Tankard explains, "He was responsible for print, advertising, press and PR, exhibitions, the whole gamut. Being surrounded by it, talking about it, your tastes are ultimately fashioned. I am lucky in that my Dad, due to his design education, is design-aware, and not just about graphics and typography, but furniture, ceramics, print, interiors, product, among other things."

Tankard reflects that as he learns more "about design and its history, you come to terms with the fact that nothing is new. The more I see my own ideas and work, the more I understand what I'm doing, the more I realize how I draw a curve (why I do it a certain way – what looks right to my eye), and question proportion, relation, rhythm, pattern, the more I understand the little tricks that help to increase the effectiveness of a design – the bits people don't appreciate or see (or should see)."

THE SHiRE TYPES

Six typefaces designed to create a dense textural mass of lettering

Jeremy Tankard Typography

From around the Black Country

DERBYSHIRE
STAFFORDSHIRE
CHESHIRE
SHROPSHIRE
WARWICKSHIRE
WORCESTERSHIRE

¶ the SHiRES ARE THE MIDLAND COUNTIES OF ENGLAND.

The typefaces take their names from six of the shires that are grouped together around the Black Country and the neighbouring rural areas.

¶ THE LETTERFORMS OF THE SHIRES CHANGE STYLE AS YOU MOVE AROUND THEM AND, LIKE PEOPLE, ARE NOT TIED TO ANY ONE PLACE BUT CAN TRAVEL FREELY FROM SHiRE TO SHiRE AND MiX WITH THEIR NEiGHBOURS.

¶ THE CONCEPT FOR THE SHIRE TYPES™

Köln
VRÅ
øster
TRES
æSTHETiC
ŒDiPUS

AAAaaa

03

Derbyshire | Staffordshire | Cheshire | Shropshire | Warwickshire | Worcestershire

Opposite: Poster for Tankard's Alchemy typeface
Above: Poster for The Shire Types. Tankard designs a poster for each retail face he creates.

DESIGN/TYPE DESIGN: JEREMY TANKARD

Enigma

Tankard's Enigma typeface was developed
from elements of Rotunda (with a nod, he
says, "toward W. A. Dwiggins' experiments
with his Electra and Caledonia types").
DESIGN/TYPE DESIGN: JEREMY TANKARD

TYPE AND TYPOGRAPHY
Tankard's philosophy is centered on his
work with type. He says, "Each of my type-
faces tends to be different. I am not into
working in a style. I like type with all its
warts, all its incarnations. I absorb infor-
mation on all areas of type as and when
I come across it — I sort of live in fear of
not knowing. I buy books on type history,
type designers — any article I see I grab.
I constantly take photos of lettering I see
around, be it carved in the wall, a shop
fascia, a mosaic in the floor. I latch on
to things and see where it takes me.

Usually, I end up with five to ten books
open, having cross-referenced and found
a new line of inquiry, and then I go on."

The typefaces that have emerged from
this fertile process include Alchemy,
Tankard's modern gothic letter face rev-
erential in intensity; The Shire Types
(six fonts: Derbyshire, Staffordshire,
Cheshire, Shropshire, Warwickshire, and
Worcestershire) based on English tradi-
tional lettering inspired by the gro-
tesque and clarendon styles; and
Enigma, influenced in part by rotunda
letterforms. Although Tankard creates

¶ IF THERE ARE any *enigmatic qualities* to a typeface then they are hidden within the detailing of each symbol; we accept the symbol 'a' for what it is but we also understand that there are many alternative ways of drawing the same symbol. *It is incredible that a simple structure can have a seemingly endless number of expressions.*

sensitive, artful typefaces, he states, "I do think of type design as industrial design rather than art per se. It is more technical and has to function at levels more akin to industrial design."

He describes what he does by saying, "I suppose to some extent I work in a 'perfect world'—I control the design of the type. I live with it for a year or two, watch it grow and develop, see it take on a personality (change its nappy, so to speak). Then I put it in a marketing brochure and pack it off into the big wide world."

And as to his future, Tankard adds, "All I know is that I will be working with type for a long time yet."

Don Zinzell

Top right: Interpretation of "T" for Boston
ATypI incorporating photographs of images
of found type
DESIGN/PHOTOGRAPHY: DON ZINZELL

Above: Poster for Devilish typeface
DESIGN/PHOTOGRAPHY/TYPE DESIGN: DON ZINZELL

Opposite: Spreads from book, *How to Be
Happy Damn It*
DESIGN/PHOTOGRAPHY/TYPE DESIGN: DON ZINZELL
WRITER: KAREN SALMANSOHN

ZINZELL IS BASED in a loft at the far edge of SoHo in Manhattan. Don Zinzell is its creative force, and when necessary, he draws from a network of highly talented collaborators. Beginning in 1987 as a "designer for hire," as he describes himself, Zinzell decided in 1995 to establish the studio as it is today. Recently, his wife Manon, with a background in architecture and branding, joined in as studio manager and project director. The studio space is large, airy, open, and filled with bustling energy. In many ways, Zinzell has set up a prototype for design of the future, a model for working that is unencumbered and fast and with design that transmits what Zinzell calls "the vernacular of modern culture."

With clients such as Sony, Prescriptives, Tommy Hilfiger, and Tourneau, and prospective clients lining up, Zinzell is always busy. He provides original concepts and his skills as a photographer, type designer, and art director. What Zinzell offers is a "360-degree attack on the senses: a three-pronged approach to design that is visual, cerebral, and emotional," he says. He lists his favorite tools of the trade as "metaphors, negative space, found objects, and chance."

His style of photography, which he refers to as "utilitarian," is often seen in his design work, and his photographs have been acquired by the Nonstøck agency, which specializes in alternative, non-traditional photography. (Zinzell has created ads for Nonstøck as well.)

His type designs, now available for sale, have often evolved from the custom logo designed for clients. He designs not only for print, but the Web, branding, identity, signage, video, motion graphics, multimedia projects, and packaging.

Don Zinzell relates to design as an experience of total involvement. His clients look to him for a "different" take on designing, an expanded and exhaustive response to any brief. So Zinzell tends to give them just that, often starting with creating an identity—a logo treatment—and then developing that concept into anything from an advertising campaign to a Web site. His designs merge his photographs with his type treatments to create what he calls "design as a total environment."

9

AND THINGS
CAN CHANGE AT ANY TIME,
LIKE THIS TYPEFACE
OR THIS LANGUAGE... VOILA. SI!
BØRGKP MJPO?
INTO A LANGUAGE YOU
CANNOT UNDERSTAND.
YOUR WORST FEAR:
NOT UNDERSTANDING.
ALTHOUGH YOU KNOW, THAT...

YOU KNOW?

6

YOU NEVER KNOW,

nonstøck.

7iN73LL

1_800_673_6222
www.nonstock.com

DESIGN PHILOSOPHY
In explaining his design philosophy, Zinzell refers to "cultural relevance," which he explains this way: "If I create a piece that lacks cultural relevance, a total sense of resounding to what is important at this time, the design is dead, it has no life. So that thinking and context always has to be there." Zinzell feels that his design is based on looking at things from unexpected sources. He explains, "I am greatly influenced by new discoveries in science. I would like to think of design in terms of quantum theory or chaos theory. For example, if you as a designer can open yourself up to a project, discoveries will just materialize. A sort of 'super luminal' connection will occur. This is where an idea or concept almost exists before the event. It is as if you are developing something from the inside out, working in reverse, tapping into your inner self, like traveling 'into' a typeface rather than designing it only on the surface. I find that the most rewarding aspect of design is 'discoherence' when several contradicting conditions exist simultaneously, but

product

1250

disconnect

Opposite left: Promotional piece for Zinzell
photography for NonStøck. Opposite right:
Page from Zinzell brochure
DESIGN/PHOTOGRAPHY: DON ZINZELL

Above: Spread for *Addict* magazine
Below: Logo and label for Kogos
DESIGN/PHOTOGRAPHY/TYPE DESIGN: DON ZINZELL

kogos™

the coffee commodity

savory 11

0 22548 00514

contribute to singularity. It is the equiva-
lent of stripping something down to its
basic elements while maintaining multi-
ple layers of meaning. Working within
these concepts means embracing change
when you get an unpredictable result.
This allows you to work with rather than

fight with the unexpected. It can make
what you do very special and very hon-
est. Design 'accidents' always make the
work more interesting if you incorpo-
rate them."

Zinzell wants the designs that he pro-
duces to have a "clean, generic, almost

pharmaceutical look. I like to strip things
down to basics, to challenge that memory
overload with which we are constantly
bombarded," he says.

He credits his growing up in a punk
rock/new wave environment for much
of his current thinking. He is a musician

and had until recently been involved
with a techno band that also included col-
leagues and collaborators like Michael
Uman, a broadcast director, and Gavin
Wilson, photographer and illustrator.
These two, as well as a coterie of other
like-minded photographers, artists,

Below: Advertisement and logo for
Tourneau watch gear
DESIGN: DON ZINZELL

Opposite: Design and logo commis-
sioned by Christine Belich (Sony
Style, New York) for a Sony/Cooper
Hewitt Design Museum event
DESIGN/TYPE DESIGN: DON ZINZELL

designers, writers and guests, meet
every Tuesday to keep in touch, but also
to keep a fresh perspective on the work
they are doing.

Zinzell is also involved in think-tank
collaborations that cross disciplines. He
works with architects, writers, musicians,

visual artists, and fashion and furniture
designers, and he finds these interactions
essential. "It is a continuing education,"
he says, adding that these alliances keep
ideas flowing and lead to new areas of
work opening up.

TYPE AND TYPOGRAPHY
What also distinguishes Zinzell's work
is finely honed type treatments with
typefaces he designs for each project.
Because Zinzell creates specific type-
faces for clients, he transforms these or
his logo designs into the beginnings of

a typeface and then continues to round
out the character sets into whole type
families. Recently, because of requests
to make his faces available for sale, he
has become his own "type foundry."
Undaunted by the number and range
of typefaces now in the marketplace,

Zinzell feels that there can never be too many type choices, and he continues to design new ones. His own type designs he describes as being based on "a relationship with contemporary elements, both planned and accidental. In other words, any experience, visual inspiration from any source, things in everyday life, can lead to a type design. So, too, can a botched design where what results is far better than what I had planned." Zinzell's fonts include Devilish, Vixa, Amp, and Int'l Runway.

For Don Zinzell, designing everything and anything is not a profession, or a career, or merely work. It is his forum for his obsession. It is a way of life .

Torben Wilhelmsen

AT HIS DEN BLAA TROMPET (The Blue Trumpet) studio in Copenhagen, Torben Wilhelmsen works on graphic design, multimedia, and Web production. He aspired to be an illustrator, but found that graphic design "offered more jobs," he says. "I taught myself graphic design, and whenever new opportunities in graphic design came up, I jumped at them. These were mostly magazines, leaflets, and posters," he adds. This work eventually brought Wilhelmsen awards, including one for magazine and one for book design. Wilhelmsen reports that in 1994 he also turned to multimedia (creating two CD-ROMs). Then he joined the growing league of Web designers and eventually wrote *Hjemme.sider* (translated as *Home.pages*), which was designated as "a selected book of the year" in 1998. He continues to experiment with designing for the Web, apparent at his own Web site as well as in work for clients. Wilhelmsen also teaches at The Graphic Arts Institute of Denmark.

Wilhelmsen's designs are very illustrative. As exemplified by his business card, he manages to present information in a series of colorful, flowing, soft images combined with fluid type treatments. This is also reflected in other type treatments in which Wilhelmsen presents playful, layered, and yet entirely legible type.

Cover from *Rene Linier* (Cleaner, Greener Supply Lines) book

Opposite: Spread from *Rene Linier* book

DESIGN: TORBEN WILHELMSEN

Byøkologi

Urban ecology, the hub of the supply lines

In spite of resource think-tanks and major efforts designed to solve, minimise and regulate the environmental problems involved in supplying a city with energy, water and food and disposing of waste, developments indicate that if we are to adhere to Brundtland's concept of sustainability, efforts thus far are insufficient and inadequate to keep us within the estimated global environmental space that will preserve the resources we will ultimately have at our disposal.

This global environmental space is at present only theoretic in dimension. A measurement of the resources we each have at our disposal and how much refuse and waste we can dispose of in the production process if resources are to be divided equitably while maintaining an ecological balance.

Organising consumption according to the limits of ecological parametres will be an enormous challenge to our life style.

This challenge has inspired general ecological and urban ecological experiments. Experiments involving renewable energy, the collection of rainwater and recycling water resources, organic agricultural and the production and recycling of all materials.

The city's supply of utilities, that this guide essentially deals with, centres on urban ecology because efforts are directed at solving more, and ideally all, environmental problems at source and in a manner that focuses on the conditions, standards and ideas of the people who live here.

insulation, solar walls, glass extensions, low-energy window panes, solar panels, solar cells, rainwater seepage, using rainwater, recirculation of discharge water, re-establishing lakes and wetlands source sorting, composting household waste, root zone systems, compost toilets, recycling building materials clearing backyards making space for animal and plant life, greenhouses, ty gardens, school gardens, kitchen gardens, organic cultivation

URBAN ECOLOGY
CHANGING A LIFE STYLE
Urban ecology is a concept and a way of living. The objective of urban ecology is to revitalise the functions of the city so that:
• the least possible amounts of pollutants are produced in the energy supply system
• resources are saved – electricity, water and heating
• anything that can be recycled is recycled
• refuse is minimised

• more green areas and green, communal backyards are established
• organic food retail outlets are provided
This means that we must change our habits while housing and leisure facilities in the city must be transformed. This takes time and will demand concerted efforts on behalf of municipal authorities and citizens alike.

56

57

DESIGN PHILOSOPHY

Wilhelmsen relates design to finding parameters within which to work and then making a creative leap. He says, "I have always been experimenting and combining techniques and materials in various ways. But I also always search for restrictions when I work. That is how

I taught myself, and that is how creativity works. I ask myself how do I pass the limits, the restrictions of a certain task. The tighter these binds are, the more creativity flows. And the more fun it is to actually pass the limits."

Wilhelmsen also states that "the big leap in my creative process came when

I started to work on a Mac in 1989–90. Back then the computer offered wonderful restrictions (disk space, speed, PostScript errors, etc.), but I could actually make very organic design that wasn't possible without the computer."

As for inspiration, Wilhelmsen says you have to search within yourself. In

his case, he wrote a short story called "The Blue Trumpet" (hence the name of his studio), which is essentially a fairy tale about a boy and his attempts to play a blue trumpet. The more the boy plays, the more his playing provokes an explosion of color. This is Wilhelmsen's metaphor for the creative act. "You have to

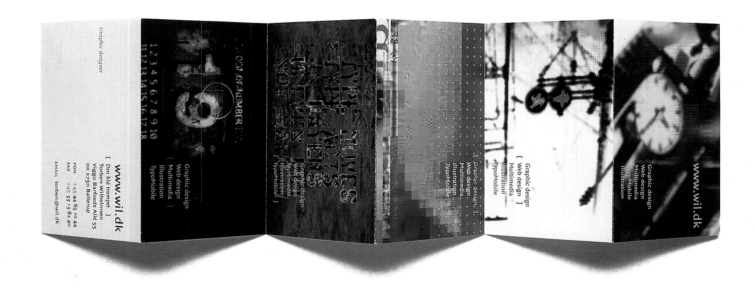

search within – creativity and inspiration come from somewhere deep in yourself and in your mind. And anything, even an old nursery rhyme, can inspire it," he says.

TYPE AND TYPOGRAPHY

Wilhelmsen experiments with type, quite aware of its challenge and restrictions.

He says, "Typography is the basic discipline in graphic design, although it is often disregarded. You may be able to create beautiful images without any typography, but in order to make graphic design work as an integrated part of communication, you have to take special care of how you present the typography.

To put it simply: you can make a beautiful graphic design solely by means of a typographic treatment, but with bad typography, even if you have nice images, it is likely these will just impede the communication rather than convey it." Wilhelmsen also points out that good typography is not just about what type-

face to use. He says, "Almost any typeface (and 'hurrah' for all the experimental typefaces) will work if the typography is well done."

Henrik Birkvig

Above Top: *Hof & Stat* (Danish State Directory)
TYPOGRAPHIC CONSULTANT: HENRIK BIRKVIG

Below: *Grafisk Teknisk Selskab* (jubilee booklet)
DESIGN: HENRIK BIRKVIG

Opposite: Spread from Den Grafiske Hojskole
newsletter *Rubrik*
DESIGN/TYPOGRAPHY: HENRIK BIRKVIG

HENRIK BIRKVIG creates classical work in a contemporary context. He designs digitally with a strong sense of craft and an emphasis on impeccable use of type on the page. Since 1984, Birkvig has been on the faculty of The Graphic Arts Institute of Denmark, where he has taught a range of subjects, including book design, magazine design, information design, packaging design, calligraphy, typography, and creativity. He says, "Teaching has made me develop an awareness, a sense of the vocabulary connected to specific problems and phenomena in design. It has also forced me to describe and analyze the process of graphic design in general and more specifically for each design discipline." In his freelance design work, he says he has to modify the "idealistic" approach he has as a teacher to match the realistic needs of his clients, while avoiding what he calls "graphic cosmetics."

In his work done primarily for *Rubrik* magazine (for which he created the logo as well as the typeface, which is also used for the Graphic Arts Institute's identity program), and in designs with design as the subject, he manages to practice what he teaches. Birkvig's work has a crisp, controlled quality. Even when he wishes to make a strong graphic statement, it is always rigorously executed so that his type treatments do not detract from content. As author, designer, and editor of design books in Denmark, he has proved that his theories work in reality.

EN GRAFIKERS KIKI KRYSTAL KUGLEN

Tekst & design:
Henrik Birkvig, 1997

Ved årsskiftet er det tradition for at gøre status. At se på det forgangne og vægte det gode, der er sket med det dårlige. Men der kan også være grund til at skue et lille stykke ud i fremtiden. At fremskrive nutiden så langt øjet rækker, og derved give den et aktuelt perspektiv.

Jeg har kikket i krystalkuglen fra min egen udsigtspost og samlet denne lille buket af scenarier, som det hedder på fremtidsforskersprog.

De handler om arbejdet med at producere og designe trykt massekommunikation ved hjælp af den personlige computer — hvadenten du er professionel eller selvlært grafisk designer, art director, desktopper eller museført — eller hvad du nu har valgt at kalde dig selv.

Læs dem i den rækkefølge, der passer dig — de er nemlig arrangeret i et layout til den scannende læser.

Fra papir ...

Inden for en overskuelig fremtid udfører du jobs, som aldrig ender på et stykke papir, men alene eksisterer som digitale data i en computer, billeder og tekst på en CD-skive, hvor slutbrugeren selv skaber rækkefølge og udvælgelse af informationer

... til skærmbilleder.

Der er mere mellem mus og printer ...

Inden for en overskuelig fremtid kan du ikke længere nøjes med kun at kunne noget med en Macintosh. Du vil være tvunget til at interessere dig for andre computerplatforme, som måske er bedre end den kære Mac. Hvem ved om Apple eksisterer om to år eller er overhalet af Microsoft Windows?

... end Mac'en.

Indhold før form ...

Inden for en overskuelig fremtid kan du ikke nøjes med at sælge grafisk form. Du komponerer af forskellige elementer. Kunderne vil i fremtiden kræve helt andre og måske målbare resultater af dit design. Derfor må du interessere dig for nye og avancerede layoutformer, hvor der tænkes i den scannende læser: den, hvis øjne tutter anarkistisk rundt på siden i en søgen efter noget interessant.

Det kræver, at der fra starten tænkes i både redigering, tekst, illustration og layout på samme tid.

Som i dette opslag, hvor du kan begynde læsningen, hvor du vil.

... og form før indhold.

Grafikerens pip ...

Inden for en overskuelig fremtid bliver det at designe og producere trykt massekommunikation en aktivitet, hvor alle og enhver kan være med — og er det. Din indfaldsvinkel til at gøre det vil måske være en særpræget kompetence du har måske en uddannelse på et helt andet felt end grafisk design: Du kan lide at nørkle med skrift, illustration og ombrydning osv. — så løsnet til at beskæftige dig tekst, måske lige og let nok — og derfor er du den bedste til at designe og redigere eksisterende vedrørende mænds blad 'Glade Fuglefløjt'.

... eller ornitologen som layouter.

Ny teknik ...

Inden for en overskuelig fremtid skal du ikke længere tænke i de rasterrypper, du arbejder med nu. Du vil få nogle trykkilm kørt ud, der indeholder såkaldte stokastiske raster. De kendte runde eller ovale prikker af forskellig størrelse er erstattet af prikker i samme størrelse, men strøet ud over fladen i en struktur, der ser tilfældig ud, men giver et langt bedre trykresultat.

Trykfilm? Næh, måske vil dine digitale data (= dit design) blive brugt direkte til belysning af trykfilm, en trykplade eller en elektrostatisk tromle.

... og nye krav til dig.

Total typografisk kontrol ...

Inden for en overskuelig fremtid vil du benytte dig af et skriftformat fra Apple, der hedder TrueType GX (= graphical extension). Det giver dig bl.a. mulighed for total kontrol over en skrifts styrke, bredde, optisk skalering i forhold til størrelse, form, ornamentik, automatisk indsætning af ligaturer og swash bogstaver og meget meget mere.

... & god typografi.

Det er spændende at undervise ...

Inden for en overskuelig fremtid vil du udføre nye typer jobs. Det kan være undervisning af dine kunders medarbejdere i alt inden for grafisk design og kommunikation: visuel komposition, kreativitet, typografi, billedbehandling, illustration, visualisering af statistik, klargøring til udkørselsbureau, konvertering af filer mellem platforme.

... og penge værd.

Godt begyndt ...

Inden for en overskuelig fremtid vil du udføre hele fabrikbyggedata til dine kunder grundopsætning af dokumenter, som kundernes medarbejdere selv gør færdige i den slags opgaver udfører du måske allerede: personaleblade, brochurerserier, bøger — eller nye former databasebaserede kataloger.

... er noget i sig selv.

Kunstig intelligens ...

Inden for en overskuelig fremtid vil du scanne billeder i farve, og du vil benytte dig af scanneprogrammets indbyggede kunstig intelligens til at opnå det bedst mulige resultat — kun ved et klik med musen (som sikkert vil være aflost af et andet redskab til styring af såvel computer som program).

... og naturlig.

REIMER *Firs*

En af dansk typografis »grand old men«
ELI REIMER fylder 80 år 23. oktober.

Som en hyldest til nestoren arrangerer
Den Grafiske Højskole et symposium

Onsdag 30. oktober 1996

på Symbion, København.

Grafiker Bent Rohde
fyldte 70 år den 4. juli.
I den anledning afholder
Den Grafiske Højskole
et hyldestsymposium
lørdag 17. oktober 1998.

R7OHDE

Kom og hør:

Garrett Boge
Richard Kindersley
Kim Pedersen

DESIGN PHILOSOPHY
Birkvig believes that designers need to be "more engaged with content than they are." And once that precept is followed, he continues, "My design philosophy is quite clear. Design solutions should honor three basic factors: function: e.g., the ability to understand an illustration, the readability of type, and all those related concerns in their context; aesthetics, by which I mean how does it look – is it beautiful, is it styled correctly?; and lastly, economy and technology: that is, factoring in all of the practicalities about how the design is going to be produced."

TYPE AND TYPOGRAPHY
Birkvig's own creation and use of type, as well as his teaching experience, provide the impetus for his ideas on type. He explains that, "putting letters together into lines, words, and columns has for too long been something only a few had been doing: namely type directors, typographers, specialists. For the past 15 years, primarily due to the introduction of computers and the related

growth in the number of typefaces avail-
able, there has been a 'democratization'
in working with type. Anyone can do it."
Birkvig feels this change is good, not in
the least, he says, "because some of the
old 'rules' of typography no longer apply
in modern typography, even though many

of these same rules still remain in
textbooks." Birkvig believes that "new-
comers who work with type need to be
taught that old rules on how to set type
no longer apply to modern typography
and shouldn't be considered the norm
just because they are there." Further, he

adds, "As I see typography today, it is
like wine: you have all sorts of levels of
quality, good and bad, but mostly some-
where in between. Modern typography,
I feel, should be just that — modern. It
should be the visual and textual equiva-
lent of a modern text."

And for Henrik Birkvig, this is what
he attempts: to find a modern sensibil-
ity, forge a modern style, and render
impeccable type treatments with a
modern response to modern texts.

Susan Mitchell / Farrar Straus & Giroux

Above: Book jacket for *The Zig Zag Kid*
Mitchell here provides typographic dimension with a transluscent overlay to the cover.
DESIGN: SUSAN MITCHELL/FARRAR STRAUS & GIROUX

Opposite: Book jacket for *Learning Human*
DESIGN: SUSAN MITCHELL/FARRAR STRAUS & GIROUX
PHOTOGRAPHY: LOUISE LISTER

SUSAN MITCHELL is the art director at the prestigious publishing house, Farrar Straus & Giroux. Located at Union Square in New York, this firm, having passed its half-century mark, continues to produce books that regularly attract the most coveted literary awards, as well as achieving best-seller status.

The FSG office has a Dickensian atmosphere and looks like a house built of paper, which fills every shelf, nook, and cranny. Within this confined space, the art of making books looms large, as does FSG's knack for selling them. And key to the making and selling of the Farrar Straus & Giroux list is the quality of the design of the books. FSG books look well-crafted, and much of that has to do with the art direction of Susan Mitchell.

Susan Mitchell came to FSG as art director three years ago from Vintage Books (part of the Random House Group), where for ten years she honed that imprint's strong visual style. Mitchell had started her career designing book interiors for Betty Anderson (legendary to book designers) at Alfred A. Knopf and later was hired to direct book interiors by Louise Fili at Pantheon (another Random House imprint). For many years, she freelanced as a book jacket designer. Working with books from the inside out, so to speak, has greatly influenced Mitchell's philosophy of design.

DESIGN PHILOSOPHY
Her approach to work she describes as simple: always start with the book. "Getting into the author's words assures the integrity of that original voice. Starting with the words also conjures up images, which are the starting point for any design," she states. Mitchell has a clear perspective on her work, explaining, "I strive to meet the target goals for the book in the best style possible, but I also want the book to have design integrity." For Mitchell, this means mining the content, style, voice, and individuality of each book and working through to a design that captures all of these.

At Farrar Straus & Giroux, Mitchell frequently has the task of tackling the expected best-sellers by authors like Scott Turow or Colin Harrison, which have to stand out on shelves (and e-shelves) and meet the expectations of the authors, the marketing department, the publicity team, and the book-sellers, as well as the general public.

For Scott Turow's latest book, *Personal Injuries,* which deals with lawyers, surprising deceptions, and betrayals, Mitchell creates a sense of movement and mystery in three subtly altered jackets (all released). Using the same type treatment — subtle gold

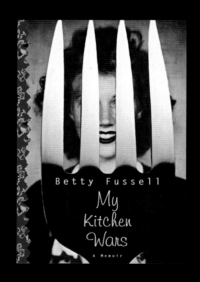

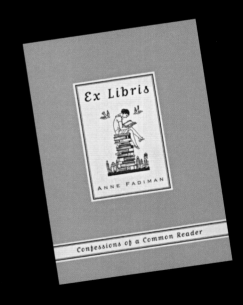

horizontal lines with a gentle serif type—Mitchell varies the placement of a photographic image so that together the trilogy of jackets look like frames from a black-and-white film.

Mitchell is also challenged by intellectually complex and esoteric subjects, and these she presents by envisioning each book as a designed "object" rather than conceiving a mere cover treatment. Her designs often suggest luxurious texture that also capture the writer's style. For example, for Harvard Professor of Aesthetics Elaine Scarry's meditation on and analysis of the process of writing, *Dreaming by the Book*, Mitchell evokes the potency of the content with a subtle choice of art by Barbara Kassell (an ink pot with trapped images and a quill) and complements the image with soft, dream-state colors and an elegant sans-serif type treatment, with hints of the lines of a writing pad.

This is Mitchell's particular talent: conveying meaning seamlessly. And with each of her FSG titles, Mitchell has found that synchronicity between content and form. She has experimented with complex production techniques using die-cuts, embossed type, and metallic inks; the resulting designs give each project its own resonance.

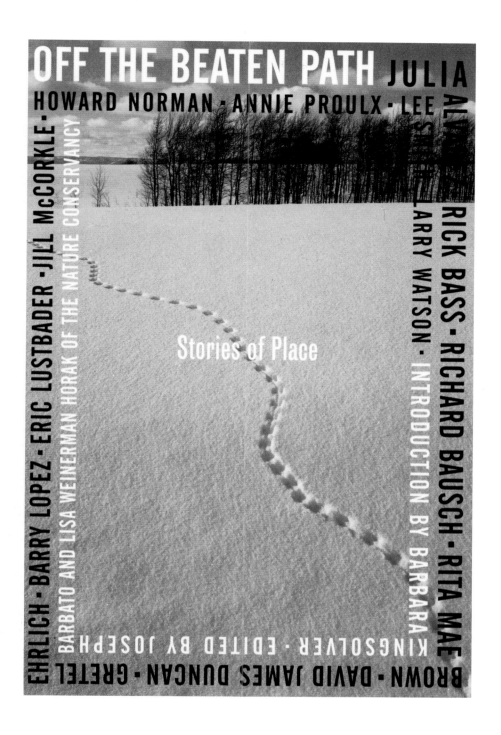

OFF THE BEATEN PATH

HOWARD NORMAN · ANNIE PROULX · LEE

JULIA

RICK BASS · RICHARD BAUSCH · RITA MAE KINGSOLVER · EDITED BY JOSEPH

LARRY WATSON · INTRODUCTION BY BARBARA

EHRLICH · BARRY LOPEZ · ERIC LUSTBADER · JILL McCORKLE ·

BARBATO AND LISA WEINERMAN HORAK OF THE NATURE CONSERVANCY

BROWN · DAVID JAMES DUNCAN · GRETEL

Stories of Place

Opposite, clockwise from upper left:

Book jacket for *Living on the Wind: Across the Hemisphere with Migratory Birds* by Scott Weidensaul
DESIGN: SUSAN MITCHELL/FARRAR STRAUS & GIROUX
BACKGROUND MAP © BY HAMMOND INC. #12426

Book jacket for *The Museum Guard* by Howard Norman
DESIGN: SUSAN MITCHELL/FARRAR STRAUS & GIROUX
ILLUSTRATION: RUTH MARTEN

Book jacket for *Bombay Ice* by Leslie Forbes
DESIGN: SUSAN MITCHELL/FARRAR STRAUS & GIROUX
PHOTOGRAPHY: LEANNE SHAPTON

Book jacket for *Ex Libris* by Anne Fadiman
DESIGN: SUSAN MITCHELL/FARRAR STRAUS & GIROUX
JACKET ART: BOOKPLATE FROM THE LIBRARY OF ELNITA STRAUS, COUNCIL HOUSE

Book jacket for *My Kitchen Wars* by Betty Fussell
DESIGN: SUSAN MITCHELL/FARRAR STRAUS & GIROUX
JACKET ART: PHOTOGRAPH OF FORK AND PHOTO-ILLUSTRATION BY SIMON LEE. BACKGROUND PHOTOGRAPH COURTESY OF THE AUTHOR

Book jacket for *Dreaming by the Book* by Elaine Scary
DESIGN: SUSAN MITCHELL/FARRAR STRAUS & GIROUX
JACKET ART BY BARBARA KASSELL "ASLEEP AND AWAKE" 1998-99, OIL AND GOLD LEAF ON GESSOED BOTTLE

Left: Book jacket for *Off the Beaten Path: Stories of Place*
DESIGN: SUSAN MITCHELL/FARRAR STRAUS & GIROUX
PHOTOGRAPHY: CARR CLIFTON/MINDEN PICTURES

Many of the book jackets Mitchell designs are intended for a readership intent on seeking out contemporary and classical literature (with a capital L) or books which reflect on the literary arts. Here Mitchell excels at conveying the subtlety and the immediacy of the text. For Anne Fadiman's *Ex Libris,* for instance, Mitchell gets the essence of this book, subtitled *Confessions of a Common Reader,* by taking a version of a traditional book plate and working the design around it. Mitchell makes FSG's new edition of *The Odyssey* into a contemporary statement by using background art that portrays the sea and hints at the voyage, while enhancing this image with lyrical type. "I wanted to convey something intangible, a tactile sensation here. I used tri-tone metallic inks on the cover and wanted to evoke subtleties under the surface," she says.

TYPE AND TYPOGRAPHY
Mitchell's approach to typographic treatments is integral to her total design. She plays type against image, as she does in *Foreign Brides* (short stories by Elaine Lappin). For *Learning Human* (poems by Les Murray), Mitchell says, "I wanted to get a sense of the

Right: Three versions of book jacket for
Personal Injuries by Scott Turow

DESIGN: SUSAN MITCHELL/FARRAR STRAUS & GIROUX
JACKET ART BY DANIEL LEE

Opposite below (from left to right):

Book jacket for *The Hours* by Michael
Cunningham

DESIGN: SUSAN MITCHELL/FARRAR STRAUS & GIROUX
JACKET ART BY ROSEANNE OLSON

Book jacket for *Foreign Brides* by
Elaine Lappin

DESIGN: SUSAN MITCHELL/FARRAR STRAUS & GIROUX
JACKET ART © RAY SPENCE/SPL/PHOTONICA

Book jacket for *The Odyssey* by Homer
translated by Robert Fitzgerald

DESIGN: SUSAN MITCHELL/FARRAR STRAUS & GIROUX
JACKET PHOTOGRAPH BY KENTARO NAKAMURA, EVENING
WAVE, CA, 1927. © HALLMARK PHOTOGRAPHIC COLLEC-
TION, HALLMARK CARDS, INC., KANSAS CITY, MISSOURI

architecture, layers for showing an
emerging species. I wanted to refer-
ence a deeper meaning, so the type is
built into five different layers reminis-
cent of the drawings of Da Vinci." Of
course, Mitchell is concerned about the
readability of the type, but also builds

in other factors like the onomatopoeia
(it sounds like what it looks like) of the
words. An example is *The Zig Zag Kid,* a
mystery by David Grossman, where the
word play is evident in the type in a vel-
lum overlay that creates a pattern with
the book ca▓▓ In her type treatments,

Mitchell talks about lilt and movement
in the placement of type, as well as
meaning and form.

Mitchell designs ideas based on text.
Her designs are an intelligent response
to often complex subjects. She manages
to convey not only a sense of the content

and some resonance of the writer's style,
but she also builds a tactile elegance, a
way of presenting books as objets d'art,
with her jacket designs. These are tex-
tural, intellectual, emotionally charged,
typographically sensitive images.

Stephen Farrell/Slipstudios

Above right: Contents page for *The Pannus Index*
(Vol. 2 No. 1)
VISUAL CONCEPT/DESIGN: STEPHEN FARRELL/SLIPSTUDIOS
SENIOR EDITOR: VINCENT BATOR

Above: Two spreads from "Farewell to Kilimanjaro"
in *The Pannus Index*
DESIGN: STEPHEN FARRELL/SLIPSTUDIOS. WRITER: STEVE TOMASULA

Opposite: Book jacket for *The Pannus Index*
VISUAL CONCEPT/DESIGN: STEPHEN FARRELL/SLIPSTUDIOS

STEPHEN FARRELL could be described as a type designer, a typographer, and a graphic designer, but these descriptions in no way capture the full extent of his impact on typographic design. Farrell is a virtuoso, with type as his instrument. He has managed through his close collaboration with writers and poets (most notably Steve Tomasula and Daniel X. O'Neill) to inspire and to expand a new genre that could be called literary typography. He talks about type as if it were a living presence: the "dramatis personae" on the page. For Farrell, working with type is like working with an actor developing a role, or a musician interpreting a new composition.

Working in collaboration to develop what Farrell calls "image-fictions, visual essays and language investigations" constitutes the chief focus of Farrell's Slipstudios, founded in 1992 and based in his bungalow in Chicago. Farrell describes the studio as "a multi-disciplinary design environment which fosters the creative interaction of writers and visual artists…. We treat the two main components of the studio—graphic literature and digital typography—as inseparable and essential for the creation and distribution of each."

This may sound esoteric, and it is. Many of Farrell's self-funded collaborations appear in literary journals, design journals, or exhibition catalogs, all of which are forums for critical discourse on language, image, and storytelling. Although this often means a brief appearance for each piece of work, Farrell, who takes no clients at Slipstudios, is committed to this arena of design. And it has brought him recognition and acknowledgment from his peers. In fact, he was one of the designers whose work was chosen for the recent Cooper-Hewitt, National Design Museum inaugural Triennial, "Design Culture Now." He explains, "I focused on tangent points between my most recent digital typeface, Volgare, and the unconscious event of handwriting." The exhibition work featured a "series of handmade books and wall texts which provided a 'font travelogue,' where individual letterforms can be inspected as constructed islands and sentences are fluid archipelagos," he says.

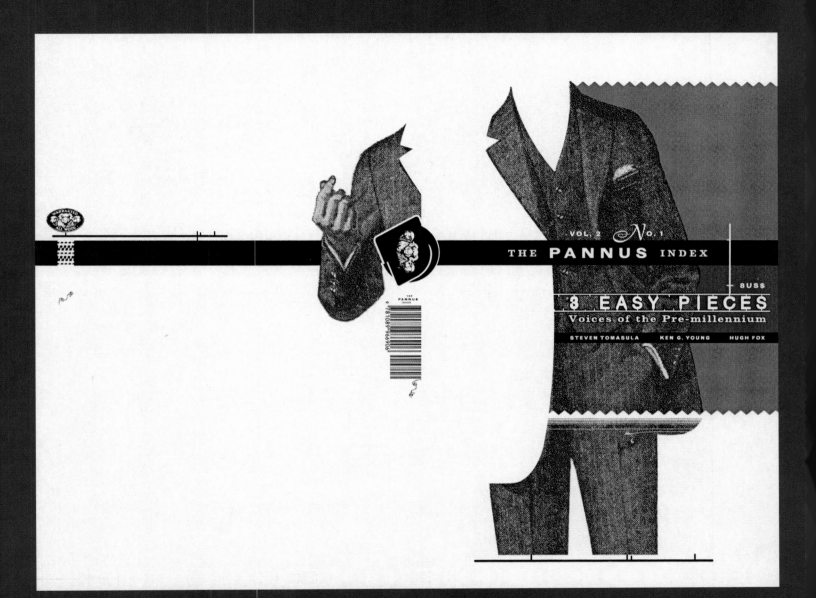

VOL. 2 No. 1

THE **PANNUS** INDEX

8US$

3 EASY PIECES
Voices of the Pre-millennium

STEVEN TOMASULA KEN G. YOUNG HUGH FOX

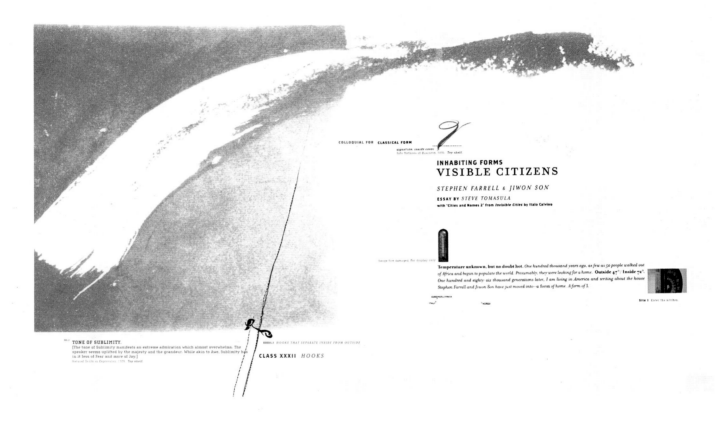

DESIGN PHILOSOPHY
For Farrell, his philosophy of design and his approach to aesthetics are the crucial rationales for everything he does. Admitting to what he calls "an obsessive methodology of cross-referencing, splicing, and grafting," Farrell explores type and language as "relay systems."

For example, Farrell's typographic "realization" of Steve Tomasula's "Farewell to Kilimanjaro" in the literary publication *The Pannus Index* incorporates what he describes as "indeterminacy of position, avant-garde Modern typography, and layout techniques."

TYPE AND TYPOGRAPHY
Farrell's theories on typography are well documented, including speeches and presentations he has given across the United States and abroad and his teaching at both The School of the Art Institute of Chicago and the Illinois Institute of Art. He bolsters his prem-

ises with examples from science, philosophy, cultural anthropology, history, and literature, as well as design theory, pop culture, and advertising. "My interest," he says, "is translating across disciplines, which both acknowledges and challenges the impulse to classify and establish boundaries."

TONE OF MEDITATION.
[The tone of Meditation is always linked with some other (usually Argument) and indicates to the listener self-communion. The speaker is subjective. He is thinking aloud.]
Natural Drills in Expression, 1909. Top shelf.

CLASS III *FLOOR BROOMS*

Have you ever had the experience of going through a stranger's old photos, maybe found in an attic, and seeing yourself in them? The familiar patterns are inherently recognizable; rituals of holidays; the group-shot to document, "We were here. Together." Yet at the same time there is something deflating in the commonness of our collective togetherness. We like to think of ourselves as radically unique, even if finite form—two legs, one head—means this can only be true with qualification. Our own family photos underscore how radically un-unique we are. There on Uncle Billy's face is my nose. Aunt Dodo has my hair. Skin color, surname, genetic tithes. The real surprise is in discovering that a form that is so intimate can be so invisible, even as it directs what we think, what we do—almost to the point of being destiny. As a male, for example, I will never be a mother, while two thirds of you who are reading this will die because of some genetic legacy you carry within, working its way to conclusion. Old homes are like that. Or as Italo Calvino puts it:

Gods of two species protect the city of Leandra. Both are too tiny to be seen and too numerous to be counted. One species stands at the doors of the houses, inside, next to the coatrack and the umbrella stand; in moves, they follow the families and install themselves in the new home at the consignment of the keys. The others stay in the kitchen, hiding by preference under pots or in the chimney flue or broom closet; they belong to the house, and when the family that has lived there goes away, they remain with the new tenants; perhaps they were already there before the house existed, among the weeds of the vacant lot, concealed in a rusty can; if the house is torn down and a huge block of fifty families is built in its place, they will be found, multiplied, in the kitchens of that many apartments. To distinguish the two species we will call the first one Penates and the other Lares.

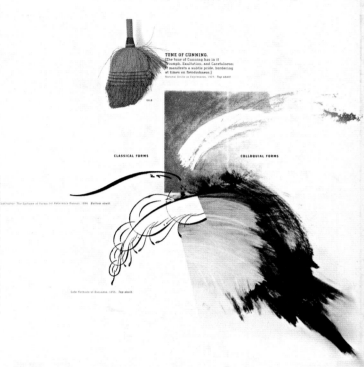

TONE OF CUNNING.
[The tone of Cunning has in it Triumph, Exultation, and Carefulness; it manifests a subtle pride, bordering at times on fiendishness.]
Natural Drills in Expression, 1909. Top shelf.

CLASSICAL FORMS

COLLOQUIAL FORMS

The Universal Self Instructor: The Epitome of Forms (or) Reference Manual, 1884. Bottom shelf.

Late Methods of Romance, 1856. Top shelf.

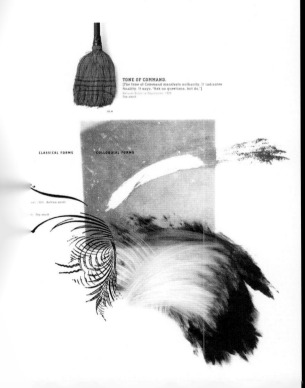

TONE OF COMMAND.
[The tone of Command manifests authority. It indicates finality. It says, "Ask no questions, but do."]
Natural Drills in Expression, 1909. Top shelf.

CLASSICAL FORMS

COLLOQUIAL FORMS

1884. Bottom shelf.

Top shelf.

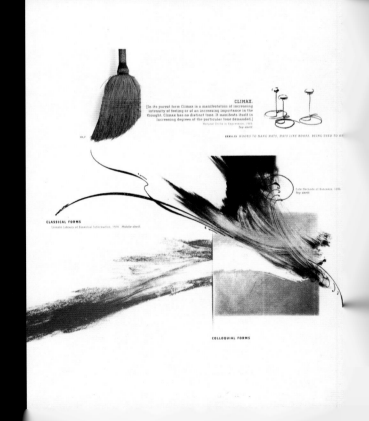

CLIMAX.
[In its purest form Climax is a manifestation of increasing intensity of feeling or at an increasing importance in the thought. Climax has no distinct tone. It manifests itself in increasing degrees of the particular tone demanded.]
Natural Drills in Expression, 1909. Top shelf.

XXXII.12. *HOOKS TO HANG HATS, HATS LIKE ROOFS, BEING USED TO RE...*

CLASSICAL FORMS
Lincoln Library of Essential Information, 1924. Middle shelf.

Late Methods of Romance, 1856. Top shelf.

COLLOQUIAL FORMS

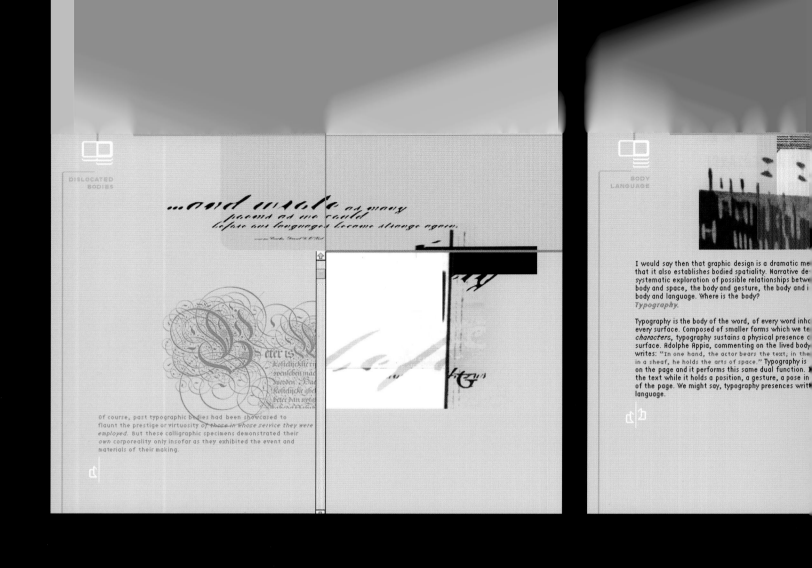

Of course, past typographic bodies had been showcased to
flaunt the prestige or virtuosity *of those in whose service they were
employed.* But these calligraphic specimens demonstrated their
own corporeality only insofar as they exhibited the event and
materials of their making.

I would say then that graphic design is a dramatic me...
that it also establishes bodied spatiality. Narrative de...
systematic exploration of possible relationships betwe...
body and space, the body and gesture, the body and i...
body and language. Where is the body?
Typography.

Typography is the body of the word, of every word inhe...
every surface. Composed of smaller forms which we te...
characters, typography sustains a physical presence c...
surface. Adolphe Appia, commenting on the lived body...
writes: "In one hand, the actor bears the text, in the...
in a sheaf, he holds the arts of space." Typography is...
on the page and it performs this same dual function. ...
the text while it holds a position, a gesture, a pose in...
of the page. We might say, typography presences writ...
language.

Those who may not have seen
Farrell's work in literary journals or
Emigre magazine or at the "Design
Culture Now" exhibition, may know him
best as a type designer. Since 1994,
Farrell has been scrutinizing handwrit-
ing from historical periods. Farrell says

that he became interested in the warmth
and humanity of what had been produced
by an actual person's hand. From this he
says, "I cautiously pursued its transla-
tion into a digital medium. I was inter-
ested in answering these questions:
'What does it mean to place handwrit-

ing outside the act of creation?' Sud-
denly, the living hand embedded in the
marks of handwriting is unlinked from
a particular body and a particular event
of writing. Might the digital medium
offer to a handwriting performance its
eternal return?"

One of the most striking examples he
found was "an original Florentine death
record dated 1601, which I discovered at
the Newberry Library in Chicago." This
manuscript, "penned by an anonymous
clerk," inspired Farrell to "start working
on a typeface based on that 'hand.'"

To write *my body*

A reader's plunge into the siren surface is not without risk. Shipwrecks in a surface too shallow or too impenetrable are dangers of heeding the call, of spending time with a work whose worth has only a sketchy physiognomy. But with these potential losses come the gains of a qualitative discourse at the visceral level, a subjective edge with language. Adrienne Rich says:

"When I write 'THE BODY' I see nothing in particular. To write 'MY BODY' plunges me into lived experience, particularity: I see scars, disfigurements, discolorations, damages, losses, as well as what pleases me."

SLIP STUDIOS
CDO **2 MULTIMEDIA TRACTS** *1997-1999*

4421 NORTH FRANCISCO AVENUE CHICAGO, USA 60625 SlipStudios@compuserve.com

CDO

WHY IS IT WORSE TO SAY AN ANGLE IS COLD : BODY LANGUAGE IN THE PAPER THEATER
AND A CURVE WARM ?

Macintosh/PC platforms.
Requires 132MHz PowerPC or Pentium.
Mac OS 7.5 or Windows 95/98, or later, 32mb free ram.
x8 speed cd-rom drive and monitor set to millions of colors.
Preferred monitor resolution: 1024 x 768 pixels.
Minimum: 832 x 624 pixels.

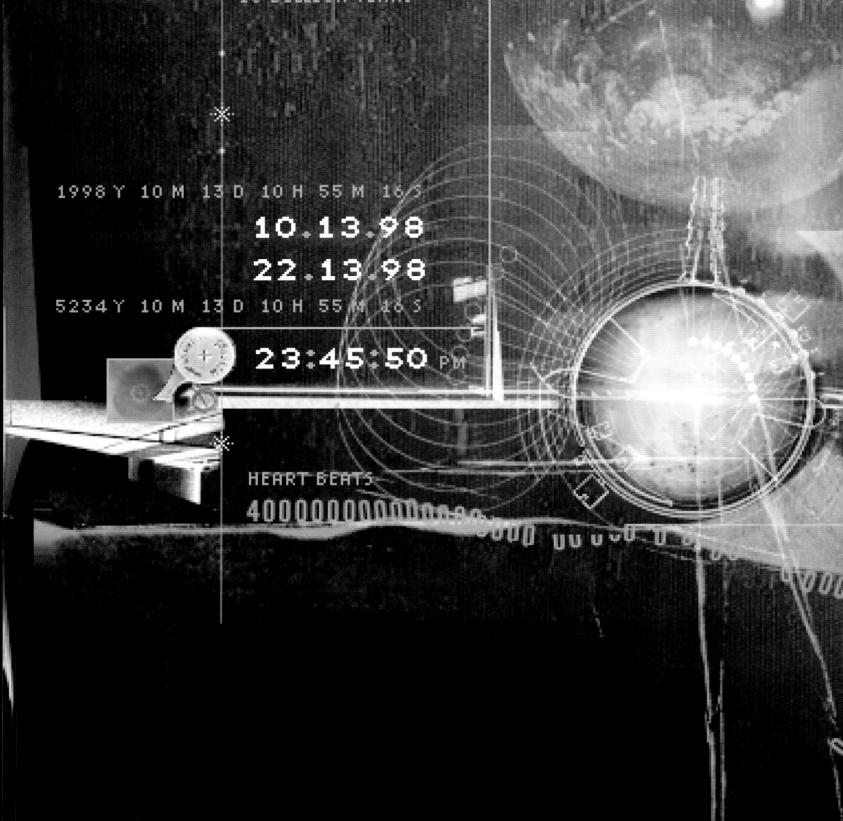

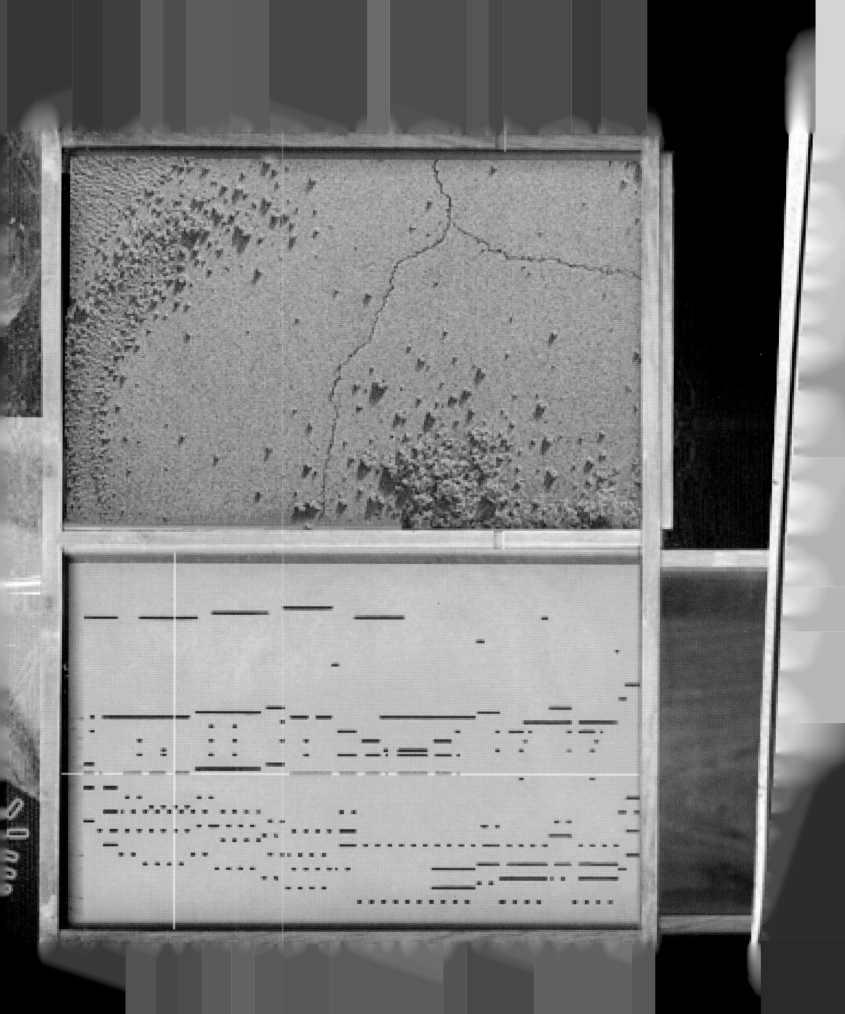

1234567890
ABCDE
FGHIJKL
MNOPQRSTUVW
XYZ
abcdefghijkl
mnopqrstu
vwxyz

Indelible Victorian

Eventually Farrell had over 500 characters, including variations of each letterform, ligature, and terminal, all of which, he says, "allowed for a more convincing simulation of the varied marks of actual handwriting." The resulting typeface, Volgare, has elegance, fluidity, and a historical flavor, as well as a sensitivity of interpretation based on the original handwriting. Since its release, Volgare has become a collector's item. What Farrell says he most enjoys is "seeing Volgare employed by a wide variety of typographers for a wide variety of uses."

Farrell also adds the context that this typeface keeps that original penman alive: "We are commonally reconstituting the identity of that anonymous individual, making him say things he never dreamed in languages he never knew."

Some of Farrell's other type designs include Flexure and Indelible Victorian.

Volgare Proclamation

I Here lie Volgare,
 wrought from the hand of X,
 birthed inside a type designer's studio,
 and being only the latest product
 in a long line of American things
 fashioned from the raw material of Europe.

II Thinkers and writers:
 Take and patch these marks onto your own speech.
 Receive and place this set of characters,
 forever re-written,
 living as endless words-in-waiting,
 an infinite event yanked from a
 hundred unconscious moments in the life of a skeletal clerk.
 May the automatic feeling of Diction be with you always.

SLIP———, 773.989.0460 DXO

Fred Woodward / Rolling Stone

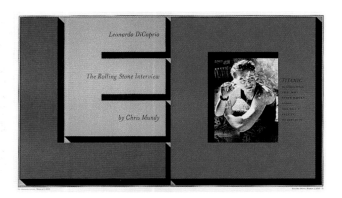

**Above: Spread for *Rolling Stone*
interview with Leonardo DiCaprio**

ART DIRECTION: FRED WOODWARD. DESIGN:
FRED WOODWARD, SIUNG TJIA. PHOTOGRAPHY:
MARK SELIGER

**Spread for *Rolling Stone* interview
with Ricky Martin**

ART DIRECTION: FRED WOODWARD. DESIGN:
FRED WOODWARD, GAIL ANDERSON. PHOTOG-
RAPHY: DAVID LACHAPELLE

**Opposite: Spread for *Rolling Stone*
feature on Sarah Michelle Gellar**

ART DIRECTION: FRED WOODWARD. DESIGN:
FRED WOODWARD, GAIL ANDERSON. PHOTOG-
RAPHY: MARK SELIGER

ROLLING STONE is a magazine with roots in 1970s counterculture that grew up to be the establishment entertainment magazine. Noted for its music-insider editorial perspective and its street-smarts in matching writer with subject (novelist David Foster Wallace writes on then-presidential candidate John McCain, for example), what also sets *Rolling Stone* apart is its design bravado.

To most designers, *Rolling Stone* art director Fred Woodward is a hero. For 13 years, Woodward has risen to the challenge of creating savvy, insightful editorial interpretations of every star on the planet. Although these are the same celebs who appear in every magazine, in *Rolling Stone,* they get the stellar treatment they deserve.

Working closely with exceptional photographers (such as Mark Seliger, Albert Watson, David LaChapelle) and a host of remarkable illustrators, Fred Woodward and his design team combine image, headline treatment, and text ingeniously. Especially notable in the *Rolling Stone* interviews, the designs project a persona rather than a personality. The synergy of subject and presentation is seamless. In design terms, Woodward and his collaborators have forged contemporary editorial design classics.

For example, the design for an interview with Leonardo DiCaprio has a Bauhaus flavor, with brightly colored blocks spelling out "Leo." The design transforms the teen idol into a pop icon. For Al Pacino, the actor's name spelled out in a bowl of alphabet soup contrasts with a moody photograph of the actor on the opposite page, thus capturing both familiarity and mystery. If there is a secret to the Woodward success, it is the sheer joy of finding the right gestalt for each subject.

BY JANCEE DUNN It's all well and good that the Getty Museum, in Los Angeles, has paintings by Degas and stuff, but today there is a much more exciting exhibit: Sarah Michelle Gellar is here! Where the hell's the camera?

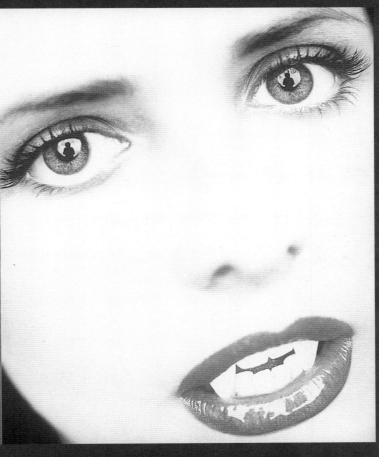

Love At First Bite

S Michelle A R A GELLAR H

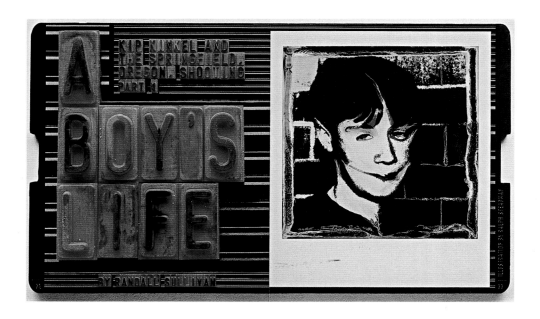

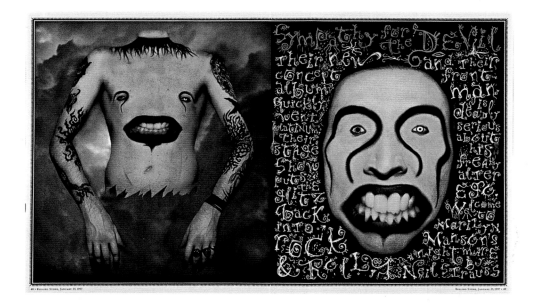

Acknowledged as typographically brilliant by every major design and typographic organization, Woodward conceives type treatments that capture mood as well as personality. In his working of Eddie van Halen's name, he creates a pyramid of type. For Ricky Martin, the name is imbedded in a type puzzle. For a feature on Crosby, Stills, Nash, and (sometimes) Young, the individuality of each, as well as their collaboration, is captured in poster-like pages. (For this layout, a *Rolling Stone* reader wrote, "I loved the photo intro—a very powerful graphic to those of us who were there when it all began.")

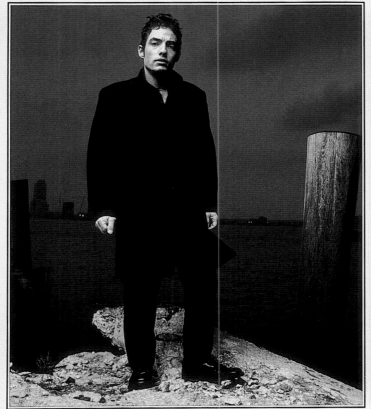

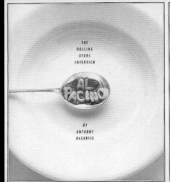

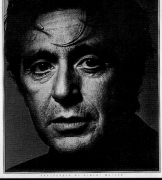

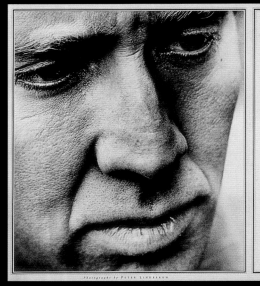

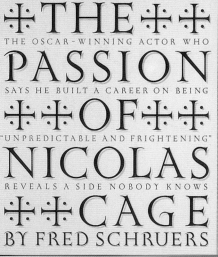

✠ THE ✠✠
THE OSCAR-WINNING ACTOR WHO
PASSION
SAYS HE BUILT A CAREER ON BEING
✠✠ OF ✠✠
"UNPREDICTABLE AND FRIGHTENING"
NICOLAS
REVEALS A SIDE NOBODY KNOWS
✠✠ CAGE
BY FRED SCHRUERS

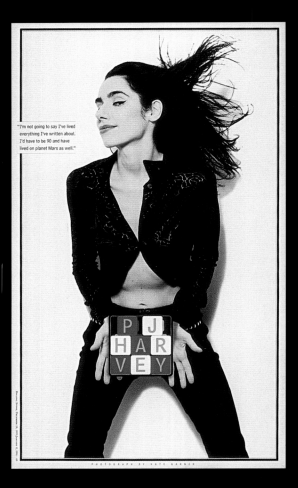

"I'm not going to say I've lived everything I've written about. I'd have to be 90 and have lived on planet Mars as well."

Above, clockwise from left to right: Spread for *Rolling Stone* interview with Al Pacino

ART DIRECTION: FRED WOODWARD. DESIGN: FRED WOODWARD, GAIL ANDERSON. PHOTOGRAPHY: ALBERT WATSON

Page for *Rolling Stone* interview with PJ Harvey

ART DIRECTION: FRED WOODWARD. DESIGN: FRED WOODWARD, GAIL ANDERSON. PHOTOGRAPHY: KATE GARNER

Spread for *Rolling Stone* interview with Nicholas Cage

ART DIRECTION: FRED WOODWARD. DESIGN: FRED WOODWARD, GAIL ANDERSON. PHOTOGRAPHY: PETER LINDBERGH

Opposite top: Spread for *Rolling Stone* feature on REM

ART DIRECTION: FRED WOODWARD. DESIGN: FRED WOODWARD, GERALDINE HESSLER PHOTOGRAPHY: ANTON CORBIJN

Below: Spread for *Rolling Stone* interview with Jack Nicholson

ART DIRECTION: FRED WOODWARD DESIGN: GAIL ANDERSON. PHOTOGRAPHY: ALBERT WATSON

R

EM

MORE SONGS about DEATH and ANXIETY...REMARKS Concerning BiLL CLINTON, psychedelic DRUGS And the SAD DECLINE OF the '60s GENERATION...the MYSTERIOUS CASE of the DISAPPEARING manager... and SOMe PERTINENT FACTS about TODAY'S R.e.M. by CHRIS HEATH

ROLLING STONE · 52 · October 17, 1996

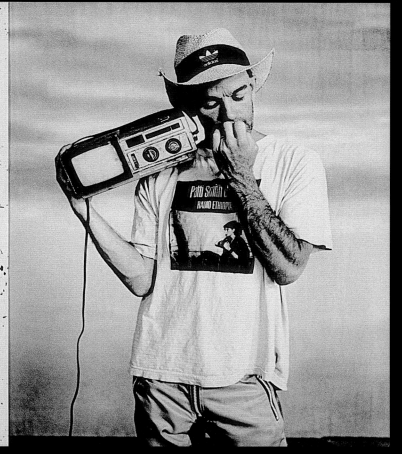

Two spreads for *Rolling Stone*
feature on Ben Stiller
ART DIRECTION: FRED WOODWARD. DESIGN:
FRED WOODWARD, HANNAH MCCAUGHEY
PHOTOGRAPHY: MARK SELIGER

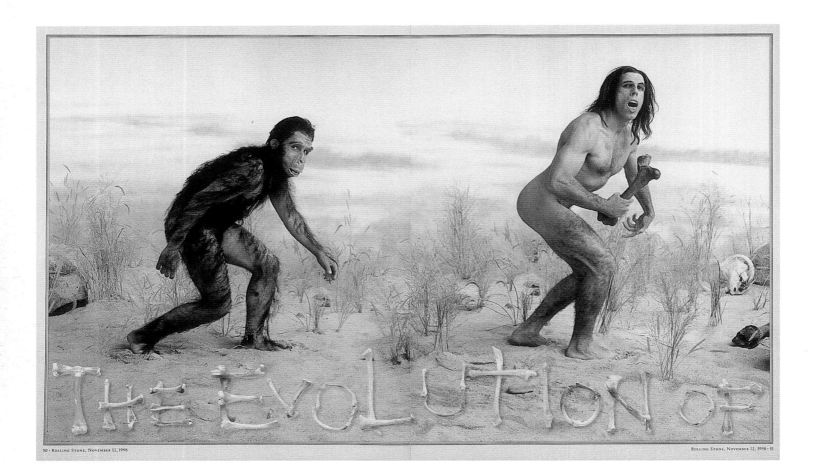

50 · ROLLING STONE, NOVEMBER 12, 1998

ROLLING STONE, NOVEMBER 12, 1998 · 51

Although Woodward also directs music videos and is feverishly designing books, these are extensions of his key role at *Rolling Stone.*

Fred Woodward is genuinely shy and eschews being in the spotlight himself.

Along the way, Woodward has accrued more national and international design awards for the magazine than any other publication. He seems quietly surprised at the consistent attention and kudos he has received.

As Woodward expressed it in a rare interview with Peter Hall, art directing *Rolling Stone* "is a blue collar job. It burns up ideas and you just have to keep feeding it." Many see the talents of Fred Woodward in terms of innova-

tive genius, but Woodward is more likely to pass these talents off as coming with the job. And that job has allowed him to create editorial displays that are instinctive, intuitive, and visually intelligent.

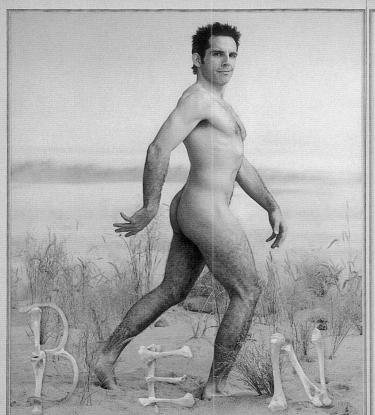

HIS JOURNEY

FROM NERDY NEW YORK KID
TO HIP HOLLYWOOD ROYALTY PROVES

THERE'S SOMETHING ABOUT BEN STILLER

by Chris Mundy

BEN STILLER'S LOS ANGELES apartment is striking for a number of reasons (the penthouse deck with a view of the Wilshire Country Club springs to mind), but what stands out most is why he feels at home there. "What I really like," says Stiller as he shows you around, "is that it feels like a New York apartment."

He's right. Much like Stiller himself, the home seems slightly out of place in the high glare of Hollywood, more subdued, the kind of space as likely to have the curtains drawn as it is to have the sun pouring in.

Stiller points out the hardwood floors, the Twenties-style kitchen, the original moldings. In the large main room of the duplex's bottom floor, there is a collection of black-and-white photographs, nothing else – like a SoHo gallery space.

As he gives the tour, Stiller is warm; yet, for someone who has made his mark in comedy, he does not strike you as the casual sort. He is unfailingly polite; he is friendly; but there is also a quiet intensity and a nervousness that seeps into the air around him. You like him. You just wouldn't call him to entertain at a child's birthday party.

"I've never really felt like a funny, funny guy," says Stiller as we make our way to the deck. "I've never really felt like Mr. Life of the Party. People who know me know that I'm not the most gregarious person. I'm trying to open myself up more. I've realized in the last few years that my state of mind affects how I live my life."

Stiller's mind these days must be in a dizzy state – a career high induced by the sheer goofiness and phenomenal success of *There's Something About Mary*. Stiller has always been one of the most versatile talents of his generation: an Emmy-winning writer (for *The Ben Stiller Show*); a director of major stars in major motion pictures (Winona Ryder in *Reality Bites*, Jim Carrey in *The Cable Guy*); and a steadily employed actor drawn to small, intriguing comedies such as *Flirting With Disaster*, *Zero Effect* and the controversial *Your Friends and Neighbors*. But rarely have the heavens been better aligned for a performer than they are now for Stiller. First comes *There's Something About Mary*, the summer comedy that won't quit even deep into the fall and the kind of colossal hit that every star needs. At the same time, Stiller nails a performance as a junkie TV writer in *Permanent Midnight* that most serious actors wait a lifetime to deliver. After a career spent working diligently, Stiller has finally hit the big time by shooting dope, donning braces and getting his penis caught in his zipper.

But then, the map of Stiller's world has always been drawn with blurry borders between reality and pop-culture fantasy. As a child, he was taught to swim, in Las Vegas, by the Pips; he watched home movies of Rodney Dangerfield holding him when he was an infant; Stiller even had the Swami Satchidananda borrow his skateboard outside the Stillers' apartment building, on Riverside Drive in New York. When one of the Beatles' robed gurus of choice borrows your skateboard, it's tough to talk about a normal childhood with a straight face.

Stiller's parents, Jerry Stiller and Anne Meara, are a veteran comedy duo and were thirty-two-time guests on *The Ed Sullivan Show*. (Today, Dad is best known as Frank Costanza on *Seinfeld*, and Mom from movies like *The Daytrippers*.) The pair often traveled for work, leaving Ben and his older sister, Amy, alone. Upset that show business had taken their parents out of town, the two would fill the void with show business. Not surprisingly, both are now actors. From the moment Ben began to look at the world around him, he has been building his body of work.

"Ben and Amy did a lot of films together," says Anne Meara. "They would do show tunes and do our act. We weren't there a lot, and I think that was painful for them."

"But we didn't want to go to L.A.," says Jerry. "We thought a bigger danger was growing up in a community where the neighbors were all stars and the kids were in competition with their parents' roles."

The irony is that while his parents agonized over whether to live in New York or Los Angeles, Stiller was learning to exist in the entertainment industry. Today, at thirty-two, Stiller lives comfortably in all three.

SCENE 2 – AS STILLER lounges on his deck in L.A., he tips back in his chair and tries to make some sense of it all. He has spent a great deal of time in therapy – "I haven't been going for about a year, but I actually really like it," he says – and his approach to answers often seems rooted in those sessions.

"I'm working on that whole happiness-balance issue in life," says Stiller. "I think you're always working on that. I tend to lean more toward the work side of life. It's important to find happiness outside of your work."

Yet, if you listen to the people who know him best, you wonder how precarious that balance really is.

His friend (and *Permanent Midnight* memoirist) Jerry Stahl: "I've never seen anybody put in the sheer man hours Ben does. Being a forty-five-year-old guy with a liver that lives in an adjoining county, I sure as hell can't keep up. It's amazing."

His father: "He works much too hard, for my money. I just wish he would take a rest."

His friend and frequent collaborator Janeane Garofalo: "He works harder than anyone I know. He never, ever, ever is not working. It's actually bizarre."

Not that Stiller seems unhappy. On the contrary, as he sits on his deck, feet propped up, Stiller is content, almost unable to imagine another way of life. It's as if because film was his source of pleasure as a child, his work and life have morphed into one. Still, it's difficult to understand what drives him.

"As a kid, I was just fascinated by the mechanics of filmmaking," says Stiller. "I thought I was going to be a cinematographer for a while. The idea of making movies was so much fun. Then, as I got older, acting and writing and the content became more important."

The question is rephrased. His fascination with film is a well-known fact; but what drives Stiller personally?

"In terms of what I've kept on doing," he says, "I've rarely stopped and stepped back."

SCENE 3 – STILLER'S FIRST films were highly derivative. Based mostly on his favorite television shows and on movies like *Airport 1975*, they articulated his obsession with popular culture yet displayed little vision of his own. Of course, he was barely a teenager. But still. His seminal work had actually blossomed earlier – when he was able to locate his demons.

He found them on Eighty-fourth Street in Manhattan.

Stiller's apartment was on Riverside Drive; his best friend lived on Central Park West; in between was Brandeis High School. "Those four or five blocks were like a gauntlet," remembers Stiller. "I used to live in fear of those Brandeis kids."

"One day he was mugged twice, once on the East Side and once on the West Side," says Jerry Stiller. He laughs. "And once they came back and said, 'We don't like this watch.'"

All this helped young Ben evolve a personal style of film. "One guy would get mugged and then we'd run after them through Riverside Park," recalls Stiller of his earliest works. "They all had names like *They Called It Murder* and *Murder in the Park*."

As Stiller's adult career blossomed, it followed a similar path – *The Ben Stiller Show* showcased his ability to ape his favorite movies before homing in on his darker depths. Yet Stiller's range almost never came to light. Perhaps having missed his dramatic turn in *They Called It Murder*, the producers of *Permanent Midnight* first offered Stiller's role to David Duchovny and (no, this is not a typo) Jon Bon Jovi. Even Stiller had his doubts.

"The biggest challenge was convincing myself that I was allowed to play that part," Stiller says. "I was fascinated by it. There were a lot of similarities as far as Jerry Stahl as a person – this Jewish comedy writer in L.A."

Based on Stahl's autobiography of his descent into the hells of heroin and Hollywood, the film is as relentless as any in recent memory, and Stiller – who barely ate during the course of filming – is riveting.

"Meeting Jerry and talking about this role really changed me as a person," says Stiller. "The key for me was that he showed me I didn't have to be a drug addict to understand why addicts take drugs – it's about not wanting to feel pain. I figured out what I did in my

> "I've never really felt like a funny, funny guy.
> *like Mr. Life of the Party," says Stiller.*
> HE IS UNFAILINGLY POLITE; HE IS FRIENDLY;
> BUT THERE IS ALSO A QUIET INTENSITY AND A NERVOUSNESS
> *that seeps into the air around him.*

Louise Fili

THE WORK of distinguished designer Louise Fili is characterized by its elegance. Fili brings an ethereal quality to her designs based on an inherent sensitivity to the subject and exquisite type treatments. Fili began honing her craft with her work as a senior designer with the legendary typographer/designer Herb Lubalin. She then went to Pantheon Books, where she designed over 2000 book jackets. The most instantly familiar Fili design for Pantheon was the jacket for *The Lover,* the novel by Marguerite Duras, which, with its softened image, subtle color, and evocative type, has become a classic of contemporary design. The recipient of awards from every major design competition, and with work in the permanent collections of the Library of Congress, The Cooper Hewitt Museum, and the Musee des Arts Decoratifs, Fili opened her own studio in 1989.

Her firm, Louise Fili Ltd., specializes in logo, package, restaurant, type, book, and book jacket design. Fili says, "I have two assistants in the studio, and would never want to get any bigger. Since I am very much a hands-on designer, keeping it this size allows me creative control and limits my work to what I am interested in: food, type, or Italy." She adds, "I do not, and probably never will, design on a computer (although, of course, I rely on my staff to be more current)."

From her office in an area filled with design studios on Fifth Avenue, Fili reports that her windows face the Empire State Building. "I love to watch the play of light and color during the day, which inspired me to set up a tripod to document it." She also says, "Manhattan for me is a small town. My home is four blocks away from my office, and many of my clients (mostly restaurants) are in the neighborhood, so I always have a table."

Above: Book jacket for *Typology: Type Design from the Victorian Era to the Digital Age*
ART DIRECTION/DESIGN: LOUISE FILI
WRITERS: STEVEN HELLER/LOUISE FILI

Opposite: Cover for *Belles Lettres: an Arts and Crafts Writing Tablet*
ART DIRECTION/DESIGN: LOUISE FILI

Book jacket for *Streamline*
ART DIRECTION/DESIGN: LOUISE FILI
WRITERS: STEVEN HELLER/LOUISE FILI

BELLES

AN ARTS AND CRAFTS WRITING TABLET

LETTRES

STEVEN HELLER & LOUISE FILI

AMERICAN ART DECO GRAPHIC DESIGN

Streamline

Te xt
copy right
© 1998 by J. Patrick
Lewis. Illustrations
copyright © 1998
by Gary Kelley. All
rights reserved. No
part of this publication
may be reproduced or trans-
mitted in any form or by any
means, electronic or mechanical,
including photocopy, recording,
or any information storage and
retrieval system, without
permission in writing from the
publisher. Requests for permission
to make copies of any part of the
work should be mailed to: Permissions
Department, Harcourt Brace & Co.,
6277 Sea Harbor Drive, Orlando, FL
32887-6777. *Creative Editions* is an
imprint of The Creative Company,
123 South Broad Street,
Mankato, Minnesota.
56001.
Library
of Congress
Catalog
Card
Number:
98-8-
4158.
First
Edition
A C E
F D B

With co-author (and husband) Steven
Heller, Fili has collaborated on a series of
books on periods and styles of designs
that are invaluable interpretive refer-
ences to historical milestones in design.
Since Fili and Heller have vast collections
of design memorabilia, these books are
both homage to what has gone before
and labors of love. The series, published
by Chronicle Books, includes *Italian Art
Deco, Dutch Moderne, Streamline, Cover
Story, British Modern, Deco Espana,
German Modern, French Modern*, and
Typology. The book jackets designed
for the series by Fili capture each style,
mood, and nuance and embody the his-
torical knowledge and passionate inter-
ests of the collaborators.

DESIGN PHILOSOPHY
Reverence for the subject and an enlight-
ened sensitivity in response to each
project's unique character are evident
in Fili's work. Fili's designs resound with
her vast insights and perfection of tech-
nique. These qualities make Fili designs
seamless and timeless. Fili seems to de-
sign from the inside out. Her designs

st. Much of this has to do with the
tense process of creating logos and
the treatments that gives each project
raison d'être.

PE AND TYPOGRAPHY
says "Type is of the utmost impor-

tance. When we do a logo, for example,
the type we use is either scanned in
from old type books and reworked, or
completely made from scratch, or else
we start with a computer font and ma-
nipulate it. In any case, once the type
is settled, it still needs to be re-

and
Gri
Ma
the
be
ser

her personal work, which gives her the freedom to explore and interpret her own obsessions. She explains, "Although I am very happy to do the work that comes my way, I always make a point of pursuing my own personal projects. And once a year or so, we do a limited edition letterpress promotional book for the studio." These, including her *Copyright Pages* and her *More Logos A to Z*, are indicative of her commitment to and passion for type.

Fili is now at work on another labor of love. She is writing and designing a designer's guide to Italy, which will be a promotional series for a printer.

Louise Fili's work is more than design: it is inspired art that designers respect, covet, and collect.

Neville Brody/Research Studios

Above: Design for *Interview* magazine dedicated to Tibor
Kalman (Subtext: Hey Tibor, you know, you changed a lot
of things for a lot of people)
DESIGN: NEVILLE BRODY

Opposite: Poster for Fuse 15, Cities, published by
FontShop International, 1997
ART DIRECTION/DESIGN: NEVILLE BRODY

NEVILLE BRODY has been a star in the design firmament since
his meteoric rise as the designer of *The Face* magazine in London
in the early 1980s. Since then Brody has expanded his prolific
repertoire of work to include not only print but Web design, pack-
aging, and advertising for which he has consistently won awards
and provoked endless controversy. Brody works out of Research
Studios, based in glass-brick, Deco offices (which he describes as
a cross between Bauhaus and Miami Beach) in London. He also
commutes to the Research Studios satellite office in Paris and,
when he is not flying off to all points on the map, is setting up
another in San Francisco.

The name Research Studios alludes to Brody's rationale in his
work: each project is a virtual case study in research and develop-
ment in the service of a client. What the client also expects from
Neville Brody is the unexpected, the revolutionary, and the evolu-
tionary. Neville Brody is known for mercurial intelligence, formi-
dable technique, and conceptual integrity. His work can be as for-
mal as the identity for Macromedia and the packaging for a suite
of Macromedia software products, or he can obsessively attack a
concept, as seen in the variations of posters designed for the 1998
San Francisco Fuse conference.

Fuse is crucial to Brody's thinking process. *Fuse* originated as
a CD-ROM experimental magazine, a fusion of type as both medi-
um and message. Each *Fuse* CD-ROM issued has explored themes
for which designers were asked to create typefaces that explored
both form and content, centering around ideas like "disinforma-
tion." Using *Fuse* as a vehicle, Brody, his long-time collaborator
Jon Wozencroft, and the contributors to the magazine changed
the parameters of type design from commodity (type designed to
be sold as a font) to a responsive, interpretive dialogue where type
is both the expression and the form of the content.

Research Studios is currently ready to release *Fuse 18* (with
Fuse 19 and *20* in preparation).

The future city
transcends the
city limits.
Urban activity
takes place
indoors. The
streets,
once ablaze, fall
quiet, but not
dim. The voice
becomes a touch.

FUSE15CITIES CITIES

fuse 15 cities features twelve experimental typefaces plus five posters by
paul elliman tobias frere-jones peter saville and frank heine
distributed exclusively through the fontshop network

Below: Poster using Fuse fonts designed
by Brody to accompany the Thames and
Hudson limited edition boxed set of *The
Graphic Language of Neville Brody*, and
The Graphic Language of Neville Brody 2
DESIGN: NEVILLE BRODY

Below right: Identity and packaging for
Macromedia
ART DIRECTION/DESIGN: NEVILLE BRODY. IMAGES
PRODUCED IN CONJUNCTION WITH ROBERT KIRK
WILKINSON, ALYSON WALLER, SIMON GRIFFIN, JOHN
McGILL/RESEARCH STUDIOS

And *Fuse* generated another forum
for Brody. When the concept of experimenting with type through the magazine became the subject of a conference
in London in 1994, he expanded his role
as a designer at the forefront of experimentation to include leading a theoretical onslaught on contemporary design
thinking. The Fuse conference explored
a philosophy developed to respond to an
entirely new era in design. At subsequent
Fuse conferences, Brody continued to establish new paradigms for design and to
generate a response to the impact of
design on society that placed the role of
design and related fields in global, technological, and societal contexts. In keeping with the intention to shatter conventional design thinking, Brody and his collaborators are planning the next Fuse
conference for New York in 2001.

PHILOSOPHY OF DESIGN
Distilling some of the ideas that
emerged both from his involvement
in Fuse and the aftermath of the Fuse
conferences, in a recent speech in Tel
Aviv Brody posited that design is
"at a critical juncture in the world

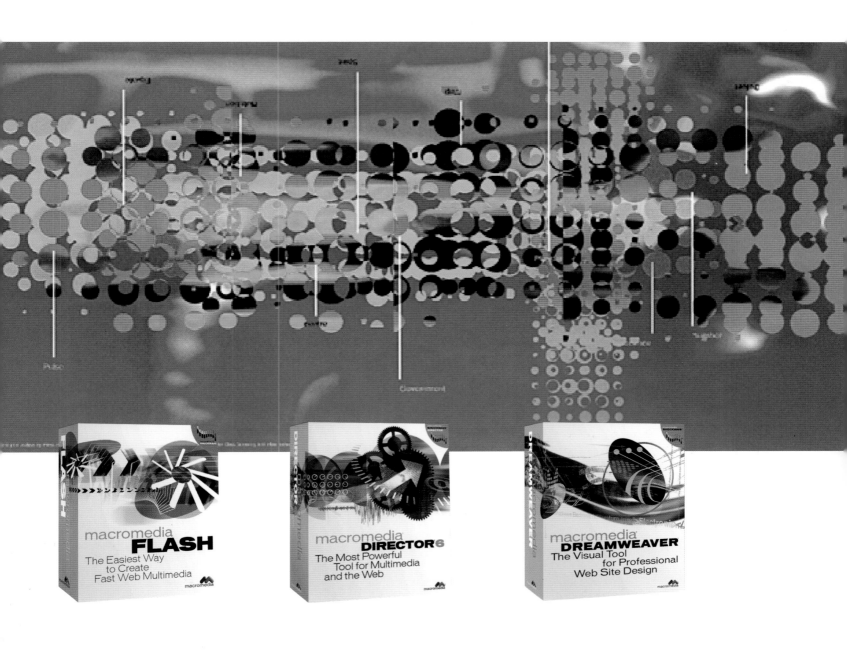

of communications." He warns that the entire design industry must redefine its role in this accelerated technological environment. Noting that because millions of messages daily compete for attention, the role of a designer, he feels, needs to evolve both in theory and practice. Brody advocates more than an immediate and frenzied response to the current sensory overload. Instead, he says, designers need to go more deeply into how the role of design has changed to define their individual responses.

Brody insists that designers can only move forward by jettisoning old models of behavior. He challenges designers to formulate a more human, catalytic role. He believes that the core of any message is based on language and cultural context. Relating how designers transmit these messages, Brody says, "As visual communicators, we are the elected translators of invisible ideas into tangible form. We have been handed the responsibility to formulate these messages. Our output becomes someone else's input. We take abstract, invisible

Series of poster designs for Fuse Conference
in San Francisco, 1998. Event organized in
conjunction with Research Studios, FontShop
International, and Meta San Francisco
ART DIRECTION/DESIGN: NEVILLE BRODY

concepts such as emotions, directions, drives, desires, needs, and hopes and give them solidity. In the translation process, in the transferal of matter from invisible to visible form, we inevitably invoke a subjective process. Our interpretation becomes part of the form. We

are imbued with such a high degree of trust because the power of the tools we have access to in order to manipulate desire is terrifying."

To support this message, Brody elaborates on the role of type.

TYPE AND TYPOGRAPHY

For Brody, type choice in design should not become merely "one of the tricks we use from our visual toolbox." Brody reflects ironically that "we are more concerned with the choice of typeface than the choice of text." In Brody's

thinking, typefaces can influence content but not always as an integral part of the message a designer conveys. He points out that a typeface per se is not only highly visible as a design element but that each has its own cultural resonance and proscribed identity. Keeping

FUSE 8 BEYOND TYPOGRAPHY

SAN FRANCISCO MAY 27-29 1998

FUSE98:
CONFERENCE
BEYOND
TYPOGRAPHY
SANFRANCISCO MAY 27-29 1998
INSTALLATION
TOWARDS
THE NEW
BODY
ELECTRIC

FUSE98:BEYONDTYPOGRAPHY

SANFRANCISCOMAY27-291998

Further poster exploration for Fuse 98
Conference. Event organized in conjunc-
tion with Research Studios, FontShop
International, and Meta San Francisco
ART DIRECTION/DESIGN: NEVILLE BRODY

FUSE98 : BEYOND TYPOGRAPHY : TOWARD

THE NEW BODY ELECTRIC : **THE VITAL DESIGN EVENT OF THE YEAR**

Petr van Blokland

г *LIGHT* Light *Light* LIGH

.84756 1023456789102293

м *MEDIUM* Medium *Medium* MEDIU

7561029384

к *BOOK* Book *Book* BOO

D *SEMIBOLD* SemiBold *SemiBold* SEMIBO

> *BOLD* Bold *Bold* BOL

må Pröfør

HT UltraLight UltraLight *UltraLight* ULTRALIG

What is the use of a new t
There are so many already

THIS EXCLAMATION IS based on the misconception th
typefaces are not being designed but that they are ju
The necessity of designing new typefaces has increas
necessarily considering the speeding technological
advancement. A typeface that is designed for station
not applicable for displays; a typeface that is meant f
black and white does not work well in a high color r
The techniques behind the typeface are developing
continuously.
 Ten years ago *Petr van Blokland* designed the typel
PROFORMA, a valuable addition to existing typefaces

**Above: Sampling of Petr van Blokland's Proforma
typeface distributed by Font Bureau**
DESIGN/TYPE DESIGN: PETR VAN BLOKLAND

**Opposite: Examples of Studio work from Buro Petr
van Blokland + Claudia Mens from a corporate Power-
Point presentation. Clockwise from left: Proforma
typeface, Deforma typeface, images for Icim corporate
identity, the corporate identity for United Notions**
DESIGN: PETR VAN BLOKLAND

BURO PETR VAN BLOKLAND + CLAUDIA MENS is idyllically located on a canal in Delft, The Netherlands. Both Petr van Blokland and Claudia Mens run their businesses there and both teach at The Royal Academy of Art and Design in The Hague. Mens is an interior and environmental design consultant. Van Blokland is a graphic designer and type designer.

Van Blokland's clients include international businesses. Often his task is to take a sprawling network of complex content and unify it into coherent context. Not only does Van Blokland devise a system of integrated graphics, but he also creates or refines an identity for each corporation.

This designer's working method is unique: complicated systems of graphic information are electronically controlled from his studio. After consulting with clients as to their specific needs, Van Blokland sets up a working procedure (using Python, Zope, and other programming tools), so that he can provide templates for each area of design: from corporate identity to every kind of printed collateral (stationery, brochures, public relations releases) to signage and Web sites. The focus is coherence through use of type and a cogent application of information design.

For example, Van Blokland (with his staff of Martin Wenzel, Ivo Wauben, and Kirsten Langmuur) is often faced with the complexities of multinational companies that require hundreds of envelope and stationery styles. These can be the result of company mergers or design variations in different branches. His goal is to establish a consistent, appropriate style that can be translated into a wide range of applications. With clients like ING (banking services), Nationale-Nederlanden (insurance), and aQute and Siennax (information technology companies), Van Blokland manages to systematically refine and interpret each company's identity. His work is known for its clarity, typographic elegance, and accessible facility.

Van Blokland adds that for the last two years, there has been an increasing shift towards database publishing. The challenge is, he says, "a large amount of unstructured database information must be published on the Internet or intranet without the possibility of designing every page."

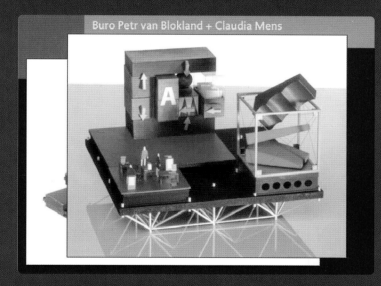

Below: Van Blokland's ideographic diagram of the studio's information design model. Van Blokland explains its function: "Traditional corporate identity manuals are unused and hard to maintain. All usage of corporate basic elements should conform to the same source: a central database that serves all media, including Web, stationery, proofing and printing."

DESIGN: PETR VAN BLOKLAND

Opposite: Web site delineating work for ING bringing together the many corporate logos which are under the ING umbrella into a central online corporate manual where the individual identities must vary enough to be recognized, but the way they are used must be compatible in the whole system

ART DIRECTION: PETR VAN BLOKLAND
DESIGN: MARTIN WENZEL

Information Design

DESIGN PHILOSOPHY

Much of Van Blokland's work is based on the theories he imparts at the Royal Academy, where he teaches type and typography for students in their graduating year. Students anticipate design projects during role-playing exercises, where the task is to create and identify a company and then analyze its needs. "I want students to investigate what a company is doing, really doing. We start from there and then look at the diversity within the company and come to create identity through coherency. And then we develop the criteria to decide whether this creates the desired connection between form and content: namely does this logo or metaphor stand for the company's identity?" he explains.

From a studio perspective, applying analysis and synthesis is exhaustive.

Van Blokland's philosophical tenet is to look not only at the problem to find a solution, but to deconstruct the gestalt into myriad forms before reconstructing an entire system that can be understood and used by anyone in the company, from the chairman of a company to the secretary.

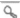

Design Kenn!sbank

Voorwoord

Corporate Identity
en Bedrijfsstijl

Functionele en
visuele synergie

Team Bedrijfsstijlen

Huisstijlhandboeken
ING Bedrijfsonderdelen

Design Kenn!sbank

Voorwoord

Corporate Identity
en Bedrijfsstijl

Functionele en
visuele synergie

Team Bedrijfsstijlen

**Op welke wijze kunt u gebruik maken van de
diensten van FBN**
In het proces om te komen tot een bedrijfsstijl kunt
u onze expertise inzetten vanaf het begin, de
conceptualisering, of indien uw identiteit- en
communicatiestructuur al bekend zijn, kan het Team
Bedrijfsstijlen op basis van uw input aan de slag met
het concretiseren en operationaliseren daarvan.
Indien u wenst dat alleen uw bedrijfsstijl wordt
beheerd in onze DesignKenn!sbank, die voor u
toegankelijk is via internet, is dat natuurlijk
eveneens mogelijk.

In alle gevallen geldt dat de fasen en stappen die
deel uit maken van Ketengeoriënteerde
bedrijfsstijlontwikkeling wordt aangehouden. U
bepaald echter zelf voor welke fasen u het Team
Bedrijfsstijlen inschakeld.

Meer weten
Wilt u meer weten over de manier waarop het Team
Bedrijfsstijlen u van dienst kan zijn? Of heeft u
misschien nu al een concreet verzoek? Wij komen
graag bij u langs voor een oriënterend gesprek.

ING Facilitair Bedrijf Nederland
Team Bedrijfsstijlen
Van Heenvlietlaan 220
Amsterdam
Postbus 1800
1000 BV Amsterdam
Locatiecode BV 03.23
Telefoon (020) 504 90 41
Fax (020) 504 96 17
Email andries@desdoc.com

Below: Design for Local Rules corporate
identity and Web site
ART DIRECTION: PETR VAN BLOKLAND
DESIGN: IVO WAUBEN

Opposite: E-commerce site for Elektuur
(with various spellings in other lan-
guages), publisher of electronic circuits
and books
ART DIRECTION: PETR VAN BLOKLAND
DESIGN: KIRSTEN LANGMUUR

Local Rules international

THE DEPARTMENT OF STORYTELLING · HAPPY HOUR · THE LIBRARY OF FOREIGN LOGIC · PROFILE / MEET YOUR HOST · STAMMTISCH/NEWS FROM THE MARKETSQUARE · TRANSFER DESK · WORDPLAY, SAYINGS AND QUOTES · SITEMAP ·

LOCAL RULES INTERNATIONAL LTD.
28 SOUTH MALL CORK, IRELAND
 T 353 (21) 273 990
F 353 (21) 277 098

GLOCALISATION Managers working internationally or even globally will allway have to spend lots of time and effort overcoming cultural barriers. Local Rules International is here to speed that up, make it less mysterious and more fun. You'll learn a lot about foreigners and even more about yourself.

By defenition, companies working internationally have to manage the balance between the corporate and the regional interests one way or the other; there will allway be tension and (potential) conflict. "Headquarters" risk either creating confusion or imposing "one best way". Now, as a company goes from local to international to multi-national to global, it does not change in nature, but in complexity; it becomes more diverse and therefore, seeks more unity. The "game plan" becomes less transparant, from the powerstructure, the logic of corporate values and objectives, the social system within the organisation up to dealing with everyday issues, such as getting paid on time.

To the extent managers at really aware of this -an thus of the need to understand cultural differences before the leap- they simply do not like it. They tend not to like any other (national or professional, for that matter) logic but their own, any other language but their own and so national culture becomes a major barrier to being effective.

Glocalisation is all about recognosing that the balance between diversity and consistency has to be managed and encouraging constructive debate about it, thereby building on the strenghts of all cultures involved. Over the years this has become my guiding principle.

MEET YOUR HOST
· AANGENAAM KENNIS TE MAKEN · PLEASED TO MEET YOU · SHöN SIE KENNEN ZU LERNEN · AANGENAAM KENNIS TE MAKEN · PLEASED TO MEET YOU · SHöN SIE KENNEN ZU LERNEN · AANGENAAM KENNIS TE MAKEN · PLEASED TO MEET YOU · SHöN SIE KENNEN ZU LERNEN
...my name is **Erik van Veenstra**. I have been a one man band for some twenty years now, consulting on company-strategy and managing companies as turn-around manager. I have worked for companies off all sizes, from one-man operations to multi-nationals, in several counries on several continents, usually at board-level. As a matter of fact, that is what I still do. In 1998 I set up Local Rules International Ltd, because the cultural component in my approach was appreciated as a separate skill.

The information graphics model devised by Van Blokland is the result of his painstaking research, frequent communication with the client, and his ability to understand and create a visual structure, with formidable attention to every detail.

To do this, he sketches ideographic drawings to test each level and phase of a graphic identity. These go directly to the client. For Petr van Blokland, what seems impossible "unifying a corporation visually and setting up a program that can be constantly updated or modified" is an intellectual challenge that he relishes.

TYPE AND TYPOGRAPHY

Type design and typographic acuity are hallmarks of Van Blokland's design. He has been creating typefaces since his student days and has also been at the forefront of creating and testing software. Buro Petr van Blokland + Claudia Mens specializes in providing typographic individuality for clients. Each type design and type treatment emanates from the studio. His retail fonts, including his best known Proforma, are distributed by Font Bureau.

Petr van Blokland, his brother Erik van Blokland, and Just van Rossum, all involved in software development relating

Above: 360° view of Buro Petr van Blokland +Claudia Mens designated as "interesting house for travelers to Delft"

Below: Business card for Architects DP6 Modular system. Cards designed so that the architectural firm can vary image, position of logo, and type information

ART DIRECTION: PETR VAN BLOKLAND AND CLAUDIA MENS. DESIGN: MARTIN WENZEL

Opposite: Detail from Web site featuring Van Blokland's typefaces

Van Blokland says, "What is shown here is VijfZeven (First Seven) which is the smallest pixel matrix font possible, using contrast of thick and thins to emphasize the difference between individual characters."

DESIGN/TYPE DESIGN: PETR VAN BLOKLAND

to type design, have devised RoboFog (www.robofog.com), a type design tool. Van Blokland writes, "Yes it is a tool for designers, but only those who are willing to learn that design is a mental process, not just physical."

Petr van Blokland is on the Board of Association Typographique Inter-nationale, the organization specifically focused on type and typography. He continues his work at The Royal Academy of Art and Design. Van Blokland and his colleagues at the academy continue to mentor the next generation of type designers and typographers.

The characters are bas
ed on a matrix of only
five by seven pixels

Die Buchstaben sind auf einer Matrix e
n nur fünf mal sieben Pixeln basiert.

For legibilit
y the contra
st within the
characters
s important

Smay Vision

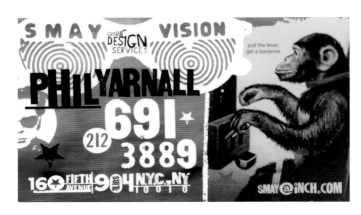

SMAY VISION is the meaningless but memorable name (cribbed from "greeking" copy appearing in an old Letraset catalog) for the design team of Stan Stanski and Phil Yarnall. The two met at Tyler School of Art (part of Temple University in Philadelphia) where, as Stanski recalls, "We attended every class together, graduated together, and moved to New York at the same time." They had also been in a band together, the Slim Guys, which was probable cause for their launch into designing for the music business.

After three years of working for *Guitar* magazine (Stanski) and PolyGram Records (Yarnall), the two joined forces and launched Smay Vision six years ago. "We started with a go-get-them attitude, which we pursued aggressively, including designing our own fonts for every project," Stanski recalls.

Smay Vision, and the client list, evolved so that now the studio may be involved in 50 or 60 projects a month. The "Smayboys'" way of working has also changed, although many of their stylistic signatures, especially notable in idiosyncratic type treatments, remain. "We used to literally work together on the one computer we had. We had two rolling chairs and we would swap places and work on the same piece," Yarnall recalls. Now, Stanski and Yarnall often have to work separately because of the volume of work, but they still collaborate. "We're like a tag-team, and we add to what each of us is doing. We are always meshing our thought processes," Yarnall adds.

Above: Smay Vision business card for Phil Yarnall

Opposite: Promotional postcard for Smay Vision.

Phil Yarnall comments on the elements used in both: "The business card incorporates type borrowed from old blues posters and street signs in Belize. The images in both incorporate everything from photo booth photos and digital photos to a three-dimensional clay devil in the postcard, and a vintage men's magazine of the blood-and-guts variety showing a man wrestling with a giant squid."

DESIGN: STAN STANSKI, PHIL YARNALL/SMAY VISION

Below: Comps for Splendid Blend CD packaging for Musicblitz.com

Yarnall says type interpretation came from "Spanish comic books and bad 1970s Italian type."
DESIGN: STAN STANSKI, PHIL YARNALL/SMAY VISION

Opposite clockwise from left to right: CD for Funky Divas, Client: Polygram Records. CD for Floodgate "Penalty," Client: Roadrunner Records. CD for Old School compilation, Client: Polygram. CD for Boiled Borscht, Alex Rostotsky Trio, Client: Pope Music. CD for Meat Puppets "No Joke," Client: Island Records. CD for Jimi Hendrix "South Saturn Delta," CD for Jimi

Hendrix "Experience," CD for Jimi Hendrix "Live at Woodstock," Client: MCA Records. CD for Janis Joplin with Big Brother and the Holding Co. "Live at Winterland '68," Client: Sony Music/Legacy Recordings
DESIGN: STAN STANSKI, PHIL YARNALL/SMAY VISION

TYPE AND TYPOGRAPHY
Since many of the Smay projects still relate to music, they have acquired a reputation for forging type treatments which are either nouveau funky, Gen-X, or contemporary retro. For boxed CD releases of Janis Joplin and Jimi

Hendrix, for example, Stanski and Yarnall had to pull off a '90s spin and attitude for '60s reissues. "This is a tricky thing. It had to be based on what had been done, yet look like new releases," says Stanski. Their type treatments look softly psychedelic for Joplin and iconically saintly

for Hendrix. Stanski and Yarnall continue to develop type serendipitously, claiming that they have collected an archive of hand-done signs from all over the world as references, from jaunts to the Caribbean and South America, among other places. And they can be inspired,

according to Yarnall, by "type that started stretching as it came through the fax machine" (actually it was a bad fax of Hendrix's face) as the basis for a new typeface.

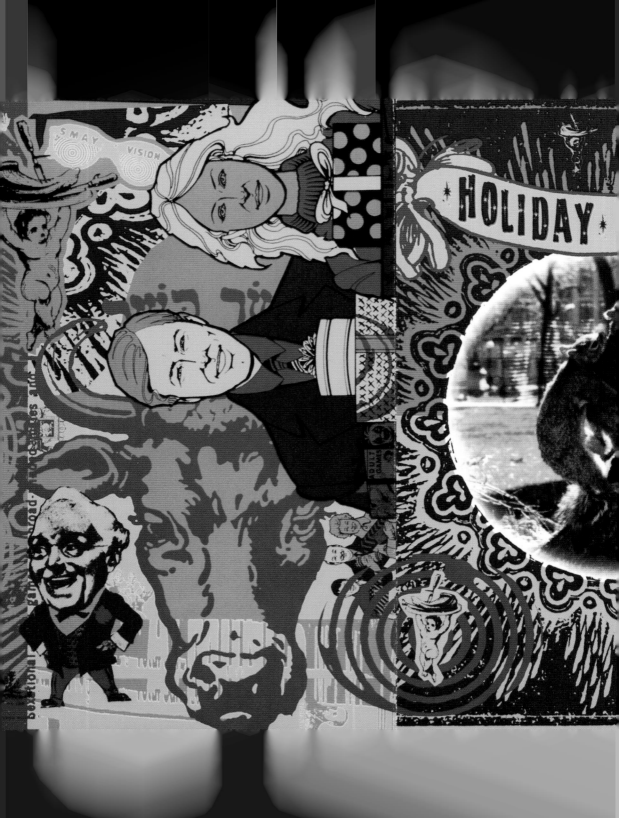

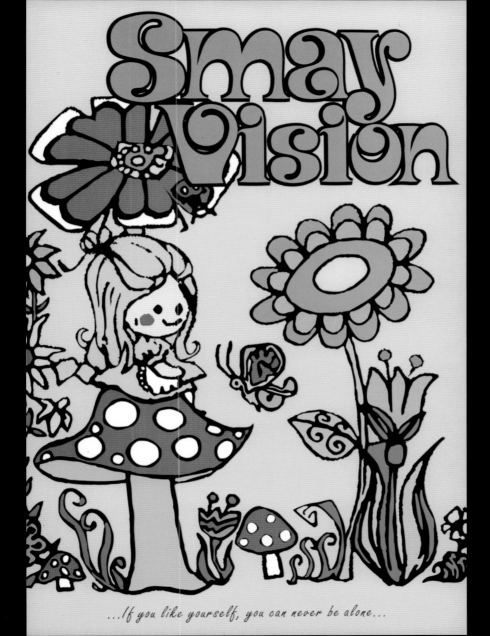

...If you like yourself, you can never be alone...

Opposite: Christmas card and promotional postcard from Smay Vision. Below: Smay Vision promotional sticker

DESIGN: STAN STANSKI, PHIL YARNALL/SMAY VISION

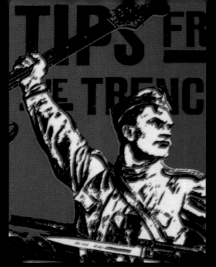
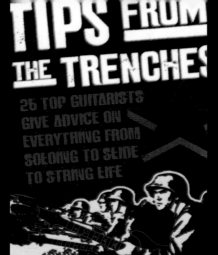

DESIGN PHILOSOPHY

"As our projects get bigger and bigger," Stanski says, "our response to clients is to try to be appropriate for their needs, which can be more restrained and more real world than what we'd like to do. Within that framework, we want to be as cutting edge as possible." "We're not super-artsy," adds Yarnall. "We don't reject or turn down projects because we can't have complete creative control, but we do want to have the concept shine through." Both concur that the labor of love is working on "our own thing," where the experimentation can be overt or over-the-top.

THE WORK

Smay Vision's array of projects spans smaller clients to mass market block-busters. Within the range of jobs, the Smay look is most conveyed by a hand-crafted feeling, even if computer-produced. Acknowledging that their college work (under the mentorship of Stan Zagarski) was cut-and-paste, they are reluctant to produce work that looks computer-generated and untouched by

Opposite: "Tips from the Trenches" special insert poster (front and back) for *Guitar* magazine. Editorial spread for *Guitar* magazine. Left: Call for Entries posters for the New York Underground Film Festival. Below: Smayboy editorial promotional brochure. Cover: Stan Stanski (standing), Phil Yarnall (on the leash)

DESIGN: STAN STANSKI, PHIL YARNALL/SMAY VISION

the human hand. "We like to do things that are made with a homemade look," says Stanski. The Smay Vision collection is characterized by editorial work that has in-your-face images and blasting type treatments (like type imbedded on the rubber sole of a shoe or food arranged in type forms); posters with distressed or elongated type and weird imagery; and CD covers packed with custom lettering. Essentially, Smay work looks like Smay—edgy, funny, and touched by the human hands of Stanski and Yarnall.

Michael Ian Kaye

Above: Book jacket for *Stork Club* by Ralph Blumenthal

DESIGN: MICHAEL IAN KAYE/LITTLE, BROWN
PHOTOGRAPH FROM THE COLLECTION OF SHERMAN
BILLINGSLEY, INSET PHOTOGRAPH: DAN BIBB

Opposite: Book jacket for *Andy Kaufman Revealed* by Bob Zmuda

DESIGN: MICHAEL IAN KAYE/LITTLE, BROWN
PHOTOGRAPHY: LEFT, COPYRIGHT WAYNE
WILLIAMS; RIGHT (INSET); BOB NOBLE/FOTOS
INTERNATIONAL/ARCHIVE PHOTOS

MICHAEL IAN KAYE has recently left Little, Brown publishers, where he had been Creative Director, to become Partner and Associate Creative Director of the Brand Integration Group at Ogilvy & Mather in New York. This new venture is indicative of the many talents of Kaye, who is primarily known for a perceptive, conceptual honing in on his subject and for his sheer bravery when attacking a design.

For Michael Ian Kaye, designing combines all his artistic pursuits. Having studied fine art, Kaye's skills transcend approaching design as mere problem solving. For Kaye, designing is the culmination of his aesthetic sense and his manifest talents.

His portfolio of book jackets reveals these traits. Kaye always bases his concepts on delving into text to find both content and nuance, so that his interpretation becomes a conceptual epiphany: the essence of the book is captured in an integral design.

Kaye does not avoid the business side of the design challenge. He is conscious of the book, but also keeps in mind the marketing, sales, and editorial expectations, as well as the targeted audience. Within these parameters, Kaye transcends the expected and tries to push concept. This is key, he feels, to identifying each book as its own entity.

For example, for the biography *Andy Kaufman Revealed* by Bob Zmuda, Kaye uses the blasting graphics of supermarket tabloids to convey the volatile subject matter. For Ralph Blumenthal's profile of Sherman Billingsley's night club, *Stork Club,* Kaye evokes the heyday of this night club with a sepia photograph and uses matchbook treatment for the type. These are appropriate, but unusual for Kaye, whose trademark designs are minimal, stark, and evocative.

FINAL SECRET

- MILK AND COOKIES
- WRESTLING
- ELVIS

PLUS much more

ANDY KAUFMAN

REVEALED!

Best Friend Tells All

of announcement cards for AIGA NY
Small Talks

ART DIRECTION/DESIGN: MICHAEL IAN KAYE

DESIGN PHILOSOPHY
Michael Ian Kaye sees design as an amalgam of all the elements of his life. This includes his visual vocabulary, his interest in art and photography, and his belief that design is grounded in a sensibility — an aesthetic. He believes that the design of a book jacket should make the audience comprehend and appreciate what the book is about. For Kaye, designing is not just finding a solution to a problem, but exploring the subject in its entirety and conveying that essence. He wants his designs to emanate the relevance, the style, the voice, and the emotional tenor of each book.

This is equally true for other projects, which include his designs for the AIGA Journal, where the audience is Kaye's peers. Here he experiments with ideas that will evoke a response in fellow designers. As he puts it, "These are judged by the best of the best."

When Kaye moved to a new area of Brooklyn and found that he could not find a decent cup of coffee near where he lived, he took over a coffee shop, Victory, and then opened a second

MAKE LOVE, NOT WAR
THE SEXUAL REVOLUTION:
AN UNFETTERED HISTORY
DAVID ALLYN

Daniel McNeill The Face

Above: Book jacket for *Make Love,
Not War* by David Allyn
DESIGN: MICHAEL IAN KAYE/LITTLE, BROWN
PHOTOGRAPHY: ERIC McNATT

Book jacket for *The Face* by Daniel
McNeill
DESIGN: MICHAEL IAN KAYE/LITTLE, BROWN
PHOTOGRAPHY/ART: ILAN RUBIN

Opposite: Clockwise from top left:
Book jacket for *Burning Girl* by Ben
Neihart, Rob Weisbach Books
ART DIRECTION/DESIGN: MICHAEL IAN KAYE
PHOTOGRAPHY: JACK LOUTH

Book jacket for *Toyer* by Gardner
McKay
DESIGN: MICHAEL IAN KAYE/LITTLE, BROWN
PHOTOGRAPHY: JACK LOUTH

Book jacket for *Void Moon* by
Michael Connelly
DESIGN: MICHAEL IAN KAYE/LITTLE, BROWN

Book jacket for *The Chivalry of Crime*
by Desmond Berry
DESIGN: MICHAEL IAN KAYE/LITTLE, BROWN
COVER ART: DAVID LEVENTHAUL, PLAYBOY #97
(MARLBORO COUNTRY), 1990. COPYRIGHT
RICHARD MISRACH, COURTESY CURT MARCUS
GALLERY

Book jacket for *The Milk of
Inquiry* by Wayne Koestenbaum
DESIGN: MICHAEL IAN KAYE/LITTLE, BROWN
PHOTOGRAPHY: ANDY WARHOL

ben neihart

burning girl

a novel

T O Y E R

A NOVEL OF SUSPENSE

GARDNER McKAY

[POEMS]

THE MILK of inquiry

WAYNE
KOESTENBAUM

THE CHIVALRY OF CRIME
DESMOND BARRY

A NOVEL

MICHAEL
CONNELLY

BESTSELLING AUTHOR OF Angels Flight

VOID
MOON

the cabal
and other stories

Ellen Gilchrist

The Dangerous Husband

A NOVEL

JANE
SHAPIRO

Opposite left: Book jacket for
The Cabal and Other Stories by
Ellen Gilchrist
DESIGN: MICHAEL IAN KAYE/LITTLE, BROWN
PHOTOGRAPHY: ANDREW KILGORE

Below left to right: Book Jacket
for *Swimming Sweet Arrow* by
Maureen Gibbon
DESIGN/PHOTOGRAPHY: MICHAEL IAN
KAYE/LITTLE, BROWN

Book jacket for *The Vegetarian
Compass* by Karen Hubert Allison
DESIGN: MICHAEL IAN KAYE/LITTLE, BROWN
PHOTOGRAPHY: EDWARD WESTON

Opposite right: Book jacket for
The Dangerous Husband by
Jane Shapiro
DESIGN: MICHAEL IAN KAYE/LITTLE, BROWN

Book jacket for *The Tipping Point*
by Malcolm Gladwell
DESIGN: MICHAEL IAN KAYE/LITTLE, BROWN

restaurant, Victory Cafe. Since he does the graphics for his two restaurants, the challenge for Kaye is to work with himself as a client. This, he maintains, is very difficult indeed. "I, as my own client, want the same scrutiny that I expect from other clients. The freedom designing for myself gives me is scary."

TYPE AND TYPOGRAPHY
Kaye's approach to typography, he says, is "very traditional. I accept the tenets of Jan Tschichold, Bruce Rogers. My type treatments are very classical. Type is about communicating, which is its best use." Kaye also maintains that his use of type is conceptual, saying, "I integrate the type into the design, rather than adding it as an afterthought."

Anyone who has worked with Michael Ian Kaye comments on his frenetic energy and his laser-like mind. For Kaye, designing is the equivalent of mentally pacing back and forth until the gestalt is in place. Since he takes formidable leaps with each design, he hovers on the edge of fear. But, as Michael Ian Kaye says, "If I wasn't scared all the time, it wouldn't be natural for me."

Typerware

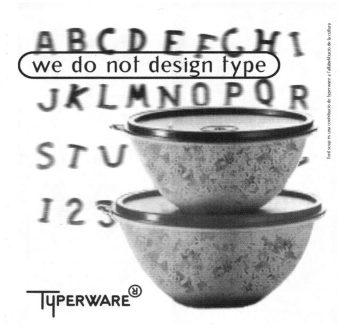

we do not design type

font soup es una contribució de typerware a l'alfabetització de la cultura

TYPERWARE®

Above: Spread from Garcia Fonts Library #3 devoted to gastronomic type design

The FontSoup type family was first featured within this library. ("FontSoup is a Typerware contribution to the literacy of culture" is stated on the right edge). According to Balius, "The controversial type project Garcia Fonts & Co. often used irony and sense of humor in order to introduce concepts, attitudes and the philosophy of the project itself. We were conscious that our approach to type design was not in the formal/traditional manner. So, we stated 'we do not design type,' (at least not in the usual formal way)."
DESIGN: ANDREU BALIUS

Opposite: Poster featuring Playtext. This typeface was used as the corporate text face for Garcia Fonts printed matter.
DESIGN: ANDREU BALIUS

FOR THE LAST SEVEN YEARS, Andreu Balius and Joan Carles P. Casasin have comprised the two-man team that runs the type foundry and (typo)graphic design company Typerware in Barcelona. The two met in 1993 and discovered mutual type interests. Both design type for pleasure as well as for use in design work they are commissioned to do. In their early days, this work was flyers, posters, and leaflets for Barcelona's night club and music scene. "We enjoyed these since we love graphic design, and we tried to experiment, to investigate, to simply learn as much as we could within our work," says Balius, who speaks for them both.

Typerware, Balius says, creates type designs "tied into our commissioned graphic design work. Sometimes we design type-faces for specific design projects, as in the work we did for the theater group La Fura del Baus. We did the graphic images for their production, "Manes." Then we designed a book based on the concept and ideas which originated from the theatrical production. We worked with a small budget, but we were happy with the results. For the book we designed two type families, FaxFont (a faxed four-weight typeface) and the NotTypewriterButPrinter type family (a four-weight type with the shapes scanned from old matrix printouts using varying amounts of ink). Both were used for the first time in the book" (and now are sold by Typerware).

Balius and Casasin have achieved an international reputation for their dynamic typographic experiments. The partners have produced graphic and type designs that capture a Catalan sensitivity and energy. Balius says, "We did not have formal (or even traditional) training in typography or type design. We both studied graphic design and so we had to work hard on our own to develop our type design. Most of this knowledge comes from our curiosity, our enthusiasm, and our self-training."

Garcia Fonts is a secondary project in which the two have been involved, a not-for-profit type exchange where type designers submit work and receive other designers' fonts for free. This commitment to expanding the availability and use of new typefaces has been a labor of love.

The two have also created commercial fonts sold by International Typeface Corporation and FontShop International.

A a B b C c

D d E e F f G g

I i J j K k

PLAYTEXT { the type wonder }

by: Andreu Balius

‹‹ for your serrano body ››

1993-96

M m

Ñ ñ O o P p Q q

S s T t U u V v

W w X x Y y

Legibility keeps your mind clean & tidy

Opposite: Center spread from Garcia Fonts Library #4 stating, "Legibility keeps your mind clean & tidy"

Balius comments, "We used an ironic picture introducing Ozo (Ozone) typeface, with an overlapping of designer Massimo Vignelli's recommended basic types since Vignelli had been adamant that 'the proliferation of typefaces and type manipulations represents a new level of visual pollution threatening our culture. Out of thousands of typefaces, all we need are a few basic ones, and trash the rest.' Ozo type, therefore, is a Typerware contribution to the ecology of communication. We used type as a way to react, as a way to say things visually."

DESIGN: ANDREU BALIUS

Below: Covers from Garcia Fonts Library #4 and #6 in which the new fonts from the Garcia Fonts catalog are featured

DESIGN: ANDREU BALIUS

DESIGN PHILOSOPHY

According to Balius, "The important thing in designing is to try to be honest in your work and to communicate in the best way possible, since communicating visually is not an easy thing. It has to do with manipulation combined with conveying knowledge. A designer cannot be outside of the things he is communicating through design. We feel that we are taking part in the content in some way. We are also part of the society in which the design will be seen. Although making things work properly in a design is the main goal, you can't forget that you are part of a bigger context and that taking a position on how your design affects society is, in most cases, inevitable."

TYPE AND TYPOGRAPHY

Balius compares type with music. He says, "With music you have words and melody which you hear at the same time. With type, it is as if you 'listen' visually; i.e. the words and the type function simultaneously. Type helps the ideas you are presenting to be 'heard' in the best way. Type is like a

10a

MOSTRA d'ART

CONTEMPORANI **CATA...**

ⓒM

centre cultural **CAN MULÀ**

**PARC DE CAN MULÀ
08100 MOLLET DEL VALLÈS
BARCELONA
TEL. (93) 570 16 17
FAX (93) 570 72 39**

HORARIS:
Dilluns, dimarts, dimecres i divendres: de 5 a 9 del vespre
Dijous: de 10 a 2 del migdia
Dissabtes: de 10 a 2 del migdia i de 5 a 9 del vespre
Diumenges i festius: de 12 a 2 del migdia

Ajuntament de
Mollet del Vallès

5 - 28 DE J

INAUGU

centre cultural CAN MULÀ

ULIOL 1996

ó

endres 5 de juliol

a les 20 h

Poster for a young Contemporary Art Exhibition at Centre Cultural Can Mulà, Mollet del Vallès in Barcelona
 "The concept suggests really fresh juice in the contemporary Catalan art scene," says Balius.
DESIGN: ANDREU BALIUS, JOAN CARLES P. CASASIN
TYPERWARE

Below, clockwise, left: Poster for a (Poli) Poetry recitation. "The illustration defines the kind of surrealistic performance that is behind this poet's recital. This serigraph poster on grey fish-wrapping paper is one of our first works as Typeware," says Balius.

One of a series of Flyers for the NITSA Club in Barcelona; Primavera Sound Poster for an indie (independent) young pop festival in Barcelona; Flyer for a DJ programme at the NITSA Club in Barcelona

DESIGN: ANDREU BALIUS, JOAN CARLES P. CASASIN/TYPEWARE

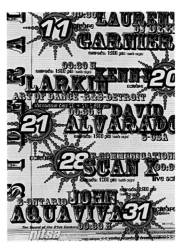

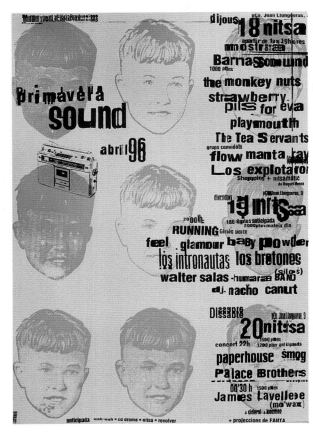

nice sound that gives sense to the silence of text."

When choosing a typeface, he adds, "Context is the important thing. This includes designing a typeface, when necessary, for a certain design project. We think of type and its context like a great meal. (We are Mediterranean, after all.) Choosing the right typeface is similar to ordering the right wine, which complements the meal. The relationship among the combined tastes of certain dishes with specific wines is important to becoming a gourmet. This is not unlike choosing the right type for the right project or specific context. This is the reason why we need as many typefaces as possible, in order to have a wide range of good choices. We think of the same appropriateness and specific relationship to the concept when we have to design a typeface. We relate to the context of the design commission, the motivation for the project, before starting the first sketches for a new type."

Balius and Casasin concur that "type conveys ideas. We use type in order provide messages that are intended to be

Below: Spread from Manes, a book designed in 1996 for the theater company La Fura dels Baus

Balius says, "We use image and text trying to have them interact. This is a book where concepts such as chaos or simultaneity are put into practice. We treat the book as a white stage where things occur. The basis of the show which the book reflects comes from this theatre's manifesto, which is 'Manes is a multitude of emotions communicated dizzily, by means of several histories that cross each other.'"

DESIGN: ANDREU BALIUS, JOAN CARLES P. CASASIN/TYPERWARE

Farm animals A personal invitation to the dream world, where cocks, fed up with waiting for sunrise, have turned into chickens. **A tale in which men are chickens** and chickens are men, in which fear has an educational value, logic destroys our imagination and security, a few grains of corn, has become an absolute value in our lives.

Quan La Fura dels Baus realitza un nou espectacle, un dels primers eixos de creació és la construcció de l'entorn.

El Corral (l'actor i el seu entorn)

A Manes, és un espai neutre on la bellesa es mostra com un vel subtil del sinistre.
Els actors conformen així una part física de l'espai en què es mouen tot provocant que aquest es transformi en una part onírica, en un apèndix dels propis actors.
Un corral on campen els ous i volen les gallines.

The dramatics
It is based on a grammar of simultaneity and no continuity. Zapping of emotions and sensations. Ahistorical dramatics in which the plot is the Here and Now. A series of scenes set against each other in which different worlds share space and time. A Gothic tale that attends unmoved the clash of several private scenes always caught unawares by an indiscreet light.

read in a certain way. But we also consider that ideas are conveyed in type. You can express ideas through type. You can design a typeface (a whole font, alphabet, a family, whatever ...) in order to say things, make people think about something, express a feeling, a personal view of the world. You can say all of these things in a type design."

Balius comments on the Typerware partnership: "We were lucky to meet each other one day at the BAU School in Barcelona, because it is difficult to find someone who can share the same thoughts and have the same motivation about design and typography. And so here we are with the energy and joy to challenge our work and to find our place in the tiny Spanish market for type design and typography."

Why Not Associates

Above: Eric Steps. Why Not Associates created a typographic treatment for the area surrounding the statue of the British comedian Eric Morecombe. This was part of an ongoing public arts project to regenerate the seaside town of Morecombe. Why Not worked in collaboration with sculptor Gordon Young. Commissioned by Lancaster City Council

Above right: Detail from Eric Steps. Opposite: The steps in relation to the statue of Eric Morecombe, a familiar figure to anyone in Britain

DESIGN: WHY NOT ASSOCIATES

WHY NOT ASSOCIATES in London have been shifting perspectives and avoiding conventional thinking for over a decade. Their designs are intellectual, intuitive, and typographically sophisticated.

The name of the studio originated when David Ellis and Andy Altmann were students at the Royal College of Art, where they received their Master's degrees in Design. They were referred to there as the Why Not boys because when asked to explain their idiosyncratic work, the usual reply was "Why not?"

Ellis and Altmann started Why Not Associates (with Howard Greenhalgh, who left to form Why Not Films in 1992) after leaving the RCA in 1987. Since then, Patrick Morrissey, Iain Cadby, Mark Molloy and Vicky Fraser have also joined the studio.

David Ellis admits that Why Not's early work was intended to be as "mad as we could get to prove all of our tutors wrong." Their style became known for type treatments set in all lower case in small type in odd patterns, along with abstract illustrations. But after running amok, according to Ellis, with a rebellious style and an anarchic attitude, their work was designated the next wave by the design press. Why Not now hones in on attacking each project for a roster of impressive clients with an original approach targeting the core of each client's brief. The designs are always refreshing in concept and experimental in the use of type.

In its second decade, Why Not does not see itself making waves, but definitely making a difference. What they do now is less about shock and more about surprise. As Patrick Morrissey, one of the Why Not team since 1994, puts it, "We take pleasure in doing what's not expected or conventional. It's what keeps the work fresh." This is echoed by Iain Cadby, who has been with Why Not since 1996. "We try to reach the essence of something, pinpoint what it is, then visualize it," Cadby explains.

BASKETBALL

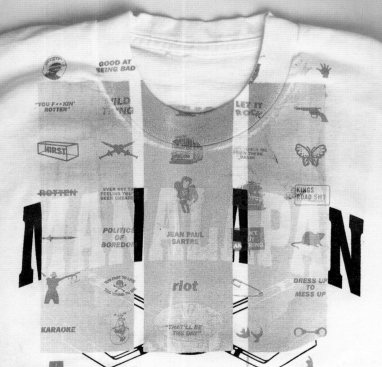

RECREATION
YOUTH HOCKEY

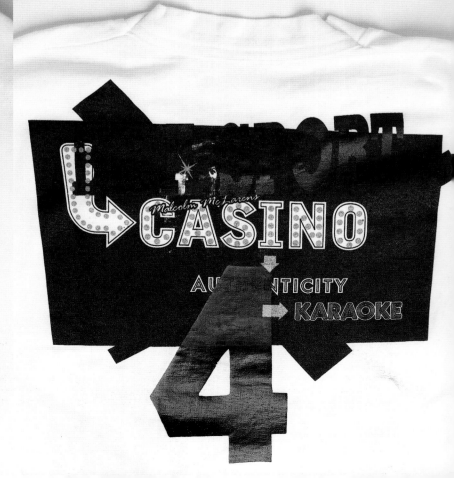

Opposite: T-shirt designs for entrepreneur Malcolm McLaren to accompany McLaren's part of an exhibition, Smaak (meaning "on taste") in Maastrict, The Netherlands
DESIGN: WHY NOT ASSOCIATES

Below: Stills from a conference video designed by Why Not for NCR. The typography illustrates words spoken by key people within the company on the subject of "relationship technology." Commissioned by Circus. Produced by The Mob
DESIGN: WHY NOT ASSOCIATES

TYPE AND TYPOGRAPHY

Why Not is known for reinventing type as an inherent, but not static, element within their designs. Type in Why Not designs moves and has energy, and, most importantly, a purpose: type is used to convey and to interpret content in every medium. Type is used instinctively, intuitively, expressively, and unexpectedly.

DESIGN PHILOSOPHY

David Ellis says that Why Not's philosophy in designing starts with "mining diversity and having a gut reaction from the start, so that the design feels right, and it feels new."

The overall design group philosophy is simple: look at the design brief and then find a way to turn it into something unexpected. Why Not's print work is loaded with idiosyncratic imagery and illustrative type treatments. This studio's exhibition designs have included montaged multi-media segments with fluid type treatments. Why Not's television titles feature type that pulsates. Their clients range from small start-up

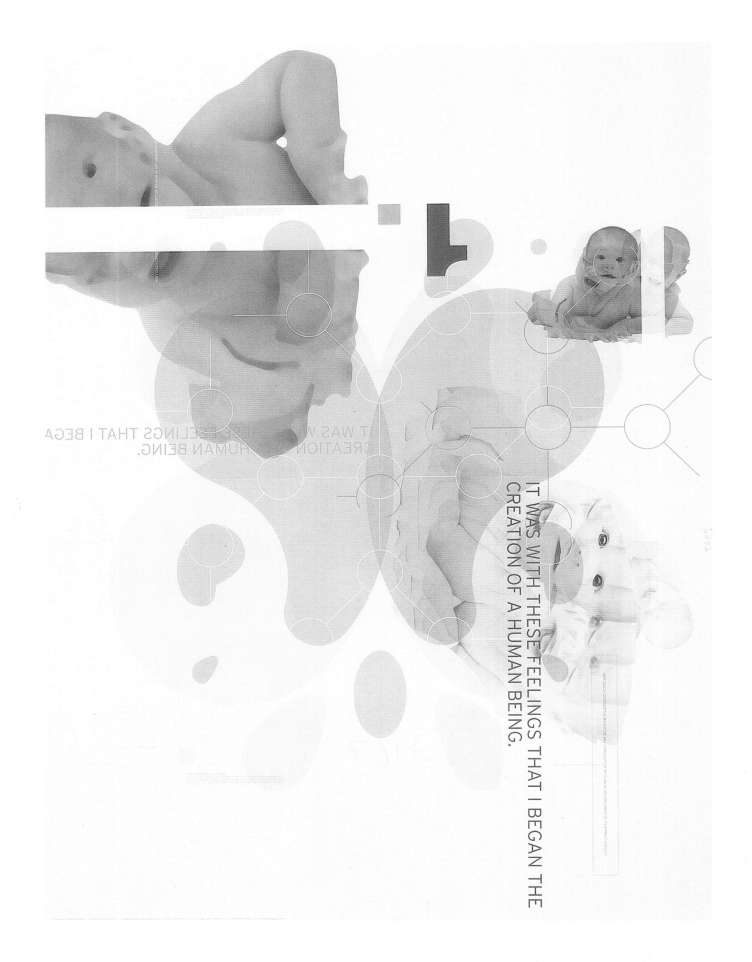

IT WAS WITH THESE FEELINGS THAT I BEGAN THE
CREATION OF A HUMAN BEING.

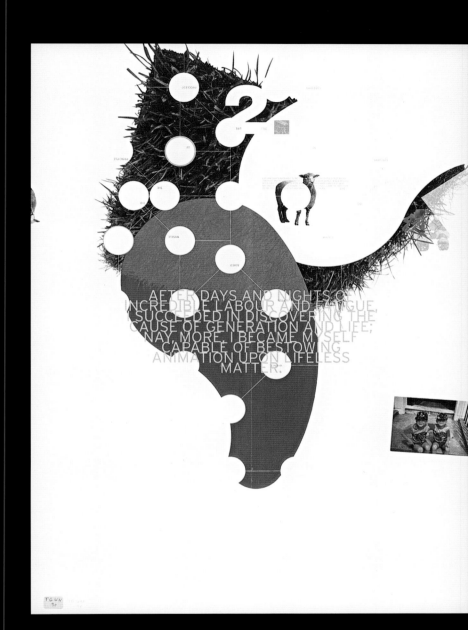

companies to Virgin Records, the BBC,
the Natural History Museum, The Royal
Academy, and entrepreneur Malcolm
McClaren. Of the studio's ethic, Altmann
adds, "We're obsessive and want each
aspect of the design to work. We're
sticklers for detail, and we don't stop
until each detail is as good as we can get
it. We want to get everything right."

THE PROCESS
According to Andy Altmann, the Why
Not team seeks out the next dimension
of work, namely work that expands what

they can bring to it and what they can
learn from it. Altmann says, "We like
pushing what we do, like working in dif-
ferent materials and finding new media
for our ideas."

THE PROJECTS
Some of this experimentation has
been done in collaboration with sculp-
tor Gordon Young. With Young, Why
Not have created public art projects
in Ayr, Scotland (Tam O'Shanter Pub
Steps featuring the poetry of "Rabbie"

Below: Stills from a title sequence for the BBC. The program, "Postcards from the Net," follows people traveling the world keeping contact by e-mail.

DESIGN: WHY NOT ASSOCIATES

Opposite: Stills from a conference video for Virgin Records

The typography is animated to quotes by Virgin recording artists, here featuring Smashing Pumpkins. Commissioned by Nancy Berry, Vice-president of Virgin Music Group. Produced by Caroline True

DESIGN: WHY NOT ASSOCIATES

Burns designed in stone) and designed "A Flock of Words," described as a "300-metre typographic path in black granite, colored concrete, steel, Creetown granite (sandblasted), Hillend granite, and bronze" for the city of Morecombe. One of their latest type-in-stone designs, also for Morecombe, is a typographic treatment for the area surrounding a statue of British comedian Eric Morecombe. According to Altmann, the concerns that arise from these projects are: "How weather affects the work. The legibility of the text as you walk forward and read backward. Considerations of space, scale, size. How the lighting works from an angle. This is so physical. There is permanence here."

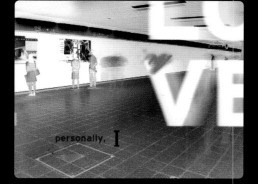

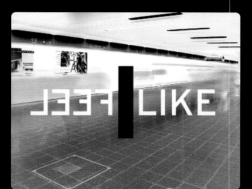

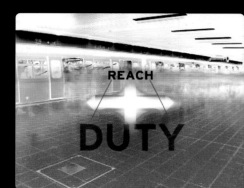

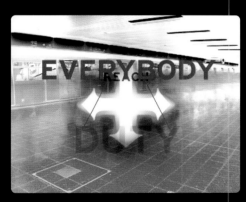

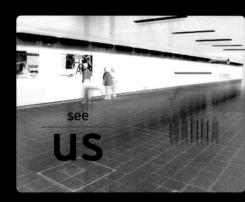

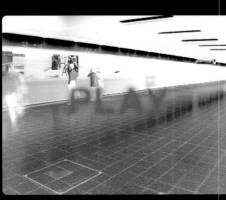

Laurie Haycock Makela

IN 1996, P. Scott Makela and Laurie Haycock Makela went to Cranbrook Academy of Art in Bloomfield Hills, Michigan, to become co-chairs of the 2-D design department there. They also merged their talents by creating a new studio, Words + Pictures for Business + Culture. Scott's studio had been primarily known for creating dynamic videos, experimental fonts, and daring designs. Laurie had been the design director of the Walker Art Center in Minneapolis, where her design innovations graphically transformed the identity and the publications of that institution. She had commissioned Matthew Carter, for example, to create a font specifically for the art center.

Together, P. Scott Makela and Laurie Haycock Makela forged a dynamic and multi-faceted program for Cranbrook students. At the same time, they pursued a range of interests including film titles, video, Web and editorial design, as well as broadcast advertising, through their studio. For most designers, the Makelas' work captured the energy, technical savvy, and graphic experimentation of the last decade. In 1998, their landmark book (co-authored with Lewis Blackwell), *Whereishere: impounded at the borders of mass communications: ideas, materials, images, narrative, toxins* was published (along with a corresponding Web site) and the Makelas achieved yet another triumph of expression and ideology, with many more expected.

In May, 1999, P. Scott Makela died unexpectedly from an undiagnosed virus. In one day, Laurie Haycock Makela found herself a widow, a single parent to their two children, and the sole head of the Cranbrook department, as well as the studio.

Above: T-shirt front (Shock) and back (Disorderly) from *Whereishere* book, 1999
DESIGN FIRM: WORDS + PICTURES FOR BUSINESS + CULTURE
ART DIRECTION: P. SCOTT MAKELA, LAURIE HAYCOCK MAKELA
DESIGN: WARREN CORBITT

Opposite: Concept proposal for advertising campaign, 1999
DESIGN FIRM: WORDS + PICTURES FOR BUSINESS + CULTURE
DESIGN/PHOTOGRAPHY: P. SCOTT MAKELA
CLIENT: ROSSIGNOL SKI + SNOWBOARD

global IS CLOSE TO YA

Right: Advertisement

DESIGN FIRM: WORDS + PICTURES FOR BUSINESS + CULTURE
ART DIRECTION: LAURIE HAYCOCK MAKELA. DESIGN: PAUL
SCHNEIDER. PHOTOGRAPHY: KEVIN ZACHER. CLIENT:
ROSSIGNOL SKI + SNOWBOARD

Below: Advertisement

DESIGN FIRM: WORDS + PICTURES FOR BUSINESS + CULTURE
ART DIRECTION: LAURIE HAYCOCK MAKELA. DESIGN: BRIGID
CABRY. PHOTOGRAPHY: MARK GALLOP/NATE CHRISTENSON
CLIENT: ROSSIGNOL SKI + SNOWBOARD

The work featured here is from the Rossignol campaign. It displays many traits of the Makelas' collaborative signature: dramatic images, expressive, interpretive type treatments, energy that vibrates on the page in a synergy of image and text.

This is how this work came to be documented in Laurie Haycock Makela's own words:

"These works represent the end of Words+Pictures for Business+Culture— the uncanny result of atomic loss. Scott's last works—"Faith and Action," "God is Close to Ya," and "Vertigo is Fun"—were created to pitch the Rossignol ski and snowboard print campaign and Web account. Scott, a passionate and strong snowboarder, possessed a graphic voice perfectly suited and eager to seduce his audience.

"The day after he died, a shocked but oddly inspired team of Cranbrook Academy of Art graduate students joined me to create dozens of new directions for our clients. Press deadlines knifed us, and the client-relationship became tense. The real issue, of course,

BACKING NOT *BUYING* THEM

STARS

THE TEAM
Nita Arpiainen
Ron Chiodi
Andrew Crawford
Dionne Delesalle
Jonas Emery
Jeremy Jones
Pascal Imhof
Goku Nagata
JF Peichat
Pauline Richon
Tony Roos
Paavo Tikkonen
Doriane Vidal

ROSSIGNOL
rossignolsnowboards.com

YOU MUST RIDE

was that Rossignol had fallen in love with Scott's passion for the project. What was Words + Pictures without the wind tunnel effect of Scott's 200 mph energy and talent?

"The team, particularly Paul Schneider,

Cadbry, lived in the forest-like vortex of his absence, subsisting on vibrant memories and holograms of the remarkable graphic voice of P. Scott Makela. The work you see here reflects our respect for that joyful, noisy, wicked voice."

the Rossignol project, Words + Pictures just had to shut down."

In recognition of the last ten years of their contribution to the design field, The America Institute of Graphic Arts awarded the Makelas the Gold Medal for Innovation 2000.

In 1999, Laurie (with Skooby Laposky) made a CD, *Wide Open: Music for P. Scott Makela,* since creating music as well as videos had also been a facet of the Makela oeuvre. She has continued her work at Cranbrook, as well as lecturing and performing at the Tate Gallery

WAS THAT DROP 50 OR 80 FT.
WHO CARES.

THE TEAM
Nita Arpiainen Ron Chiodi Andrew Crawford Dionne Delesalle Jonas Emery
Pascal Imhof Gaku Nagata JF Pelchat Pauline Richon

Tony Raos Paavo Tikkanen Dariane Vidal

ROSSIGNOL
rossignolsnowboards.com

in London and in New York, Osaka, Lausanne, and Argentina.

Laurie Haycock Makela shares the thinking behind her new venture: "As I slowly unravel the collaborative voice I shared with Scott, I'm doing new vocal and video work under the name of AudioAfterLife. New typography takes cues from the sonic culture, as its context and technologies mutate once again. I've experienced the exasperating differences between the virtues of 'time-based' typography and those of book design. I'll call the next phase 'audiographics,' where fonts come with sound, the book is wired, the auditorium is full, and the voice is real."

As a startling human being and as a designing voice, no one could be more real than Laurie Haycock Makela.

Jonathan Barnbrook

Above: Book jacket for Damien Hirst book
I WANT TO SPEND THE REST OF MY LIFE EVERY-WHERE, WITH EVERYONE, ONE TO ONE, ALWAYS, FOREVER, NOW. Booth-Clibborn Editions

Opposite: Cover and spread for *Why2K?,* Booth-Clibborn Editions. Subtitled "Anthology for a New Era," the book has a series of essays by notables such as poet Seamus Heaney, historian Eric Hobsbawm, and filmmaker Derek Jarman.

DESIGN: JONATHAN BARNBROOK

JONATHAN BARNBROOK has his studio in London, on Archer Street in Soho. Barnbrook Design, now in its tenth year, has a staff of two—Jonathan and Jason Beard—but the work that emanates from this enterprise belies its size. Barnbrook is a graphic designer, font designer, and advertising director. He may be best known for designing the book on the controversial contemporary artist, Damien Hirst, titled *I WANT TO SPEND THE REST OF MY LIFE EVERYWHERE, WITH EVERYONE, ONE TO ONE, ALWAYS, FOREVER, NOW.* The book's publisher, Edward Booth-Clibborn, has called Barnbrook a genius, and the book has won every major design award from New York to Tokyo.

In this collaboration with Damien Hirst, Barnbrook achieves an art book that redefines the genre. His design combined with the complex production surprise the reader at every spread. Not only does Barnbrook capture the essence of both Hirst's work and mind, he uses design to involve the reader with pull-outs, overlays, die-cuts, inserted posters, and puzzles. The book is not only a good read, but also an interactive experience. The first printing of this hefty tome sold out and the second printing continues to sell.

With this book, Barnbrook, who assiduously worked closely with Hirst for a year and a half, made a deliberate attempt to "redefine contemporary art book design."

A second Booth-Clibborn Book, *Why2K?,* has recently been released. In this book, Barnbrook typographically explores and illustrates essays that focus on this new century done by Britain's New Millennium Experience Commission. It, too, offers devices and surprises that move this book toward a new form. Barnbrook describes his design approach here as creating a "typographic wedding cake."

While working on yet another Booth-Clibborn book, he has continued his collaboration with Hirst by branching out into restaurant design. The resulting restaurant, Pharmacy, has won numerous design awards. Barnbrook also worked with Hirst to design a corresponding delicatessen called Outpatients. In addition, Barnbrook is designing textiles, products, and a Kanji font for Japan. In terms of which new areas he wishes to explore next, he sees his future as open-ended.

You are here

WHY 2K?

Below and opposite: Spreads from
Why2K?

Following spread: "Derek Jarman's
Garden" spread from *Why2K?*

DESIGN: JONATHAN BARNBROOK

"i didn't exist at creation
i didn't exist at the flood
and i won't be around for salvation
to sort out the sheep from the cud·

"or whatever the phrase is. the fact is
in soteriological terms
i'm a crude existential malpractice
and you are a diet of worms."
james fenton

"history repeats itself. historians repeat each other."
philip guedalla

on the move

DESIGN PHILOSOPHY
For Barnbrook, design is his forum to "make a difference." He does approach each project with the intention of finding a solution to a design problem, but he does not attack this conventionally. Key to this approach is his aspiration to "add some value to the existing culture." He says that it is "important to have an emotional reaction to text," and the passionate response produced on the page is his hallmark. For Barnbrook, there is no doubt that design can be an art form in its own right, so his work conveys that intensity and concern with form. With the Hirst book, for instance, he did not merely display Hirst's work, but demonstrated it, made it resonate, and, in so doing, created a book which has itself become a collectible art piece. His interpretation of the essays in *Why2K?* is also a considered and text-based improvisational response that enhances the writers' theories, reflections, and opinions on the future through design.

TYPE AND TYPOGRAPHY
Barnbrook is known for his vast

THE STEREOTYPE IS THE ETERNAL
FEMININE. SHE IS THE SEXUAL OBJECT
SOUGHT BY ALL MEN, AND BY ALL WOMEN.

SHE is of neither sex, for she has herself no sex at all. Her val U E
is solely attested by the demand she excites in others. All s H E
must contribute is her existence. She need achieve nothi N G ,
for she is the reward of achievement. She need never gi V E
positive evidence of her moral character because virtue I S
assumed from her loveliness, and her passivity. If any m A N
who has no right to her be found with her she will not be B E
punished, for she is morally neuter. The matter is sole L Y

one of male rivalry. Innocently she may drive men to madness and war. The more
trouble she can cause, the more her stocks go up, for possession of her means more
the more demand she excites. Nobody wants a girl whose beauty is imperceptible
to all but him; and so men welcome the stereotype because it directs their taste into
the most commonly recognised areas of value, although they may protest because

SOME ASPECTS OF
IT DO NOT TALLY
WITH THEIR FETISHES.

THE FEMALE
EUNUCH
Germaine Greer

MY EARLIEST MEMORIES

ARE OF THE OLD LAWN-MOWER WITH WHICH WE LABOURED TO CUT THE GRASS.

I am so glad there are no lawns in Dungeness. The worst lawns, and for that matter the ugliest gardens, are along the coast in Bexhill – in Close and Crescent. These are the 'gardens' that would give Gertrude Jekyll a heart attack or turn her in her grave.

ERIC HOBSBAWM

On the 28th of June 1992 President Mitterrand of France made a sudden, unannounced and unexpected appearance in Sarajevo, already the centre of the Balkan War that was to cost perhaps 150,000 lives during the remainder of the year. His object was to remind world opinion of the seriousness of the Bosnian crisis Indeed, the presence of a distinguished, elderly and visibly frail statesman under small—arms and artillery fire was much remarked on and admired. However, one aspect of M. Mitterrand's visit passed virtually without comment, even though it was plainly central to it; the date. Why had the President of France chosen to go to Sarajevo on that particular day? Because the 28th June was the anniversary of the assassination, in Sarajevo, in 1914, of the Archduke Franz Ferdinand of Austria-Hungary, which led, within a matter of weeks, to the outbreak of the First World War. For any educated European of Mitterrand's age, the connection between date, place and the reminder of a historic catastrophe precipitated by political error and miscalculation leaped to the eye.

How better to dramatize the potential implications of the Bosnian crisis than by choosing so symbolic a date? But hardly anyone caught the allusion except for a few professional historians and very senior citizens. The historical memory was no longer alive.

SARAJEVO

typographical talents. He uses type as a medium to be worked onto a blank canvas. Beginning with his "interest in language," Barnbrook paces the pages he designs, creating a visual typographic rhythm in response to the text. Each design project he attacks becomes a typographical metaphor for the thought processes of the writers. Typographically, what can be expected from Barnbrook is the unexpected.

Barnbrook also designs his own typefaces for his foundry, Virus. His font designs are equally edgy, esoteric, and intelligent and include Drone, False Idol, and Nixon. These designs are a microcosm of his thinking process. Each has a rationale, an attitude, and an emotional resonance.

For Barnbrook, it is important that his graphic work is not only good design, but relevant in many other ways. His approach to designing seeks not only a restatement of what design inherently is, but, more importantly, what it can be.

Contact Information

Phil Baines
studio@philbaines.co.uk

Jonathan Barnbrook
virus@easynet.co.uk

Henrik Birkvig
hbi@dgh.dk

Neville Brody/Research Studios
nbrody@researchstudios.com

David Carson
dcarson@earthlink.net

Rodrigo Xavier Cavazos/PsyOps
rxc@psyops.com

Scott Clum/Ride Studio
scott@scottclum.com

Stephen Farrell/Slipstudios
slipstudios@compuserve.com

Louise Fili
fili@mindspring.com

Michael Ian Kaye
michael.kaye@ogilvy.com

Laurie Haycock Makela
brickhouse@makela.com

Susan Mitchell/Farrar Straus & Giroux
susan.mitchell@fsgee.com

Following spread: Detail of a Smay Vision promotional postcard

Plazm
design@plazm.com

Smay Vision
smay@speakeasy.net

Leonardo Sonnoli
leo@pesaro.com

DJ Stout
djstout@texas.pentagram.com

Jeremy Tankard
jtankard@typography.demon.co.uk

Typerware
www.typerware.com

Petr van Blokland
buro@petr.com

Rudy VanderLans
editor@emigre.com

Why Not Associates
info@whynotassociates.com

Torben Wilhelmsen
torben@wil.dk

Fred Woodward/Rolling Stone
art@rollingstone.com

Don Zinzell
info@zinzell.com

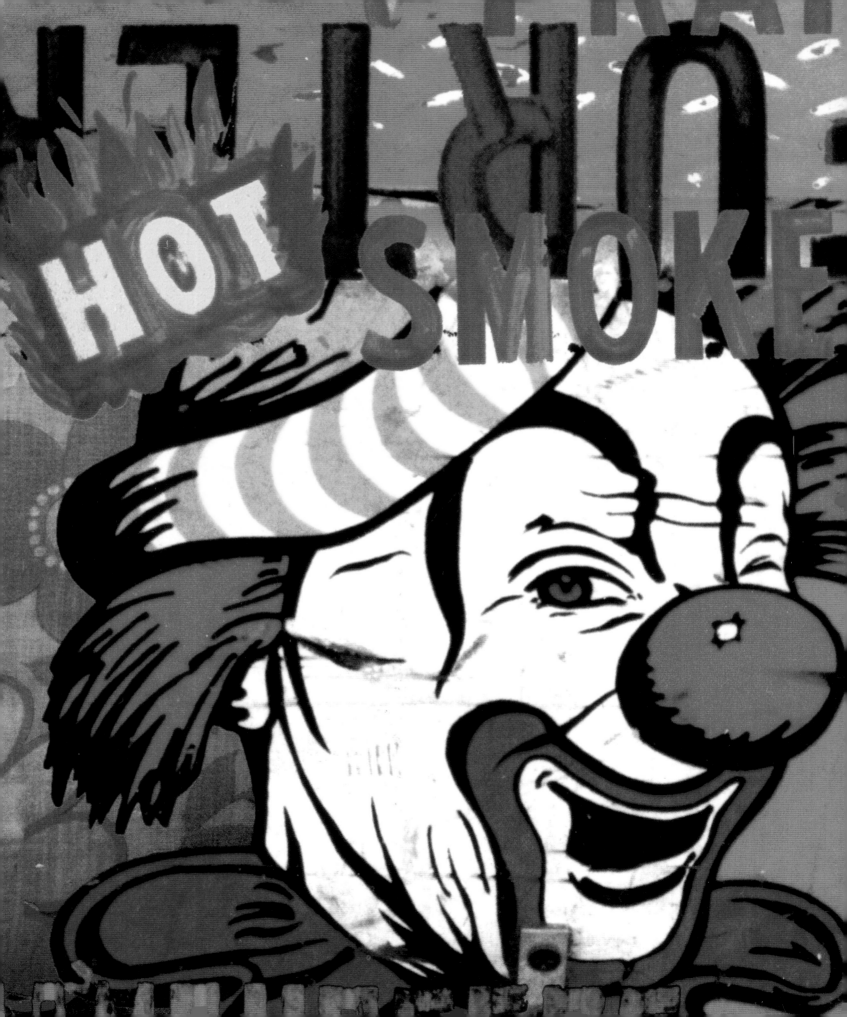

Colophon

Text and captions for *Type Graphics*
utilize the Eidetic family of typefaces
designed by Rodrigo Xavier Cavazos and
released through PsyOps Type Foundry
of San Francisco (www.psyops.com).
Headings are set in Bitstream Alternate
Gothic No. 2.